Photo-Essays about Asian American Women in *Life* Magazine 1936 to 1965

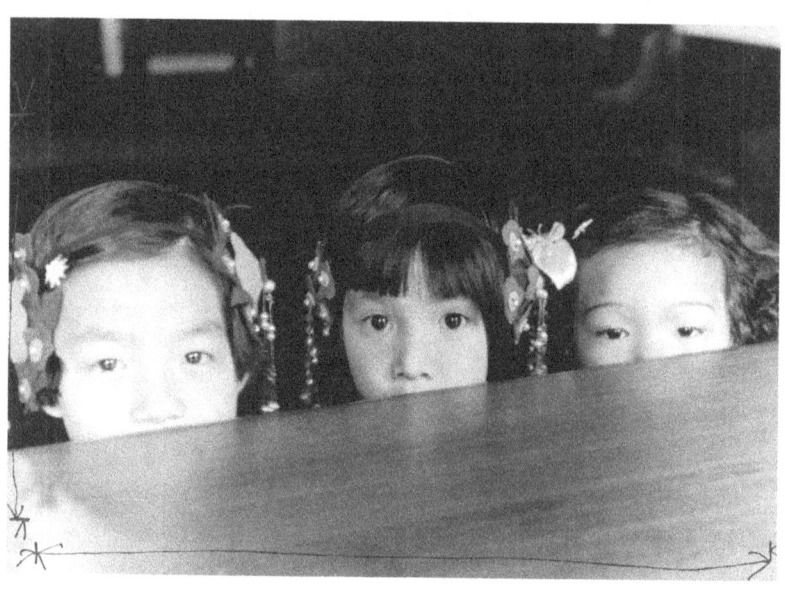

Figure 0.1 Little Girls Peeking over the Rim of the Table at California Mission Chinese School. *Source*: Getty Images, Alfred Eisenstaedt, *Life* Picture Collection.

Photo-Essays about Asian American Women in *Life* Magazine 1936 to 1965

Hidden Narratives and Breaking Stereotypes

Karen L. Ching Carter

LEXINGTON BOOKS
Lanham • Boulder • New York • London

Published by Lexington Books
An imprint of The Rowman & Littlefield Publishing Group, Inc.
4501 Forbes Boulevard, Suite 200, Lanham, Maryland 20706
www.rowman.com

6 Tinworth Street, London SE11 5AL, United Kingdom

Copyright © 2021 The Rowman & Littlefield Publishing Group, Inc.

All rights reserved. No part of this book may be reproduced in any form or by any electronic or mechanical means, including information storage and retrieval systems, without written permission from the publisher, except by a reviewer who may quote passages in a review.

British Library Cataloguing in Publication Information Available

Library of Congress Cataloging-in-Publication Data

Names: Carter, Karen L. Ching, 1955- author.
Title: Photo-essays about Asian American women in Life magazine 1936 to 1965 : hidden narratives and breaking stereotypes / Karen L. Ching Carter.
Description: Lanham : Lexington Books, [2021] | Includes bibliographical references and index.
Identifiers: LCCN 2021034399 (print) | LCCN 2021034400 (ebook) |
 ISBN 9781793613073 (cloth) | ISBN 9781793613080 (epub)
 ISBN 9781793613097 (pbk)
Subjects: LCSH: Asian American women—Pictorial works. | Asian American women—Social conditions—20th century. | Stereotypes (Social psychology)—United States—History—20th century. | United States—Race relations—History—20th century—Pictorial works. | Asian Americans—Race identity.
Classification: LCC E184.A75 C37 2021 (print) | LCC E184.A75 (ebook) |
 DDC 305.48/895073—dc23
LC record available at https://lccn.loc.gov/2021034399
LC ebook record available at https://lccn.loc.gov/2021034400

*In memory of my mom Millie Lai Ching and my
grandmothers Agnes Mun Ching and Mary Lai
My dad Clarence K.S. Ching
For their unconditional love in helping me to succeed.*

Contents

List of Figures	ix
Acknowledgments	xi
Introduction	xiii

PART 1: PRE-WAR AND THE GREAT DEPRESSION, 1936–1940 **1**

1 A Catholic "Chinese School" in America 3
2 The Charm of Novelty When "*Life* Goes to the Forbidden City" 13
3 "The Nisei" Spy Scare 21

PART II: WORLD WAR II AND JAPANESE AMERICAN INTERNMENT, 1942–1944 **35**

4 Making Choices: "Coast Japs Are Interned at Mountain Camp" 37
5 Complementary Narratives about "Tule Lake Segregation Camp" 49

PART III: IN PREPARATION FOR POSTWAR RACIAL HARMONY, 1945 **65**

6 Stylish Western Wear in "Marine Pin-Ups and Glamour on Guam" 67
7 Mixed-Race and Interracial Marriage "Hawaii a Melting Pot" 79

PART IV: THE 1960S AND THE CIVIL RIGHTS ERA, 1960–1965 **91**

8 Changed Perceptions: "Nancy Kwan, a New Movie Star" 93

9 Patsy Takemoto Mink, More than the "First Congresswoman from Overseas" 105

Afterword 113

Bibliography 115

Index 121

About the Author 129

List of Figures

Figure 0.1	Little Girls Peeking over the Rim of the Table at California Mission Chinese School	ii
Figure 1.1	Two Nuns Questioning Bashful Girl	2
Figure 1.2	Young American Chinese Girls	7
Figure 3.1	Nisei Traditions	24
Figure 5.1	Two Complementary Narratives	50
Figure 5.2	New Japanese American Baby Held by Nurse	56
Figure 5.3	Manji Family in Apartment at Tule Lake Japanese Internment Camp	57
Figure 5.4	Camp Leaders	59
Figure 5.5	Everyday Life	60
Figure 7.1	Headshots	82
Figure 9.1	Japanese American Patsy Mink Congresswoman from Hawaii	108

Acknowledgments

I thank Laura Bush, my writing coach, for support and guidance. Thank you to Holly Welker, who copy edited and took the time to develop parts of this book. Many thanks to my husband, Jim, and son, Alastair, as they acted as sounding boards to think through our own Asian American family perspectives in relation to the stories told by *Life* editors. I also thank my dad, who believed that I could do anything and be anybody I wanted.

Introduction

From the Great Depression through World War II and the 1960s' civil rights era, *Photo-Essays about Asian American Women in* Life *Magazine 1936 to 1965: Hidden Narratives and Breaking Stereotypes* is a rhetorical analysis of how *Life* magazine's photo-essays represented and shaped white American middle-class attitudes toward Asian American women. I show how *Life* editors built hidden narratives in photo-essays framing Asian American women within white American middle-class culture, situating Asian women as middle-class Americans. By middle-class culture, I mean an American middle class visually depicted, imagined, and promoted by *Life* editors.[1] Displayed as typical markers of middle-class success, *Life* photo-essays included educational advancement, professional occupations,[2] and women's domestic responsibility in promoting family values.[3] I argue that by representing Asian women as middle-class Americans, *Life* editors mediated political, legal, and social forces that rendered Asian women in the United States and its territories as foreign prostitutes. This rhetorical study analyzes *Life*'s photo-essays of Chinese American, Japanese American, and mixed-race Asian American women because these Asian ethnicities were most prevalent in the United States during *Life*'s tenure as a mass illustrated magazine.

Most writers would agree that good writing is informative and engaging. However, in terms of the photo-essay, informative and engaging writing is only the beginning. In 1936, *Life* magazine founder and publisher Henry Luce stated, "[The photo-essay] has got to be an essay with a point . . . the mere charm of photographic revelation is not enough."[4] Photographs are sufficiently engaging, but in connecting the photo to a narrative, there needs to be a, as Luce put it, "Did you know this?"[5] When *Life* magazine appeared in 1936, its dramatic use of the photo-essay—a new art form, that combined information, emotion, and entertainment—made for an unprecedented visual

style. Thus, the photo-essay, a composition of images held together by texts, holds a unique position in a mass-produced picture magazine like *Life*. The captioned pictures surrounded by advertisements were all devised to tell a coherent story—a narrative art.

As Loudon Wainwright points out, it was common knowledge that Luce was fascinated with "all things Chinese."[6] Born in China to Presbyterian missionaries, Luce spent his boyhood and his education at a British boarding school in China, but his interest extended to all of Asia. Narrative representations of Asian American women in *Life*'s photo-essays are clearly informed by Luce's personal views and experience because as founder, publisher, and editor in chief of *Life* magazine, Luce had final approval of each issue.[7]

CRAFTING A PHOTO-ESSAY

As mentioned, building a photo-essay is a narrative art.[8] Depending on the photo-essay, photos of key people could act as characters within a story while the background would establish location. Because photographic images can be read as factual, the details within a succession of photos could add dramatic or subtle facts that heighten emotional impact.[9] Furthermore, creating a coherent narrative requires choosing and shaping words and images to build a story. More importantly, narrative representations created by *Life* editors constituted a collective effort using both pictures and text within a context that occurred at a specific historical moment. While photographers decided what to shoot,[10] the narrative was a collaboration of visual rhetoric between photographers, editors, and writers. Luce wrote, "Photo selection should not be arbitrary . . . but suggest a 'mind guided' camera."[11]

At *Life*, the compositional layout of the photo-essay was always produced by a team. However, stories told through photo-essays don't exist in a vacuum. Within a specific context, the narrator(s) make choices and decisions about the words and images they use to build a story that reveals something about the human experience. Luce said, "If appropriately viewed, and properly mastered, visual images could shape and direct popular opinion,"[12] because in a photo-led story, text is used to enhance the storytelling in the form of captions or topical sentences.

The idea for a photo-essay was made first by a single editor.[13] Researchers employed at the magazine took that idea and found facts and subjects that would make good photographs. Although photographers took the photos, they had little control over the editorial content. Instead, the picture editors finalized the layouts while the writers wrote the captions. In addition, as the magazine capitalized on the growth in advertising, advertisements became

part of the narrative in *Life* magazine just as much as the layout of photos, captions, and exposé material that constituted a photo-essay. Thus, *Life* editors, targeting middle-class audiences, could reach the demographics they preferred.[14]

WHY ASIAN AND PACIFIC ISLANDER AMERICAN WOMEN

In 1936, most Americans had never seen an Asian woman in person because Asians in America made up less than 1 percent of the U.S. population. Early in the twentieth century, Hollywood depictions of Asian women as sexual nymphs, evil dragon ladies, or subservient geishas were pervasive.[15] However, narratives created by *Life* editors about Asian American and mixed-race American women generally contrasted with public narratives and sometimes brought attention to racist laws. Asian American studies scholar Karen Kuo points out that American notions of Asian women as sexually promiscuous had legal implications related to race.[16] The widespread belief that Asian women were prostitutes was used to isolate them from American society legally and socially, as laws were enacted to keep Asians from marrying other races (anti-miscegenation),[17] to keep Asians in separate housing (redlining),[18] to keep Asians segregated in terms of education (separate but equal),[19] and to keep Asians ineligible for U.S. citizenship.[20] Thus, depending on the political context, *Life* editors waffled between depicting Asian American women as stereotypical foreign "others" on the one hand and as a community within American middle-class culture on the other.

The hidden narratives in *Life* photo-essays generally show that Asian American women were far from uncivilized prostitutes. The stereotype that Asian women were prostitutes fostered the legislation of the Page Act of 1875, an anti-prostitution legislation that barred Asian women from immigrating. The law was directly applied to women from "China, Japan or any Oriental country, to the United States."[21] Because few Asian women actually immigrated to the United States, the number of Asian women was small compared to Asian men. The U.S. census indicated that Chinatowns in the United States did not reach gender balance of males to females until the mid-twentieth century.[22] Little was known of Asian women other than nonsensical depictions in Hollywood of the evil dragon lady prostitute. *Life* editors made a case for these women's humanity by showcasing their hobbies, tastes in clothing, occupations, and family backgrounds.

By Asian American women, I mean women of Asian heritage who were either born American or raised in an American context. Prior research that studied visual representations of Asian/Asian American women has

discussed civility,[23] Japanese internment camps,[24] Chinatown San Francisco as the photo documentary of a place and its people,[25] the depiction of Asian women in film,[26] and Asian women as objects of sexual desire.[27]

The importance of these photo-essays about Asian American women is that *Life* editors showed Asian American women as humans. The nineteenth-century laws that kept Asians from immigrating and assimilating into American society began with the women. As Asian American scholar Shirley Lim explains, "Proving humanity is essential to establish civilized status."[28] Lim was referring to scientific beliefs of racial hierarchy in which white European Americans were placed at the top. Her claim is instructive in the context of *Life*'s photo-essays because in addition to legal restrictions placed upon Asian women, stereotypes remained pervasive even in a forward-thinking magazine like *Life*.

THE *LIFE* BRAND

My contribution to the collection of studies on *Life* magazine is about the photo-essay, a narrative art, mediating social perceptions of Asian women in mid-twentieth-century America. Previous scholars have studied aspects of *Life* magazine, including its publication history,[29] its journalistic style and influence defining middle-class life in America,[30] its coverage of race and advancing the civil rights movement.[31] Scholars have also studied people associated with the magazine, such as publisher Henry Luce,[32] *Life* photographer Margaret Bourke-White,[33] and *Life* photographer Hansel Meith with her influence on social reform.[34] An edited collection provides analysis of the magazine's editorial content;[35] articles in this collection relevant to my analysis cover Chinese and U.S. relations,[36] race and segregation,[37] middle-class lifestyle,[38] and history of publication and audience.[39] Finally, John Jessup, *Life*'s chief editorial writer, edited 235 speeches by Luce, expounding his ideas on journalism, law, capitalism, art, religion, and America's place in the world.[40]

Life magazine built its brand "LIFE" as standing for middle-class values, with a sense of confidence, optimism, and exceptionalism, in the sure belief that the American way was the way of the world.[41] Visual rhetoric is the main element analyzed in this book because it mediates between the narrative art of the photo and the experience of the reader. By visual rhetoric I mean how editors frame photos and text to persuade an audience of a particular perspective and message. In *Life*, images of Chinese or Japanese American women sometimes defined them as simultaneously "foreign" and "progressive," dressed in Western clothing, and exhibiting middle-class American

values. Thus, by presenting Asian American women as respectably middle class, *Life* also celebrated American values of education and middle-class consumer culture that emphasized coherence and integration.[42] The photo-essay as it is sequenced in *Life* tells us about *Life* editors, *Life* audience, what was thought about Asian American women, and the times in which they were living.

In 1938, *Life* published an exhaustive measure of its readership.[43] *Life*'s study sought to analyze both its circulation and pass-along factor—that is, how many more people read rather than purchase the magazine. The pass-along factor was calculated at 14, which translated to 17 million readers. The number translated to 15 percent of all adults in America.[44] However, 31 percent of the readership was solid upper middle class. The *Life* study found that 37 percent of *Life* readers were professional men, affluent merchants, or prosperous farmers, and owned a house and car, and the magazine remained focused on the middle class throughout its history.[45] This is significant because history has shown that the educated elite and middle class in society owned the power to effect societal change.[46] With the middle-class frame, therefore, *Life*'s editors could influence its audience and by extension a large portion of American society. In the twenty-nine-year span that Luce controlled *Life*, no other magazine could compare with *Life*'s influence and power.[47] Thus, in depicting Asian American women, *Life* could reach and influence mainstream America from a point of view that could align with the reader's experience while at the same time complicating the composition and narrative of the photo-essay to show alternative ways to view Asian American women.

Life magazine held a unique position in mid-twentieth-century American media as a mass illustrated magazine because its editors spoke from the dominant American power. *Life*'s senior editors were all white men of privilege with the ability to navigate and experience the social world without racial identity hampering their experience or influence. They could speak and relate to its professional white middle-class reader about Asian American women with authority. In creating a photo-essay about Asian American women, *Life* editors conveyed a moral outlook about the women's place in society. At times, *Life* editors imposed cultural stereotypes in the captions. But while they did not always avoid stereotypes such as the sexual predatory nature of Asian women as evil dragon ladies, *Life* editors were aware that they must make the subject of Asian women in America understandable to their mostly white middle-class audience. *Life* editors did assert an authority to define, describe, and speak about Asian American women, a sort of avuncular racism that proceeded from a desire to make Asian women understandable to its audience.

METHODOLOGY IN APPLYING CRITICAL IMAGINATION, SOCIAL CIRCULATION, AND STRATEGIC CONTEMPLATION

Narratives are composed for a particular audience at particular moments in history that draw on particular discourses and values that circulate at the time.[48] To understand the periods under consideration, I invoke three tools from feminist rhetorical historiography to take a strategic approach in understanding and interpreting the narrative construction and representation of photo-essays by *Life* editors. Feminist rhetorical scholars Jacqueline Royster and Gesa Kirsch established methods of critical imagination, social circulation, and strategic contemplation as tools to gather evidence that functions to collect multiple viewpoints and interpretations in the creation of an artifact.[49] Using these tools, I analyze the photo-essays within each magazine issue in addition to the context of the times.

Critical imagination is an analytical tool that imagines context for the creation of an artifact. In the case of narrative construction of *Life* photo-essays on Asian American women, critical imagination enables the researcher to look at the historic lives of *Life* editors, Asian American women, and the interlinking political and social norms of the time. From feminist historiography, critical imagination studies the available artifact in the context that surrounded the making of that artifact. In this case, the artifact is a photo-essay that refers either directly or indirectly to Asian American women. Critical imagination enables the researcher to understand what is said in context and what is not said in context about Asian American women. Thus, critical imagination enables a researcher to look at events and practices in the specific time and context in the creation of the photo-essay that gave rise to the narrative.

Social circulation is an analytical effort that takes words and phrases from the narrative to understand how it might interact with other narratives. In the case of a photo-essay referring to Asian American women, an explicit verbal narrative may interact with a hidden narrative. For example, words used by *Life* editors to construct a narrative would also circulate in society with other functional meanings. The word "docile" was used by *Life* editors to contrast Nisei (American-born Japanese) women from women in Japan in a context implying that women from Japan are submissive, while Nisei women are American, more ambitious, a necessary trait for a modern middle-class American.

Strategic contemplation is a tool to attend to fieldwork and lived experience. It builds on critical imagination to not only understand the context but reflect on its meaning and impact on the creation of the artifact. In the case of photo-essays on Asian American women, strategic contemplation is my lived experience as an Asian American woman who lived within the Asian

American communities described in the photo-essays and the lived experiences of my elders and extended friends and family in Asian American communities. Lived experience is a form of archival work.

Mid-twentieth-century America was a transformational time for Asians in America as the second- and third-generation Asians born in America grew in number. Politically, mid-twentieth century was an ambiguous period for Asians born in America because they began to push legal and social boundaries set for their immigrant parents and grandparents that limited social integration due to racial restrictions in housing and jobs. American-born Asians became a political and economic force because they were American educated, meaning that language and culture were no longer barriers to comprehension of legal rights. In addition, general history tells us that white Americans were also aware of Asia due in part to World War II and increased trade with countries in Asia; however, outside of California and Hawaii, many white Americans had never met an Asian person and remained unaware that Asians living and working in America spoke English, went to school, held professional jobs, and led middle-class lives within Asian American communities. Thus, photo-essays about Asian American women were newsworthy stories.

FOUR AMERICAN ERAS UNDER ANALYSIS

In this monograph, I show the narrative representation of Asian American women as an art in which *Life* editors used tools of photographic design layout, captions, titles, and text to persuade readers of the humanity of Asian American women from 1936 to 1965. The photo-essay was born as a means to tell a story that corresponded to the ideology of *Life* editors.[50] Over a twenty-nine-year period, *Life* editors aligned concepts about assimilation of Asian American women with the ethos of education, domesticity of the family, and an American ideology of financial independence. By creating narrative representations of Asian women as college graduates, loyal homemakers, and aspiring career women indistinguishable from white middle-class readers, *Life* magazine created the Asian American woman.

I analyze nine photo-essays distinctive to the lives of Asian American and mixed-race women and family. The photo-essays are grouped into four parts corresponding with four eras of American experience. They are: (1) "Pre-War and the Great Depression, 1936–1940"; (2) "World War II and Japanese American Internment, 1942–1944"; (3) "Preparation for Postwar Racial Harmony, 1945–1946"; (4) "The Sixties, representing the era of the civil rights movements 1952–1965."

PART I: "PRE-WAR AND THE GREAT DEPRESSION, 1936–1940"

Chapter 1: "A Catholic 'Chinese School' in America"

Loudon Wainwright said, "The first *Life* had the quality of an album jammed with snapshots the collector couldn't bear to throw away."[51] Wainwright's admission illustrates that the photo-essay, as a journalistic medium, began with *Life*'s first issue. What was new in *Life* photo-essays was the crafted display of candid shots mixed with storytelling. Developments in photography in the 1920s made it easier to shoot more realistic, more honest candid photos.

Life's motto for the first issue was "To See Life; to See Hope." Published at the height of the Great Depression, the issue reflected hope and optimism through candid pictures of famous and ordinary people that showed life beyond economic crisis and suggested possible paths toward middle-class advancement.[52] The photo-essay "Chinese School" made visible ordinary Chinese in America to a large segment of the American population as the magazine sold out 250,000 copies in the first day. Chinese girls born in America were novel to the white middle-class audience. The hidden message is that hope for the future will rely on children of immigrants.

Chapter 2: "The Charm of Novelty When 'Life Goes to the Forbidden City'"

News by definition means a published report of something out of the ordinary. The photo-essay about Asian American dancers at a Chinese-themed night club in San Francisco was novel.

Life editors also utilized advertisements to create consumption scenarios to sell the magazine. For example, in *Life*, advertisements were commonly sandwiched between and within photo-essays promoting consumer products such as household appliances, new cars, Campbell's soup, and Listerine. Therefore, through the strategic positioning of advertisements, *Life* editors could address their middle-class audience directly as stories they published blended with advertisements that targeted middle-class society. Asian American women dancers at the Chinese-themed night club were embedded into middle-class white society through consumer advertisements, so that the photo-essay was a kind of advertisement for the night club.

Chapter 3: "'The Nisei' Spy Scare"

Posed pictures do more than show physical facts; posed pictures reveal the emotional manner of the subject. "The Nisei" is about Japanese American

lives prior to World War II. In this photo-essay, *Life* editors confronted the fear and anxiety American readers felt in 1940 about Japanese Americans as foreign spies and sought to assuage them. The photo-essay shows narrative representations of Japanese American family life in Los Angeles such as weddings, birthday parties, and community activities, all of which are organized and nurtured by women. Japanese women are depicted as modern American mothers and housewives.

PART II: "WORLD WAR II AND JAPANESE AMERICAN INTERNMENT, 1942–1944"

Chapter 4: "Making Choices: 'Coast Japs Interned at Mountain Camp'"

Life editors chose certain photos to frame the narrative of interning Japanese Americans during World War II. The photo-essay "Coast Japs Are Interned at Mountain Camp" is interesting for the tension it produces. (Most likely, the result of tension was set by the military and WRA (War Relocation Authority) rules that there be no photos of barbed wire; furthermore, photos were subject to military censorship.[53]) On the one hand, there is editorial support for Japanese American internment that addresses the fear of Imperial Japan; Japanese Americans are referred to as "Japs" or "enemies." On the other hand, there are hidden assertions of Japanese American loyalty to the United States. The narration of the photo-essay distracts the reader from the realities of imprisoning 120,000 Japanese Americans by focusing on the scenic beauty of the camp's location in the Sierra Nevada Mountains and the modern conveniences provided by the U.S. government. Shockingly, there were no women pictured in the photo-essay, meaning there are no families, an implicit demonstration that that Japanese Americans are different from ordinary white Americans because there is no evidence of family values.

Chapter 5: "Complementary Narratives about "Tule Lake Segregation Camp""

In "Tule Lake" there were actually two narrators, *Life* editors and Carl Mydans; Mydans's contribution is creating photos that engendered empathy. Wartime hysteria led *Life* editors to endorse internment, whereas Mydans countered with a narrative of constitutional rights denied to U.S. citizens. In keeping with army censorship and WRA rule, the photos show the tension between two narrators. In the process, Japanese American women are depicted as human and living, much like their middle-class white American counterparts.

PART III: "IN PREPARATION FOR POSTWAR RACIAL HARMONY, 1945"

Chapter 6: "Stylish Western Wear in 'Marine Pin-Ups and Glamour on Guam'"

What is *Life*'s response to the complex terrain of defining who is American? Or put another way, how did *Life*'s coverage of Asian American women and those of mixed Asian ancestry reflect the possibilities for picturing respectable middle-class Americans? "Marine Pin-Ups" was placed in the "Speaking of Pictures" section, which was typically a light news story about something happening within a larger political, social, or economic frame. The photo-essay is about young women on Guam whom Marines were befriending. As mixed-race Asian island women, they were represented by *Life* editors as middle-class Americans. Dressed in trendy Western styles, the women were portrayed as attractive and respectable through typical modest fashion. Their photo backgrounds show tropical surroundings with counterparts in many parks on the U.S. mainland.

Chapter 7: "Mixed-Race and Intermarriage 'Hawaii A Melting Pot'"

"Hawaii: A Melting Pot" is a large photo-feature made up of four mini photo-essays on mixed-race Asian women and interracial marriage in Hawaii. The collection of photo-essays spans thirteen pages. I contend that *Life* editors make the point through the women that race is not static in America. In a democracy in which all men (and women) are created equal, most people are in fact descendants of multiple ethnic sources. Yet, the census treats ethnicity as if each person has one ethnicity and that multiple ethnicities are rare. Hence, *Life* editors point out that in Hawaii people chose to identify with all their ethnicities. Choosing to identify with all mixtures of ethnicities and races was in stark contrast to the laws and social norms on the mainland United States in 1945. By explicitly highlighting Asian and mixed-race women and family in Hawaii, *Life* editors demonstrate that racial purity is an illusion.

PART IV: "THE 1960'S AND THE CIVIL RIGHTS ERA, 1960–1965"

Chapter 8: "Changed Perceptions 'Nancy Kwan: A New Movie Star'"

Nancy Kwan, who starred in the movie *The World of Suzie Wong*, was introduced on the cover as a new movie star in the October 24, 1960, issue.

The photo of a sultry Asian woman in a traditional dress called a cheongsam on the cover of *Life* means anything *Life* editors want it to mean. While the caption calls Kwan a new movie star, the story inside is less stereotypical of Asian women as prostitutes. The photos inside are of Kwan at work on the set of the movie. The sexuality on the cover was to garner sales, while the photo-essay itself was about an actress with talent. The narrative is that Nancy Kwan was the first Asian woman cast in a leading role that called for the character of an Asian woman. Previously, Hollywood had only cast white women to look Asian in leading roles.

Chapter 9: "Patsy Takemoto Mink, More than the 'First Congresswoman from Overseas'"

In what world do you see Asian American women as forerunners in American politics? The answer is: only from Hawaii in 1965. In a close-up feature in January 1965, *Life* editors presented Patsy Takemoto Mink, the first woman of color in Congress. This photo-essay was published one week before President Lyndon Johnson's inaugural. The representation of Ms. Mink illustrates the acceptance of Asian American women in American polity and the culmination of *Life*'s representation of Asian American women.

NOTES

1. Sheila M. Webb, "'America Is a Middle-Class Nation': The Presentation of Class in the Pages of *Life*," in *Class and News*, ed. Don Heider (Lanham, MD: Rowman & Littlefield, 2004), 167–198.

2. Sheila M. Webb, "The Consumer-Citizen: *Life* magazine's Construction of a Middle-Class Lifestyle through Consumption Scenarios," *Studies in Popular Culture* 34, no. 2 (2012): 23–47.

3. Wendy Kozol, *Life's America: Family and Nation in Postwar Photojournalism* (Philadelphia: Temple University Press, 1994).

4. Wainwright, Loudon, *The Great American Magazine: An Inside History of Life* (New York: Knopf 1986), 100.

5. Wainwright, *The Great American Magazine*, 100.

6. Wainwright, *The Great American Magazine*, 5.

7. Wainwright, *The Great American Magazine*, 72. Wainwright writes that ideas for stories were discussed with Luce regularly for current and future issues. The Henry Luce Foundation, started by Luce in 1936, still offers grants for research and scholarship to promote U.S. and Asia relations.

8. Karen L. Ching Carter, "High and Low Art in Narrative Construction of a Photo Essay: When Asian American Women became Middle-Class Americans at the Forbidden City Nightclub in San Francisco," *South Atlantic Review* 84, no. 1 (2019): 160.

9. Patrick Sutherland, "The Photo Essay," *Visual Anthropology Review* 32, no. 2 (2016): 115–121. https://doi.org/10.1111/var.12103.

10. James L. Baughman, *Henry R. Luce and the Rise of the American News Media* (Boston: Twayne Publishers, 1987), 97.

11. Wainwright, *The Great American Magazine*, 84.

12. Erika Doss, *Looking at LIFE Magazine* (Washington, DC: Smithsonian Institution Press, 2001), 11.

13. Claude Cookman, *American Photojournalism: Motivations and Meanings* (Evanston, IL: Northwestern University Press, 2009), 155.

14. Webb, "America Is a Middle-Class Nation," 168.

15. Sheridan Prasso, *The Asian Mystique: Dragon Ladies, Geisha Girls, and Our Fantasies of the Exotic Orient* (New York: Public Affairs, 2005), 8.

16. Karen Kuo, *East Is West and West Is East: Gender, Culture, and Interwar Encounters between Asia and America* (Philadelphia: Temple University Press, 2013).

17. Phyl Newbeck, *Virginia Hasn't Always Been for Lovers: Interracial Marriage Bans and the Case of Richard and Mildred Loving* (Carbondale: Southern Illinois University Press, 2008), 25–36.

18. Terry Gross, "A 'Forgotten History' of How the U.S. Government Segregated America," *Fresh Air*, NPR, May 3, 2017. https://www.npr.org/2017/05/03/526655831/a-forgotten-history-of-how-the-u-s-government-segregated-america.

19. *Plessy v. Ferguson*, 163 US 537 (1896), was the landmark case that upheld the constitutionality of racial segregation. This was applied to education.

20. The Immigration Act of 1924 prohibited immigration from Asia. The Act also upheld the law from the Chinese Exclusion Act (1882) that Chinese and Japanese immigrants were ineligible for U.S. citizenship.

21. Stewart L. Chang, "Feminism in Yellowface," *Harvard Journal of Law & Gender* 38, no. 2 (2015): 242.

22. George Anthony Peffer, *If They Don't Bring Their Women Here: Chinese Female Immigration before Exclusion* (Urbana: University of Illinois Press, 1999), 4.

23. Thy Phu, *Picturing Model Citizens: Civility in Asian American Visual Culture* (Philadelphia: Temple University Press, 2012).

24. Elena Tajima Creef, *Imaging Japanese America: The Visual Construction of Citizenship, Nation, and the Body* (New York: New York University Press, 2004).

25. Anthony W. Lee, *Picturing Chinatown: Art and Orientalism in San Francisco* (Berkeley: University of California Press, 2001).

26. Kuo, *East Is West and West Is East*.

27. Prasso, *The Asian Mystique*.

28. Shirley Jennifer Lim, *A Feeling of Belonging: Asian American Women's Public Culture, 1930–1960* (New York: New York University Press, 2005), 49.

29. Baughman, *Rise of the American News Media*, and Wainwright, *The Great American Magazine*.

30. Webb, "America Is a Middle-Class Nation," and Kozol, *Life's America*.

31. Michael DiBari Jr., *Advancing the Civil Rights Movement: Race and Geography of Life magazine's Visual Representation, 1954–1965* (Lanham, MD: Rowman & Littlefield, 2017).

32. Baughman, *Rise of the American News Media*.

33. Chris Vials, "The Popular Front in the American Century: *Life* magazine, Margaret Bourke-White, and Consumer Realism, 1936–1941," *American Periodicals: A Journal of History & Criticism* 16, no. 1 (2006): 74–102. https://muse.jhu.edu/article/196324.

34. Dolores Flamiano, *Women, Workers, and Race in LIFE Magazine: Hansel Mieth's Reform Photojournalism, 1934–1955* (London: Routledge, 2016).

35. Doss, *Looking at LIFE Magazine*.

36. Kelly Ann Long, "Friend or Foe: *Life*'s Wartime Images of the Chinese," In *Looking at LIFE Magazine*, ed. Erika Doss, 55–75 (Washington, DC: Smithsonian Institution Press, 2001).

37. Wendy Kozol, "Gazing at Race in the Pages of *Life*: Picturing Segregation through Theory and History," in Doss, *Looking at LIFE Magazine*, 159–175.

38. Terry Smith, "*Life*-Style Modernity: Making Modern America," in Doss, *Looking at LIFE Magazine*, 25–39.

39. James L. Baughman, "Who Read *Life*? The Circulation of America's Favorite Magazine," in Doss, *Looking at LIFE Magazine*, 41–51.

40. Henry Robinson Luce, *The Ideas of Henry Luce* (New York: Atheneum, 1959).

41. Doss, *Looking at LIFE Magazine*, 15.

42. Doss, *Looking at LIFE Magazine*, 15.

43. Baughman, *Rise of the American News Media*, 94.

44. Baughman, *Rise of the American News Media*, 94.

45. Webb, "America Is a Middle-Class Nation," 26.

46. Doss, *Looking at LIFE Magazine*, 4.

47. Baughman, "Who Read *Life*?" 41.

48. Riessman, Catherine Kohler. *Narrative Methods for the Human Sciences* (Thousand Oaks, CA: Sage, 2007), 3.

49. Jacqueline Jones Royster and Gesa E. Kirsch, *Feminist Rhetorical Practices: New Horizons for Rhetoric, Composition, and Literacy Studies* (Carbondale: Southern Illinois University Press, 2012).

50. Doss, *Looking at LIFE Magazine*, 16.

51. Wainwright, *The Great American Magazine*, 75.

52. Webb, "America Is a Middle-Class Nation," 169.

53. Wainwright, *The Great American Magazine*, 126. All photos concerning the war were subject to military censorship.

Part 1

PRE-WAR AND THE GREAT DEPRESSION, 1936–1940

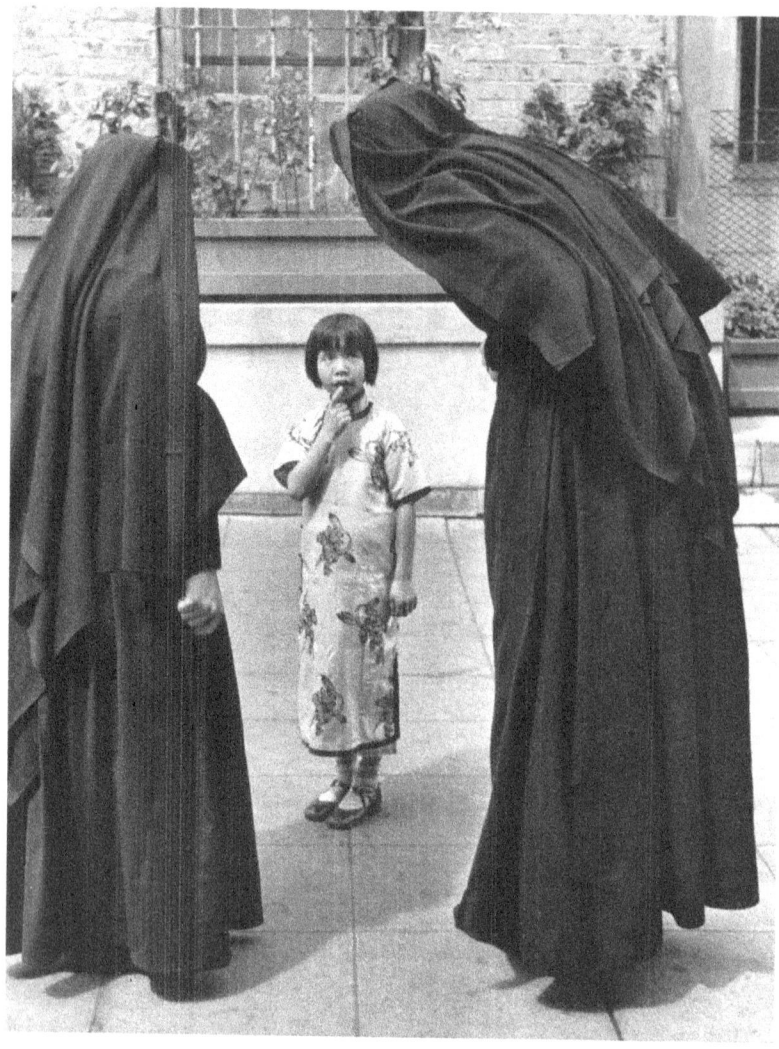

Figure 1.1 Two Nuns Questioning Bashful Girl. *Source*: Getty Images, Alfred Eisenstaedt, *Life* Picture Collection.

Chapter 1

A Catholic "Chinese School" in America

THE FIRST ISSUE: NOVEMBER 1936

In *Life*'s first issue, inside the editor's introduction, *Life* editors pointed out that "the first issue of the magazine is not the magazine. It is the beginning." With these words *Life* editors acknowledged that constructing news through photos was new. Thus, they instructed readers to expect that the continued production of *Life* involves a learning curve for the editors. Loudon Wainwright, senior editor at *Life*, commented on the rough quality of the first issue in that the stories had no particular order or organization but instead "had the quality of an album jammed together with snapshots the collector couldn't bear to throw away."[1] In the mix of eclectic photos in this first issue is a small photo-essay called "Chinese School" about American-born Chinese girls at St. Mary's Chinese Catholic school in San Francisco.

"Chinese School" was of special interest to publisher Henry Luce, who "was fascinated with most matters Chinese."[2] Luce was born in Dengzhou, China, in 1898. His parents were Presbyterian missionaries. He spent his early years among the Chinese as he also went to both Chinese and English boarding schools. Thus, the narrative of "Chinese School" may have been in *Life*'s inaugural issue because Luce, who had approval of all photo layouts,[3] may have wanted it there. In any event, "Chinese School" appeared to be of special interest to the editors because in their introduction, they made a point to say thank you "to the little Chinese girls who go about their lessons with an almost breathless grace."[4]

Producing a photo-essay involves many people. In the case of *Life*, there was a managing editor along with deputy editors, copywriters, reporters, researchers, graphic designers, and (of course) the photographers. Creating a photo-essay is a team effort in which the editors always have the final say in

what gets published. Regardless of Luce's involvement in "Chinese School," the narrative was largely a product of *Life* editors.

Life editors wrote short text paragraphs in photo-essays and called them "exposés." A journalistic staple, an exposé exposes hidden information that is often shocking or scandalous. *Life* magazine considered itself a general news picture magazine in which photo-essays would reveal hidden truths or something out of the ordinary about the subject matter. In a picture magazine, such as *Life*, photos lead the story, but the exposé would move the story forward and aid in setting the narrative. Henry Luce said, "The essay was no longer a vital means of communication. But what is vital is the photographic essay."[5] For *Life* editors, the goal was not merely to reveal something about the subject(s) of the photo-essay, but also to reveal something about America and life in that year.[6]

The exposé in *Life*'s 1936 photo-essay "Chinese School" states that there were 75,000 Chinese in the United States. According to the U.S. census bureau, in 1936, there was a total of about 123 million people in the United States, which means that ethnic Chinese constituted less than one-tenth of 1 percent of the U.S. population. One might wonder: Why was the percentage so low when Chinese laborers had been immigrating regularly to the United States since 1852? The answer is that Chinese women were not allowed to immigrate. The U.S. government wanted cheap Asian labor, and they were willing to let those laborers send their wages back to China. But they did not want them to establish families and permanent communities within the United States. That is one reason why Chinese women in particular were invisible to most Americans.

According to Loudon Wainwright, a writer who held various positions on the *Life* staff, "Chinese School," about a Catholic School in Chinatown San Francisco, was a heartfelt narrative about little girls, or as Wainwright said, "fluffy little story shot by Alfred Eisenstadt, a Chinese school in San Francisco where they taught [children] to say 'very' instead of 'velly,' to distinguish 'he' from 'she'";[7] his comment relies on and emphasizes old stereotypes about Asian accents. But notable here was that via these photos taken during the Great Depression, *Life* editors introduced American-born Chinese girls to an audience of white Americans who might not even know these girls existed.

Crucial to understanding the importance of this photo-essay is that the 1930s were synonymous with the Great Depression. When Franklin Delano Roosevelt took office in 1933, unemployment stood at 25 percent.[8] Henry Luce said, "*Life* is in favor of the human race, and is hopeful . . . this is *Life*'s bias."[9] *Life* editors sought to convey optimism in their new picture magazine to readers weary of economic hardship. Thus, the photo-essay "Chinese School" not only educated *Life*'s audience about the Chinese in America but

also reinforced the value of education in attaining the middle-class status. The hidden narrative is that parents of these Chinese girls could afford the tuition. They chose to send their daughters to a Catholic school. *Life* editors represented little Chinese girls as Americans who held middle-class status because of the parent's desire to prioritize education and a Christian religion.

This photo-essay in the first issue of *Life* was a precursor to the theme of future *Life* photo-essays that would follow for the next thirty-nine years—a picture magazine that reflected its society's desire for modern middle-class status but also intervened to create American society's middle-class culture and what it means to be American.

In the next section, I provide background on the status and social isolation of Chinese women in America. I then analyze the narrative construction of "Chinese School."

FEW WOMEN, EVEN FEWER FAMILIES

For the Chinese American community in San Francisco, second- and third-generation Chinese girls born in America were the most precious gifts the community had received. The Page Act of 1875 was the key legal restriction preventing Chinese women from immigrating, thereby preventing family formation and growth of Chinese American population. The Page Law stated that "immigration of any subject of China, Japan, or any Oriental country to the United States is free and voluntary . . . [and not] for lewd or immoral purposes." The law on its face was meant to keep out prostitutes; however, it authorized port surveyors to act on unsubstantiated suspicions that all Chinese women were presumed prostitutes.[10]

The Page Law was vigorously enforced, targeting Chinese women. As a result, few Chinese women entered the United States because there was no meaningful distinction that could differentiate between a Chinese prostitute and a Chinese man's wife.[11] Motivated by capitalism, the Page Law also excluded the entry of children, elderly, and the sick. The reasoning was that able-bodied Chinese males could be housed in bunkhouses so that housing for families and education facilities for children would not be necessary.[12] Thus, the Page Law was an anti-Chinese immigration tool to prevent the Chinese population from growing in the United States.

Later, the Congress passed the Chinese Exclusion Act of 1882 that limited the immigration of both men and women. There were a few exceptions in that Chinese women married to a wealthy Chinese merchant would pass as a legitimate wife, because the wife of a merchant could prove wealth and status through dress, jewelry, and a first-class cabin travel ticket.[13]

Therefore, in the context of the Page Law and Chinese Exclusion Act, immigration of Chinese women was so limited that it created a gender imbalance. In 1910, the Chinese female-to-Chinese male ratio was 70 females to 1,000 males;[14] the Chinese American community did not reach sexual parity until the mid-twentieth century.[15] Thus, without growth in Chinese American families, Chinese immigrants and Chinese born in America remained invisible to most Americans. Within the historical context of restrictive race laws, it is essential that I also recognize and analyze the powerful effects of social perceptions that entered into the narrative construction of photo-essays of Asian American women by *Life* magazine editors.

ANALYSIS

Life editors convey the following message: *The little Chinese girls you see here are Americans by birth, and race is not a factor in being an American.* *Life* editors did not make the statement with those exact words. Instead, they conveyed it much more succinctly, through a photo and two words in a caption. The photo on the second page of this two-page photo-essay shows a cluster of Chinese girls lining up while reading large books. They wear mandarin-collared Chinese dresses, their hair adorned with beaded and flowered head ornaments. The caption in block lettering begins, "YOUNG AMERICANS," and is followed by two sentences of description: "Eight little students at the only Catholic Chinese school in America snatch a last peek at their lessons before filing into their classrooms. Most of the girls at this school wear embroidered tunics and beaded ornaments in their hair" (figure 1.2).

Using critical imagination, we understand that *Life* editors were explicit in referring to the little girls as "Young Americans" because it was not common at the time for many white Americans to think of ethnic Chinese in America as birthright citizens. Not only was the Chinese culture alien to most Americans, but many white Americans had never seen, spoken with, or even met a person of Asian descent.[16]

Adopted in 1868 in the wake of the Emancipation Proclamation and the Civil War, the Fourteenth Amendment of the U.S. Constitution declares: "All persons born or naturalized in the United States, and subject to the jurisdiction thereof, are citizens of the United States and of the State wherein they reside." However, historically, the core of American citizenship depended on race. The social circulation of citizenship began in 1790. The first Congress restricted American citizenship to "free white persons" in the Naturalization Act, which was modified in 1870 to include persons of African nativity or descent. Chinese immigrants were barred from citizenship until 1943. In

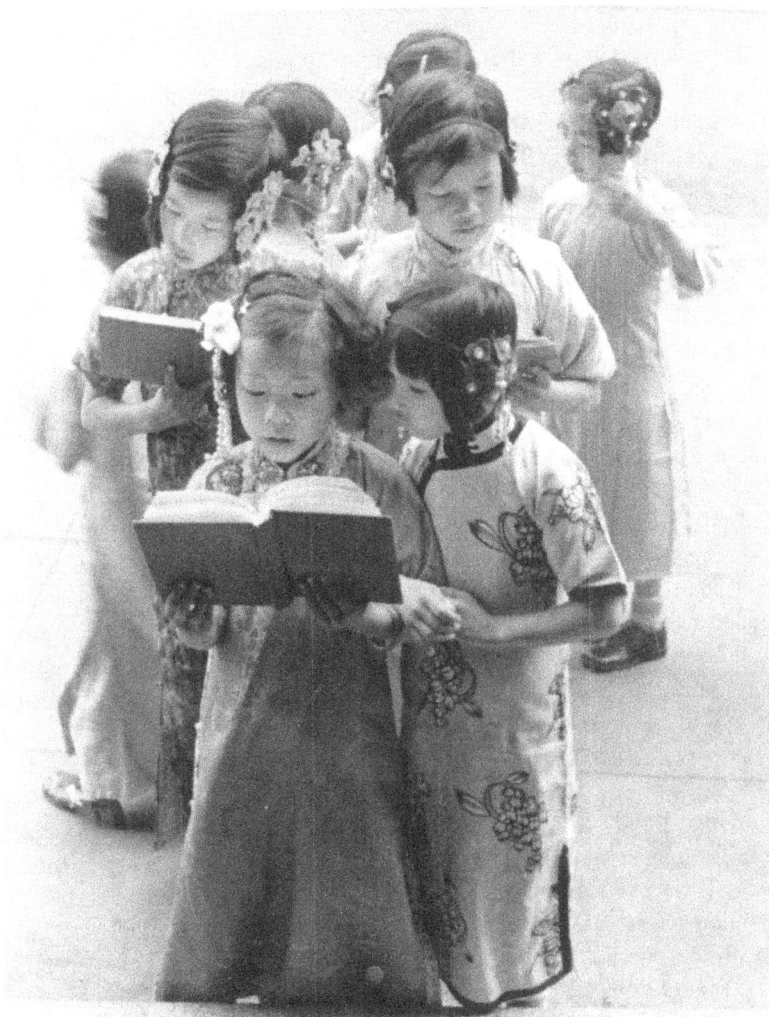

Figure 1.2 Young American Chinese Girls. *Source*: Getty Images, Alfred Eisenstaedt, *Life* Picture Collection.

1952, the McCarran-Walter Act ended all racial restrictions on American citizenship. It took 162 years after the original Naturalization Act to accept that all races were worthy of American citizenship. But laws barring American citizenship to Asian immigrants did not apply to the students at St. Mary's because they were born as Americans.

"Chinese School" is newsworthy in several ways. First is the fact that Chinese girls are born American; second, that Chinese girls are educated at a Catholic school; and third, it's newsworthy that *Life* thought this story was

newsworthy. Thus, for the average white American, this photo-essay may have been a "gee whiz, I didn't know this" moment.

The double-page spread begins on the left page which consists of three photos and the exposé. Filling the top half of the page is a photograph of a shy little girl wearing a silk Chinese dress intricately embroidered in ornate floral. We see the backs of two nuns bending forward, talking to the little girl, who looks up at them with her index finger on her lower lip. The title "Chinese School" is in script lettering directly below the photo. The accompanying exposé reads:

> In San Francisco dwell 12,000 of the 75,000 Chinese in the U.S. In its Chinatown is the only Catholic parochial school for Chinese children in the U.S. Outside St. Mary's school is gloomy with stone; inside, bright with crucifixes, oriental silks and pearl-beaded headgear. Here 400 Chinese boys and girls, Americans of the second and third generation, learn to say *very* instead of *velly*, to distinguish *he* from *she*. Since Chinese may be spoken in most Chinatown homes, these youngsters start with a bare smattering of English and almost no knowledge of the land in which they were born. A third of them are Catholics when they enter kindergarten. By the time they reach the eighth grade another third converted. Slant-eyed and shy, for five hours a day, nine years of their lives, they read, pray, sing and play in the U.S. manner under the tutelage of nine black-clad nuns of the St. Joseph order. But when 3 o'clock bell clangs the end of school, home they skip to Chinatown to lapse again into the speech of their ancestors.[17]

Having already discussed the fact that *Life* editors establish these seemingly "foreign" children as bona fide Americans, I'll focus on a troubling aspect of the exposé: the smug commentary about what the children learn in language lessons. A well-documented feature of Chinese is that unlike English, there is no differentiation in the spoken language between he, she, and it. In addition, the letter "r" does not exist in most Chinese dialects. So, while *Life* editors made assumptions about the language ability of the children, they do so in an affectionately patronizing way, even referring to them as "slant-eyed and shy."

The exposé ends by noting that at home, the children "lapse into the speech of their ancestors." This phrase "lapse into the speech of their ancestors" was intentional to emphasize that these girls are Chinese and American, an odd mixture of otherness belonging to neither culture entirely. The word "ancestors" implies a distant past from which these girls derive. In essence they are Americans first and happen to be of Chinese descent in the distant past.

The school's Catholicism is emphasized by the two nuns looming over the child in the first photo. The exposé explicitly states this school "is the only Catholic parochial school for Chinese children in the U.S." As one

might suspect, the idea of Chinese Catholic might be unusual for most white Americans at the time. The best-selling novel in 1931–1932 was *The Good Earth* by Pearl S. Buck, a fictional account of family life in a village in China. In the novel there are references to Eastern religion such as Taoist philosophy—and the appreciation of nature. The social circulation of religion depicted in the novel helps readers to understand the novelty of Catholicism among the Chinese. Thus, aside from Hollywood films showing evil Chinese women as prostitutes, the white middle-class American who read *The Good Earth* might be surprised to see Chinese Catholics. A reader's quick scan, however, may notice that the girls are neatly groomed and well behaved. As such, readers may see the girls in relation to themselves as Christians.

The photo's caption reads: "The New Pupil: Bashful uncertainty overtakes the newest and tiniest girl at St. Mary's as two nuns stop to chat with her." This is a charming opening to a story anyone who has gone to school can relate to; anxiety about making new friends and learning new rules is universal as children matriculate through elementary, middle, and high school. In 1990, Alfred Eisenstadt, the photographer responsible for this photo-essay, republished this particular photo in his book *Eisenstadt: Remembrances*. He said it was one of his favorites and provided his own caption: "Two nuns stop to talk with a bashful student at a parochial school for Chinese-American children. San Francisco 1936."[18] Neither Eisenstadt nor the editors at *Life* mention what the discussion between the nuns and the little girl was about. Perhaps they didn't know. The *Life* caption claims that the little girl is the "newest and tiniest" student in the school, making her seem particularly worthy of photographing.

The large full-page photo on the right page of the little girls holding books is a close-up high frontal angle. The angle of the shot enables the reader to view the girls subjectively. According to visual design scholars Kress and Van Leeuwen the difference between a frontal angle and an oblique angle is the difference between detachment and involvement.[19] The frontal angle means that the viewer sees the subject as part of or involved with their world.

Clearly, then, educational attainment is respected. *Life* editors must have liked this photo because they allocated a full page for it. The books that the girls are reading are the key focus in the photo, which depicts the girls, without adults, reading on their own volition. The implication is that the girls come from Chinese families who value education. In addition, as mentioned in the introduction, *Life* editors thank the little girls, "going about their lessons with grace." The words of the *Life* editors and the team who created this photo-essay illustrate that *Life* editors cared about educational attainment as a path to a better future.

On the left page next to the title, two small photos are placed to the right of the exposé. The top photo shows just the heads of three girls looking at the camera, emphasizing the three pairs of eyes. The caption reads: "Eyes over Table: Gravely curious are these unsmiling Chinese pupils as the cameraman talks to the teacher." This photo is striking because it is clear this photo was not planned ahead of time and thus shows how Eisenstadt practiced candid photography. Eisenstadt stated, "I seldom think when I take a picture—my eyes and fingers react. Click."[20] The photo caption also alerts the reader that the classroom is being disrupted by cameraman Eisenstadt.

In the lower right corner of the left page is a photo of eight little girls seated in a semicircle with hands neatly folded on their laps. The nun, their teacher, is reading a story. The caption reads: "Any Child Loves a Fairy Story: Solemn as owls and no less intent, these little Chinese Girls at St. Mary's school listen to their teacher reading a fairy story." Both small photos reveal that Chinese children are like American children. Children are curious about visitors (the cameraman), and little girls enjoy a story about fairies and magic. The implication in the lower photo is that the children are well behaved while listening intently to their teacher.

COSTUMES SHOW MIDDLE-CLASS STATUS

During the Great Depression, this photo-essay indicates that the girls were from middle-class families. If we critically imagine the rules for attending a Catholic school, we can safely assume that Catholic school parents would be required to pay a tuition fee and purchase uniforms for their children. The cost for school tuition and uniforms suggests that parents could afford private education. While *Life* editors presented photos of little girls in Chinese dress, it was unlikely that the girls dressed daily in embroidered tunics as one caption states. Critical imagination tells us that at a Catholic school, students were required to wear uniforms. Uniform dress (white blouse, plaid jumper, and black Mary Jane shoes) was and often still is required for Catholic schools around the country. Critical thought in reflecting on middle-income families at St. Mary's school suggests that Chinese costumes such as those seen in the photos were specially made. The materials to make costumes and the headpieces that match would require discretionary income that many families during the Great Depression could not afford.

To look at the photos of little Chinese girls in Chinese silk tunics and beaded head pieces might lead a reader in the 1930s to believe that this was normal dress for Chinese children in America. I attended St. Mary's Catholic school in Chinatown in the 1960s. I also have two uncles who attended St. Mary's school in the 1940s. As at Catholic schools across the nation, uniforms

at St. Mary's were mandatory. There was only one day a year that we were allowed not to wear a uniform. On that day in May, a mass was held at Old St. Mary's Church, our parish church, to honor the Virgin Mary on Mother's Day. We arrived at school in our uniforms, but later in the day we changed into Chinese costume. Then we walked to the mass from school to the church along Grant Avenue, the main street that sliced through Chinatown.

It was not unusual for children who attended St. Mary's to purchase a Chinese costume for the purpose of the Virgin Mary Mass. Some children had a Chinese costume that was uniquely tailored with embroidered sequins. Typically, students would get a new costume every year, due to outgrowing the one from the year before. For girls, the costume was specially made and sized. In the 1960s, some of my classmates had their Chinese costume tailored and ordered from Hong Kong; others purchased theirs in a Chinatown tourist gift shop. For me it was simple: my paternal grandparents owned a clothing gift store for tourist on Grant Avenue in San Francisco.[21] I simply picked a child-sized Chinese costume off the shelf. However, during the Great Depression, a Chinese costume tailored in Hong Kong was likely not affordable. Nor were there tourist gift shops available along Grant Avenue. Instead, mothers during the Great Depression might have made their girl's costumes. However, families still had to afford the silk fabric, beads, and sequins to make the costume. There might have been another costly alternative at the time. My maternal grandfather, Sik Foon Lai, was a tailor with his own shop on Pacific Avenue in San Francisco during the Great Depression.[22] He could have very well created one of the costumes seen on the little girls.

Life editors most likely asked that the children be dressed in Chinese costume to add drama and interest for the reader. A visit by *Life* photographer Alfred Eisenstadt to St. Mary's in San Francisco surely had to be arranged in advance. Either an editor or public relations professional representing *Life* contacted St. Mary's school to ask permission to visit for the purpose of a story and to photograph some children. After some discussion between the nuns and the priest who head the school, parents would have to be notified and possibly be required to sign permission forms to allow their children to be photographed. Most likely, the children were asked to wear a Chinese costume for the occasion. Also, most likely the girls did not walk to school in their Chinese costume; instead they arrived at school in their uniforms.

This was *Life*'s first issue in the time of national financial hardship. If rhetoric is about privileging certain words over others to make a point and to persuade, then the photo-essay about "Chinese School" privileges the words "Young Americans" and the photos of little Chinese girls. As previously noted, the editors stated in their introduction, "The first issue of a magazine . . . is the beginning." In this beginning the inclusion of little Chinese girls at a Catholic school shows how *Life* editors mediated historical forces that

rendered Asian women invisible. *Life* editors showed little Chinese girls in costume dress at a Catholic school that fit within the paradigm of white middle-class status.

NOTES

1. Loudon Wainwright, *The Great American Magazine: An Inside History of LIFE* (New York: Knopf, 1986), 75.
2. Wainwright, *The Great American Magazine*, 78.
3. Wainwright, *The Great American Magazine*, 86.
4. "Introduction to the First Issue of LIFE," *Life*, November 23, 1936, 3.
5. Wainwright, *The Great American Magazine*, 89.
6. Wainwright, *The Great American Magazine*, 90.
7. Wainwright, *The Great American Magazine*, 78.
8. Miriam Cohen, "Population, Politics, and Unemployment Policy in the Great Depression." *Social Science History* 38, nos. 1–2 (2015): 82.
9. Wainwright, *The Great American Magazine*, 93.
10. George Anthony Peffer, *If They Don't Bring Their Women Here: Chinese Female Immigration before Exclusion* (Urbana: University of Illinois Press, 1999), 6.
11. Peffer, *If They Don't Bring Their Women Here*, 9.
12. Peffer, *If They Don't Bring Their Women Here*, 9.
13. Erika Lee, *At America's Gates: Chinese Immigration during the Exclusion Era, 1882–1943* (Chapel Hill: University of North Carolina Press, 2003), 123. In an effort to impress immigration officials, the Chinese wore their best clothes during interviews.

See also: Karen Lynn Ching Carter, "Performing Ethos in Administrative Hearings Constructing a Credible Persona under the Chinese Exclusion Act over Time," PhD diss., Arizona State University, 2016. ProQuest (AAT 10105910). Actual interview of author's grandparents. In an interview about her status, Soon She Lai, the wife of a Chinese merchant (Sik Foon Lai), Soon She Lai wore a silk dress with an embroidered sweater and displayed her diamond ring, thereby proving her respectability as wife, not a prostitute.

14. Peffer, *If They Don't Bring Their Women Here*, 25.
15. Peffer, *If They Don't Bring Their Women Here*, 4.
16. Peffer, *If They Don't Bring Their Women Here*, 4.
17. LIFE. "Chinatown School." *Life*, November 23, 1936, 24.
18. Alfred Eisenstaedt, *Eisenstaedt: Remembrances*, ed. Doris C. O'Neil (New York: Little, Brown, 1990), 46.
19. Gunther R. Kress and Theo van Leeuwen. *Reading Images: The Grammar of Visual Design*, 2nd ed. (London: Routledge, 2006), 136.
20. Eisenstaedt, *Eisenstaedt: Remembrances*. xvi.
21. My father's parents, George and Agnes Ching, owned Chinn's: the Aloha gift shop at 449 Grant Avenue.
22. Sik Foon Lai sold the store in 1940 and opened a sewing factory thereafter.

Chapter 2

The Charm of Novelty When *"Life* Goes to the Forbidden City"

The first managing editor at *Life*, John Shaw Billings, said of one issue in 1939, "I am determined to get charm, sex and glamour into this issue."[1] Henry Luce said, "[*Life*] needs more charming pictures, more boy-girl material, more fun."[2] With that spirit from the top two *Life* editors, "*Life* Goes to The Forbidden City," a photo-essay about Asian American dancers at the Chinese-themed nightclub, enlivened the December 9, 1940, issue. The photo-essay shows how layout and photographs play into sexual stereotypes about Asian women, yet *Life* editors also tell the story of educational attainment and middle-class Americans. The dancers were novel to *Life*'s white middle-class readers and even to *Life* editors because a Chinese-themed night club like the Forbidden City did not exist outside California. Asian women that could dance like Westerners and spoke in English were unfamiliar to most white Americans.

Photos taken at the Forbidden City nightclub were of Asian American women during their acts that played to prevailing "Oriental" stereotypes such as sex-scheming prostitutes. However, *Life* editors crafted a narrative contrary to expectations of the *Life* reader. *Life* editors did not perpetuate the stereotype of Asian women as prostitutes in their captions and exposé. Instead, *Life* editors created a narrative of women who valued hard work and education as a path to career advancement. One caption reads: "Some of the girls in the floor show are paying their way through college." In the exposé, *Life* editors describe the Chinese girls as having "extraordinary aptitude for Western dance forms." Hints of racism are present in such statements as "they dance to any tempo with charm distinctive of their race." But more importantly, *Life* editors also speak respectfully such as when they say of burlesque dancer, "she doesn't drink or go out with men."

This particular photo-essay was a novel miscellaneous story in which *Life* editors reveal that Asian American women are human. Dancing at the Forbidden City nightclub were acts. The actors or dancers were middle-class Americans to which *Life*'s readers could relate. While the photos portrayed the dancers as exotic Asians with stereotypical sexual allure, *Life* editors also presented the Forbidden City as a place frequented by respectable white middle-class people who watched dignified Asian American women perform. According to journalism scholar Sheila Webb, *Life* editors were constructing a middle-class path for readers to follow,[3] letting them know that for middle-class professionals, the nightclub was a social environment for leisure entertainment and dancing.[4] The photos show that the Forbidden City in San Francisco was a unique nightclub in producing both Oriental themes and non-Chinese themes that could draw attention to irony or parody of Chinese dancers.

The Forbidden City nightclub was in San Francisco—not the Orient—and the publication of the photo-essay in *Life* suggested to the American reader that the Oriental mystique seen in the movies can be experienced and touched in a nightclub in America. Oriental themes referenced early twentieth-century Hollywood films that portray Chinese males as the predatory Fu Man Chu character, who sought to conquer Europe and Asia, and portray Chinese females as oversexualized prostitutes or subservient harem girls. These cinema stereotypes provided moviegoers a way to engage in personal fantasy not easily obtainable in other venues.[5] Therefore, in the mind of the white middle-class *Life* reader, the Asian woman dancer provoked a sense of exotic wonder.

Luce's eyes were on the emerging middle class of an industrializing America. This included entertainment. The night club offered a space for modern Americans to gather and engage in culture and entertainment. According to journalism historian Sheila Webb, *Life* editors wanted to create a community of citizens who with proper training and knowledge could thrive in a new modern society. This view heavily reflected Luce's interest in the modern age, the emergent middle-class consumer culture, and his virtual "obsession with the state of the World and America's role in it."[6]

NOVELTY IS NEWSWORTHY

In the catchy headline, "*Life* Goes to the Forbidden City," The words "forbidden" and "city" evoke an emotional interest in reading about something taboo. As a photo-essay, the opening photo is on the left page with an attention-grabbing full-body image of Jadin Wong. The photo is a close-up in which the reader can see Wong's full face and eyes, as well as the contours

of her scantily clad body. She wears a sequined bra, beaded belt, and veiled harem pants. Her exposed midriff puts her belly in focus. *Life* editors are saying, look here and read this story.

Life editors placed this photo in the opening so it could be consumed by a white audience as "Oriental" mystery. The full-page black-and-white glossy photo shows Jadin Wong with her arms crossed at chest level and her torso bent back, engaged in a sensual flow. The two-paragraph exposé on the opposite page states: "Gracious Jadin Wong is performing her chaste Moon Goddess dance." The photo of Wong in this close-up sensual pose shows us what kind of stereotypes were in circulation about Asian women at that time—that Asian women were prototyped in Hollywood roles as mongrel slave, mysterious prostitute, concubine, or maid.[7] While *Life* editors use the word "chaste," which implies respect for Wong as a dancer, her pose and costume does not contradict the image of a prostitute or mongrel slave.

The exposé, opposite Jadin Wong, is surrounded by captioned black-and-white photos that featured an Asian woman singer, a chorus line of Asian women dancers, an Asian couple dancing, and white Stanford University students eating with chopsticks. The title, "*Life* Goes to the Forbidden City," is centered in stylized script. Below the title in bold block lettering reads, "San Franciscans pack Chinatown's No. 1 night club."

The exposé reads:

> At 363 Sutter Street, in San Francisco stands "Forbidden City." The No.1 all-Chinese night club in the U.S. Here each evening Californians flock to watch a talented floor show that ranges from slumberous oriental moods to hot Western swing. San Francisco is numerically ill equipped with Broadway style cabarets. Its citizenry eats at home, dances at hotels. When "Forbidden City" opened two years ago, it filled a local cultural need. It has prospered ever since.
>
> In décor, "Forbidden City" blandly jumbles rice-paper screens, lighted fishbowls, college colors and football trophies. Somehow the net result is satisfactory. Its tri-nightly floorshow as blandly scrambled congas, tangos, tap numbers and snaky stuff from the Far East. Chinese girls have an extraordinary aptitude for Western dance forms. As singers, not many achieve success according to occidental standards. But slim of body, trim of leg, they dance to any tempo with a fragile charm distinctive to their race. Opposite you see gracious Jadine Wong performing her chaste "Dance of the Moon Goddess."[8]

The name of the nightclub, "Forbidden City," is borrowed from the ancient walled compound in Beijing; however, in the context of this nightclub, "forbidden" could also mean showcasing performances by nonwhites (Chinese people) of what had previously been considered white entertainment.[9] An all-Chinese-themed nightclub implied that white Americans could experience

the paradox of Asians acting like more conventional Americans by singing and dancing in English and Western costume.[10]

The photos surrounding the exposé draw the reader's immediate attention to the all-Chinese composition of the dancers and singers. The floor shows are described as "from slumberous oriental moods to hot Western swing," drawing attention to the racial differences between the acts. In this exposé, *Life* editors explicitly emphasized racial differences by stating that the "Chinese girls have an extraordinary aptitude for Western dance forms," as demonstrated by a woman dancing in a cowgirl costume. From the perspective of the white middle-class reader, the novelty lay in the assumption that the dancers were imitating an entertainment culture they did not belong to.[11] The paragraph continues to point that "[Chinese] singers, not many achieve success according to occidental standards . . . they dance to any tempo . . . distinctive to their race." Thus, the opinion of editors that the dancers were "far from expert" and "distinctive of their race" invokes a sense of superiority of Western dance from Eastern or Chinese dance forms.

Above the exposé is a picture of four dancers looking into the camera. The caption says, "Versatile Chinese Chorus girls Conga, To Latin-American Jazz Rhythms." A larger photo to the right of the exposé is of Li Tei Ming, age twenty-two. Per the caption, she is singing "When Irish Eyes Are Smiling." While the captions for the chorus girls and Li Tei Ming are details explaining the photo, *Life* editors' use of ethnic identifiers such as "Latin-American" and "Irish" add to the newsworthiness and novelty of this photo-essay by emphasizing racial roleplaying by Chinese women.

Below the exposé are three photos that run across the bottom. They appear to be random photos strung together, but each one individually tells the reader something more about the Forbidden City. The photo on the bottom left tells of "Stanford students using chopsticks." *Life* editors published their names "Louis Reese & Ray Diekemper." In addition, as Stanford students, they have middle-class status in showing educational aspirations. The bottom right photo shows Ray Diekemper and another Stanford student, Robert Breckner, who is dancing with Dorothy Sun and Li Tei Ming. By naming the students and the women dancers, *Life* editors draw attention to racial mixing, possibly in an attempt to transport the reader into empathetic identification to relate to the Stanford students enjoying a night out.

The photos and captions illustrate the type of patrons at the Forbidden City: respectable middle-class people like Stanford students seek entertainment at the Forbidden City. The center photo shows "The dancing Mei Lings." Clearly the Mei Lings are Chinese, but dressed in a tuxedo and dress ball gown; the caption calls them "classy cosmopolitan dancing a slick tango number entitled *Clair de Lune*." The photos read together connect with the narrative that the Forbidden City is a cosmopolitan place where white

respectable middle-class people gather. Thus, the nightclub is a respectable place for middle-class people like *Life* readers.

HIDDEN NARRATIVES OF MIDDLE-CLASS STATUS

Life editors reveal that the Asian women dancers are educated and from middle-class families. In the centerfold on pages following the opening photos is an additional photo of sparsely dressed Jadin Wong on the left page, and two more photos that include two chorines in cowgirl style attire and Noel Toy, a burlesque dancer on the right page. The chorines are in college, Jadin Wong is a high school graduate, and Noel Toy is a French major at U.C. Berkeley.

Life editors contribute to the circulation of middle-class values in this photo-essay. Consider the photo on the top in the centerfold of the two chorines in cowboy hats, neckerchiefs, and fringed glittery short skirts. They are twirling lariats. The caption reads: "Chinese chorines twirl lariats in Western number, 'Pony Boy.' Some of the girls in floor show are paying their way through college by working nights at the 'Forbidden City.' In the two years since the club opened, its show has won national fame. Its minimum $1 weeknights, $1.50 weekends. It's clientele: 10% Chinese 90% American."

The dancers are not mysterious Asian prostitutes but middle-class women going to college, and since the club's clientele is "90% American," it is a safe place to visit.

On the inside right center is a photo of Noel Toy raising a "bubble" to conceal what appears to be her naked body. The caption reads, "(Chinese Sally Rand) majored in French at U. of C. until money ran out. She doesn't drink, go out with men." The narrative that Chinese women are believed to be prostitutes is broken by *Life* editors stating that Noel Toy does not go out with men. This statement is juxtaposed with the conclusion: "One night last week her bubble broke." Thus, the caption provides the reader with a sense of alluring possibility to see a naked Noel Toy if one should attend the Forbidden City night club while at the same time discounting her talent as a dancer by inserting in quotations "(Chinese Sally Rand)"—as if Sally Rand is the real burlesque dancer and Noel is the Chinese imitation.

Opposite Noel Toy on page 126 is a photo of Jadin Wong. She is dressed in a skimpy gold glittery costume. In the background stands a large gong. The caption reads, "Jadin Wong, 21, is a native of San Francisco, high school graduate. Her father runs a Chinatown store. Miss Wong specializes in oriental numbers, can also jitterbug." The Chinatown store implies that Wong's father is a merchant and of middle-class status. The implication is that a store owner does not work as an employee but buys and sells goods as

a self-sustaining businessman. The entire caption explicates that Wong's life may not be all that different from *Life*'s middle-class white American readers.

Thus, through the photo-essay, *Life* editors insert humanity about Asian women dancers at the Forbidden City nightclub—that Chinese women dancers are not prostitutes, but like their white American audience—gaining an education as aspiring middle-class Americans.

MIDDLE-CLASS CONSUMER CONSUMPTION

Life editors placed the ads in the social world of nightclub entertainment. An advertisement for "Black and White" whiskey flanks the left page, and an advertisement for hand lotion flanks the outside margin of the right page. Whether the audience is interested in the advertisements or not, the target of the advertisements is middle-class white Americans. We cannot know whether the ads changed the reader's experience of the photo-essay in 1940; however, we can speculate that the ads were placed intentionally in those spots. The ads create a complementary narrative to the photo-essay. Carter asserts that narrative of the ads could say something like this:

> Scotch Whiskey could enhance your experience while enjoying the entertainment of beautiful Asian women dancers. Hand and body lotion will soften your skin that women dancers also use. If you purchase this hand and body lotion, you too can have soft skin.[12]

The Scotch whiskey ad features the logo of two dogs, one black and one white, with the caption "warm friends." This ad speaks to a reader who might have a drink before or after a night out. The hand and body lotion advertisement is designed in the form of a comic strip. A woman on her way to a party says she wants soft skin. This ad for lotion speaks directly to the woman reader who would like soft skin. Both ads appeal to the consumer with middle-class status and the luxury of spending discretionary income. While highlighting middle-class consumer culture through advertisements, the narrative combined with a photo-essay on a Chinese nightclub in San Francisco is a masterpiece in understated middle-class consumption.[13]

FROM THE PERSPECTIVE OF *LIFE* EDITORS

"*Life* Goes to the Forbidden City" was created to drive readers between viewing a spectacle of Asian women and the possibility of empathy for Asian American women striving for an American middle-class life. In 1936 Henry

Luce wrote in a memo that "photo displays should not be arbitrary." He also wrote, "To see and to be shown is now the will and new expectancy of half of mankind."[14] The phrase "half of mankind" means the women. I contend that the story told showed that none of the Asian women dancers at the Forbidden City nightclub lacked voice or the possibility of empathetic identification with *Life*'s white middle-class audience. *Life* editors showed that Asian American women existed and are human. I begin the next section by turning to the photo-essay that employs the notion of middle-class American life.

NOTES

1. James L. Baughman, *Henry R. Luce and the Rise of the American News Media* (Boston: Twayne Publishers, 1987), 46.

2. Baughman, *Henry R. Luce and the Rise*, 46.

3. Sheila M. Webb, "'America Is a Middle-Class Nation': The Presentation of Class in the Pages of *Life*." In *Class and News*, ed. Don Heider (Lanham, MD: Rowman & Littlefield. 2004), 2.

4. Karen L. Ching Carter, "High and Low Art in Narrative Construction of a Photo Essay: When Asian American Women Became Middle-Class Americans at the Forbidden City Nightclub in San Francisco," *South Atlantic Review* 84, no. 1 (2019): 160.

5. Anthony W. Lee, "Crooning Kings and Dancing Queens: San Francisco's Chinatown and the Forbidden City Theater," in *Reading California: Art, Image, and Identity, 1900–2000*, ed. Stephanie Barron et al. (Berkeley: University of California Press, 2000), 212.

6. Loudon Wainwright, *The Great American Magazine: An Inside History of LIFE* (New York: Knopf, 1986), 118.

7. Yumiko Murakami, "Hollywood's Slanted View," *Japan Quarterly* 46, no. 3 (1999): 3.

8. LIFE. "*Life* Goes to the Forbidden City: San Franciscans Pack Chinatown's No. 1 Night Club." *Life*, December 9, 1940, 125.

9. Lee, "Crooning Kings and Dancing Queens," 200.

10. Lorraine Dong, "The Forbidden City Legacy and Its Chinese American Women," *Chinese America: History and Perspectives* 2 (1992): 125–148.

11. Lee, "Crooning Kings and Dancing Queens," 202.

12. Carter, "High and Low Art," 160.

13. Carter, "High and Low Art," 173.

14. Baughman, *Rise of the American News Media*, 84.

Chapter 3

"The Nisei" Spy Scare

Even in the early 1900s, rumors circulated that Japanese immigrants created outposts for Japanese espionage.[1] The paranoia persisted due to international events such as the conflict between Japan and China and the "rape of Nanking" in 1937. Hollywood also played a role in the spy scare. In a 1920 film called *Shadow of the West*, Japanese immigrant farmers were depicted as spies for Japan and predators of innocent white girls.[2] A year before the attack on Pearl Harbor, the U.S. intelligence uncovered what appeared to be messages that named Japanese espionage networks on the West Coast. However, exaggeration of the message due to improper translations coupled with the climate of fear gave way to a twisted interpretation of a national security threat which didn't exist.[3]

Life's 1940 photo-feature "The Nisei: California Casts an Anxious Eye upon the Japanese-Americans in its Midst" is divided into three mini photo-essays. In the opening photo layout, *Life* editors introduce the problem of conflating Japanese Americans with Japanese espionage. The second mini photo-essay is a double-page layout that juxtaposes old Japanese traditions with American traditions. Women are privileged in these photos. Young Japanese American women are shown as leaders forging toward middle-class American life. The third mini photo-essay consists of several pages of photos mixed with advertisements. These photos show Japanese American women and girls in community activities.

THE OPENING PHOTO

A Japanese American man with sleeves rolled over his elbows stands alone in a field of flowers. He is doing physical labor, trimming waist-high flowers on this farm. The medium-distance shot shows the man's face in intense

concentration as he works. With this photo, *Life* editors urge readers to look at the life of this man and the lives of Japanese Americans. The man is not looking at the camera. Thus, the reader is not engaging with the man but watching from outside. In the far ends of the photo are numerous oil rigs; their tall towers scatter into the horizon. The lush flower farm dominates the scene. Yet, the scene shows the need for oil colliding with a potential spy—Japanese American flower farmer.

The caption states: "Graduate of U. of C. Agricultural School tends his flowers in a Los Angeles county flower field. Californians dislike the proximity of Japanese farms to oil wells." This identification establishes him as educated and middle class.

Thus the opening photo orients the reader to the problem. Using social circulation, the Japanese farmer seen here is associated with *Shadow of the West*, in which Japanese immigrant farmers were depicted as spies for Japan. The oil rigs in the background represent the lifeblood of an industrial society that, if interrupted, could halt American power. Below the half-page photo in small print is the title to the feature, "The Nisei." The subtitle reads: "California casts an anxious eye upon the Japanese-Americans in its midst."

Life editors smartly framed the opening page to show how Japan's new military alliance with Germany and Italy would affect the Nisei, Japanese Americans in America. They state, for Japanese-Americans—"it meant more trouble, more discrimination and more work to survive." Implicit is that Japanese Americans look like the enemy. The fear among the Japanese American community is that white Americans would conflate their Japanese ancestry with that of loyalty to Japan. Along the bottom of the page are two photos, one of a fishing barracks and the other of a fishing vessel. The captions reveal that the photos represent Californians' fear that fishing boats could transport torpedoes. To assuage the fear of Japanese Americans on the West Coast, *Life* editors directly address those fears in the five-paragraph exposé of approximately 400 words.

The exposé recaps the fear of Japanese spy attack on the U.S. Naval base that operates in San Pedro. However, *Life* editors begin to assuage the fear by emphasizing that most Japanese are Americans by birth: "there are 141,000 Japanese Americans in the country of which 100,000 are American citizens" called the Nisei, which means that they are (at least) second-generation immigrants and American by birth. They also explain the status of the 41,000 Japanese who are not citizens. The paragraph makes a case that the Japanese came to this country to make a home and a life. *Life* editors provide the Niseis answers to American questions: "The fishing boats are locally made and unable to carry any heavy machinery such as a torpedo, let alone be able to shoot one; and the flower fields were farms long before they became oil wells."

The last line concludes the exposé: "They [Japanese Americans] insisted they love America and are willing to fight in its defense." Implicit is that readers trust *Life* editors to bring them the truth. Therefore, *Life* editors reassure Americans not to be afraid.

This opening confronts the fear and anxiety that white middle-class readers may have felt of Japanese Americans. *Life* editors give facts in the opening of the photo-essay. The photo-essay's thesis is that the Nisei are more American than Japanese and have achieved economic independence, established families, and built community respect, which *Life* editors purport are American values. Women in particular are represented as mothers, students, daughters, and wives who embody the success of the Japanese American family.

FOCUS ON ANCIENT JAPANESE AND AMERICAN TRADITIONS

According to Asian American scholar Shirley Lim, the leading "litmus test for social fitness of immigrants and third-world nations had been the cultural status of their women."[4] Lim, referring to racism in which the white imperial woman was the model for modern civilized behavior, posits that all "others" such as immigrants of color were measured against the white imperial model.[5] Thus, the greater the differences from the model white imperial woman, the more "backward" was the immigrant culture from which the immigrant woman came.

Life editors used markers to show the Americanness of Japanese American women. In the double-page layout following the opening, for example, *Life* editors depict Japanese Americans as inclined to be more American than Japanese, in that they appear modern and Westernized, dressed in Western-style clothing doing ordinary activities such as holding a baby contest, going to and from choir practice, performing in a theater show, or joining a club, all of which mark these women as modern Americans. Involvement in a special activity such as Kendo practice requires uniforms as would a special parade dressed in a kimono. Thus, *Life* editors show that the Japanese American community is not that different from the white middle-class *Life* reader.

If we consider how photos formulate meaning in a photo-essay, then it is the layout of the photo-essay that creates a social culture's reality. Using representational strategies such as visual structuring in layout, *Life* editors focused on Japanese American women's mundane ordinary activities, to show that Japanese Americans have more in common with white middle-class Americans. The "more American than Japanese" narrative is enhanced by juxtaposing six photos across the top with six photos along the bottom.

The top photos represent Japanese traditions; the bottom photos represent a modern American equivalent.

The top six photos with captions show Japanese traditions. From left to right: (1) a Buddhist shrine, (2) men greeting with a bow, (3) girls parading in Japanese kimono, (4) a Kendo class, (5) eating at a Japanese restaurant, and (6) wedding in Western attire at a Buddhist temple. The bottom six photos juxtapose with the top from left to right: (1) moms and babies at a baby contest, (2) boys in American Legionnaires, (3) young girls at Sunday church attendance, (4) boys and girls playing in dirt, (5) young girls in theater dance, and (6) a young girl's induction ceremony. The juxtaposition of photos that show Japanese traditions matched with American traditions is shown in figure 3.1.

Life editors make the following statement in the left top corner exposé: "Americans have only themselves to blame for the clannishness of the Nisei. Excluded from White residential neighborhoods, forbidden by law to intermarry with Whites, hired at substandard wages, the Nisei have been thrown largely on their own resources. Some adhere desperately to their ancestral language and culture. Others simply try more diligently to make a place for themselves in U.S. life. But all achieve economic independence that most infuriates those White Americans who have failed to achieve it for themselves."

The phrase "working harder than white men in the fields" says something about *Life* editors—that *Life* editors valued hard work and independence. The phrase, "Nisei have been thrown largely on their own resources," shows that *Life* editors held strong views about economic independence despite obstacles. In the case of Japanese Americans, the obstacles were racially discriminatory practices. *Life* editors didn't hesitate to express views that racial prejudice against Japanese Americans was rooted in some white Americans' inability to achieve their own economic independence.

The exposé for the bottom photos is titled, "Western Ways Appeal to the Younger Generation." The paragraph states, "at home to their elders they speak Japanese. But in school, in church, in business the language of the Nisei is English." In addition, "English is the tongue which they teach the Sansei—the third-generation Japanese in the U.S." Through language, *Life*

Exposé-Ancient Japanese Traditions	Buddhist Shrine	Men greeting with bow	Girls in Japanese Kimono	Kendo Class	Japanese Restaurant	Wedding family portrait Buddhist Temple	
	Baby contest	Boys American Legionnaires	Young Girls Church Choir	Children digging in dirt	Girls in a theater performance	Girls induction into club.	Exposé-Western ways

Figure 3.1 Nisei Traditions. *Source: Life* magazine, October 14, 1940, pp. 76–77.

editors emphasize assimilation into American society with each successive generation.

Life editors didn't avoid the fact that many Japanese Americans follow some ancient Japanese traditions, but stress that Japanese Americans can live with both Japanese and American traditions. For example, the photo of a garden Buddhist shrine in Los Angeles is juxtaposed to a photo of a girls choir outside an Episcopal church; the caption says they are in an "Episcopal Choir." Another photo shows a Western wedding with a Buddhist ceremony. That photo is juxtaposed with moms holding a baby contest. A photo of girls practicing the martial art of Kendo is juxtaposed with girls performing at an American theater. The caption for the theater performance says, "Pure American drama, deriving nothing from Asia, is staged by girls' clubs of the Los Angeles Japanese Methodist church." The photo of girls parading in traditional kimonos is juxtaposed with boys as members of the American Legionnaires. *Life* editors emphasize that the boy leaders are veterans of the American Expeditionary Forces sent to fight in Europe during World War I, while the girls in kimono bring a soft elegance to an ancient tradition, implying the kimono is old and not part of everyday wear.

With the juxtaposition of ancient and modern activities, *Life* editors show that immigrants bring with them cultural traditions—but also, make new traditions as Americans. Picturing the women as representations aligning Japanese traditions with American values, *Life* editors make a statement—that immigrants bring with them their culture and eventually assimilate into American society, adopting values such as family stability (shown through a wedding ceremony and baby contest), religious beliefs (shown with the Buddhist shrine and girls church choir), and developing a well-rounded education (shown through Kendo, choir practice, and theater performance).

Life editors stress that America has a problem with racism and that discrimination of Japanese Americans is unjustified and un-American. They state more specifically, "color imposes a barrier which few of the ever manage to transcend." While Japanese American younger generations (Nisei) "are excellent students and excellent athletes." "Few are admitted to college fraternities or sororities." When they graduate college, "few find easy employment in business or professional world." The implication is that unlike white American college students and college graduates, Japanese Americans face adversity in society due to their race.

In a final paragraph, *Life* editors also raise the issue of patriotism and conscription concerning possible war. To exclude Japanese Americans in society would hurt American readiness for war. *Life* editors give facts: "The Japanese American Citizenship League made up of Nisei supports conscription" and that "16,500 are eligible for the draft." In addition, "Japanese Americans fought with the A.E.F. (American Expeditionary Forces) in the last war and

will fight . . . in the next." The talk of war and the number of eligible men for conscription was an important point to make at this time with the news that Japan just allied with Germany.

A PLACE IN THE SUN

In the next series of photos, *Life* editors show Japanese Americans living as modern Americans despite blatant racial prejudice. In the case of Japanese Americans, the past would be what white Americans perceive to be "Japanese" markers such as literacy in the Japanese language, wearing traditional Japanese clothing, or travel to Japan. Since white Americans would conflate Japanese Americans with loyalty to Japan, markers that showed Japanese heritage would constitute suspicion of espionage. Hence, the circulation of rumors in the suspicion of espionage is interchanged with racial prejudice.

On the following pages, the title, "Dangling between Two Worlds, the Nisei, Fight for a Place in the American Sun," is a statement that Japanese Americans can only partially assimilate into American culture because they still face racial obstacles. In the center photos, *Life* editors make a statement that Japanese espionage is an excuse for racial prejudice. The photos speak of American domesticity and racial prejudice in a Japanese American neighborhood. A Japanese couple with a baby stands outside the front door of their home on a porch. The caption informs the reader that the man is Frank Yamaguchi and that he is off to work. Yamaguchi holds a lunch box under his right arm and is kissing his wife. Mrs. Yamaguchi, wearing a stylish plaid skirt and white blouse, cradles a baby. The caption states that "Mr. Yamaguchi works at the McDonnell Douglas aircraft plant in Santa Monica." *Life* editors present the Yamaguchi family as the quintessential middle-class family—just like *Life* readers. The only exception stated in the caption is that visitors at the aircraft plant report Mr. Yamaguchi as a spy. To further demonstrate the obstacles Japanese Americans face is a photo to the right that shows a sign. It says, "Racial Restrictions." The caption gets to the point: "The Color Line is drawn by real estate owners who say that white tenants move as soon as Japanese enter neighborhood. Housing is the worst problem of the Nisei."

The caption implicates that the Yamaguchi family has just moved to this neighborhood. As a result, white families have moved out. Yet, *Life* editors place an image of intimacy between husband and wife with their baby. The intimate image of the couple shows the irony of harboring racial prejudice against an image of an American family.

In the photos that line the bottom centerfold, *Life* editors show how young Japanese American students dangle between two worlds. Nisei students are

encouraged to travel to Japan for extended stays; however, *Life* editors show that young Nisei girls are not like docile Japanese women. The left of the centerfold shows a room of young Japanese American women. Dressed in poodle skirts, pearl button blouses, bobby socks, and saddle shoes, the young women are seen relaxing on sofas and chairs and appear to be talking and laughing. The caption provides the setting: "In a Los Angeles Dormitory." The women are "single girls" discussing problems. The implication is that Nisei women are American in dress, thought, and ambition. Thus, Nisei girls can be distinguished from women from Japan.

The photo on the bottom right next to the college girls is a large cruise ship docked with many people on the pier waving to people on the departing ship. Hundreds of streamers run from the ship to people on the dock. The caption tells readers that "Its Back to Japan." "Several hundred Nisei" would travel to Japan for study. The commentary from *Life* editors says, "Californians strongly disapprove of these excursions." The commentary uses the word "excursion" to describe travel as a leisurely trip. The term "excursion" implicates that the young schoolgirls may take a short vacation to visit Japan. Thus, the photos show how young Nisei girls dangle between two worlds. As Japanese American schoolgirls, they are encouraged to study in Japan.

JAPANESE AMERICAN WOMEN REPRESENT HIGH-CLASS SOCIETY

Japanese American women didn't just assimilate into American culture. *Life* editors claim that they created Japanese American society and celebrate their heritage proudly as a way to show their Americanness. The final series of photos is titled "Little Tokyo Turns out for Nisei Festival," a social event that celebrates Nisei society with a carnival and ball. *Life*'s attention to Japanese American women shows that the editors believe in a modern society that equalizes women as leaders and contributors in promoting American values. The three photos represented in this photo-essay show women enjoying the fruits of their labor in organizing the Nisei week with a formal invitation to the mayor of Los Angeles, a Nisei week queen coronation, and a coronation ball.

In the top photo, *Life* editors show Japanese American women in kimono greeting the mayor of Los Angeles, Fletcher Bowron. The photo shows women in traditional kimonos in interaction with white American power—the mayor, official for the city of Los Angeles. The caption says, "the Mayor was handed an invitation to the Nisei festival." *Life* editors say that the festival is "staged yearly by second-generation Japanese-Americans." This photo is on the left page at the top of the inside column. It reaches the reader's

eye first. Using critical imagination, this photo implies that the Japanese American women play a large role in the development of the Japanese American community. While the kimonos they wear represent formality and respect for their Japanese heritage, Japanese American women are involved visibly with the Los Angeles community, which indicates commitment to American society.

The middle photo is placed in part as an editorial. The caption says the ball is held at the "Los Angeles' swank Biltmore Hotel." The term "swank" suggests upper-class status. The Biltmore Hotel Los Angeles opened in 1923 and was the venue for the Academy Awards from 1930 to 1943. With the show of wealth, there must also be a show of royalty. The coronation of a queen for the Nisei week and the court is the subject of the photo. The ladies are dressed in Western evening gowns. In this way *Life* editors show markers of Americanness while illuminating the beauty of Japanese American women. The queen, Shizue Kobayashi, sits on a throne, wears a crown, carries a scepter, and is covered with royal red robe. The caption says that the queen's court is part of a coronation ball. Clearly, the Nisei week is not a small community affair, but is large and upscale.

In the bottom photo *Life* editors show that the Japanese American community is the "cream of Los Angeles Nisei Society" and that the "atmosphere is strictly Occidental in keeping with the desire of the Nisei for cultural assimilation." The photo shows Japanese American class status. The women in Western evening gowns and men in tuxedos mark them as American. The dancing couples represent class status and community engagement. The implication in the narrative is that Japanese American society is sophisticated, cultured, and respectable.

GIRLS REPRESENT NEW TALENT AND THE FUTURE

Like proud parents, *Life* editors brag that Nisei girls are talented. Third-generation American girls are featured under a simple title, "Nisei Week Turns Up Many Kinds of Talent." The top photo is of a little girl smiling, singing into a microphone that towers over her head. Her eyes sparkle as she looks out to the audience. She wears black tap shoes over white bobby socks, shiny matching sequined top and shorts, and a headpiece in the shape of a flower. As she sings and dances, her left-hand gestures around her mouth. The image could be at any recital or school performance anywhere in America. The caption introduces the child simply as "A Sansei Child." By simple reference to Sansei, *Life* editors place the image of the girl among third-generation children of immigrants. The caption informs of other stage acts that might take place which could be "torch ballads, hot American swing, ancient

Japanese folk songs." The list shows a variety of performances but also that those performances are like any other talent revue that could happen in any American community.

The photo below is a side view of another young girl dancing, dressed in strapless top and skort, or short with a skirt, with a matching headband. Her arms are raised above her head. The caption reads: "A Nisei dancer sets sinuous Oriental evolutions to Western airs. Japanese voices seldom please U.S. ears. But Nisei girls dance as ably as they play tennis and swim."

Here, *Life* editors show the condescending stereotypes that circulated in calling the girl's dance "Oriental evolutions to Western airs" and the "Japanese voices are not pleasing." The social circulation of condescension tells us what the reader might be thinking of Japanese dance and music. In speaking to a white middle-class audience, the photo brought interest to understand the Japanese girl while learning that Nisei girls, distinct from Japanese girls, also swim and plays tennis like other American children.

JAPANESE AMERICANS RECONTEXTUALIZED AS MIDDLE-CLASS CONSUMERS

Advertisements embedded in the middle of a photo-essay temporarily disengage readers from the story. Like an intermission in a movie, they give readers a break to digest the storyline. As the "Nisei" story progressed over seven pages, advertisements in aggregate temporarily disengaged the reader from the photo-essay, thereby recontextualizing the narrative spanning Japanese potential spies to Japanese Americans as middle-class Americans. Thus, through social circulation, advertisements played a role in engaging readers as middle-class consumers. Advertisements were also part of *Life* publisher Henry Luce's vision for *Life* to urge advertisers to take a position of cultural and moral leadership by supporting quality journalism.[6] Aligning Japanese American middle-class status with the *Life* middle-class educated reader, five advertisements flanked the outside columns in a double-page spread of which included the "Nisei Week."

Opposite the "Nisei Week" on the right page is a full-page John Hancock Insurance ad that may or may not be intentionally placed; however, the photo-essay of Japanese American women is recontextualized in that the ad includes an imaginary relationship with a need for life insurance for an uncertain future. The photo in the ad shows a man dressed up as George Rogers Clark with three trappers in fur caps wearing buckskin clothing. They huddle with soldiers with hats turned up on three sides in colonial uniform. Clark and a soldier are hunched over a map studying the Northwest Territories in the

United States. Supplies and provisions pictured such as muskets, rifles, and food barrels indicate the men are about to embark on a journey. The short paragraph speaks of the journey of George Rogers Clark in his expedition to defend the Northwest Territories in 1779.

The John Hancock ad speaks to readers' fear of hardship due to war. To envision the context in 1940, the social circulation of news tells us that at the time of "The Nisei" photo-essay, war broke out in Europe in 1939, and the United States was not certain it would join. This is evident in the news section of this issue, titled "*Life* on the Newsfronts of the World." The subheading in part reads "Japan shouts war at the U.S." While the news section reports about the war in Europe, the picture of the week on the opposite page shows Americans at the Washington National Cathedral in prayer. The caption states: "Americans pray for Great Britain." Thus, in the context of war, Japan was a threat, and *Life* editors thought it important to show Japanese Americans as more American than Japanese.

The John Hancock Insurance ad is titled "The Part Provisions Played in Winning the West" and is about insuring that one has the necessities when unexpected dangers arise. The relationship to winning the West can be associated with Japan joining Germany in war. Japan is a threat from the East and the title "winning the West" reminds readers of a war. The image of George Rogers Clark preparing to go on a journey of unknown consequences allows readers to see tangible evidence of the need for life insurance. At this point in the photo-essay, Japanese Americans are shown in American life; there is one more page that concludes the photo-essay about the "Nisei." Whether or not the reader reads the conclusion of the photo-essay does not matter. The emotional impact from the life insurance ad may elicit empathy for Japanese Americans or not but it causes the reader to think about life insurance, war, and the plight of Japanese Americans and their place in American society.

MODERN AMERICAN FAMILY INCLUDES THE PROFESSIONAL WOMAN

In the same issue that featured "The Nisei," *Life* editors tell readers that *Life* is a family magazine that includes women as educated professionals. In a double-page spread, *Life* editors present an eye-level portrait of a smiling family of four. From right to left: professionally dressed father with a fedora hat links his arm with his professionally dressed wife. The woman wears a stylish hat with a feather. She is dressed in a suit. An overcoat drapes over her right arm as she clutches her purse. Presumably, daughter and son are holding hands. Each member of the family pictured looks straight at the reader.

Opposite the page of the family portrait in large block letters is the number 20,000,000. The text says, "We, the American people—more than 20 million of us—read *Life* each week." The words "of us" that follow the words 20 million speaks to *Life*'s audience. *Life* editors directly speak to their audience warmly like intimate friends.

While this page is an advertisement about the latest report conducted by *Life* on its readership, the underlying message is that *Life* editors consider its reader's upper and middle-class professional white families. To reinforce the meaning of middle-class family, across the bottom of the left page are representations of family members reading *Life* magazine. From left to right the first photo is a professionally dressed man relaxing on a reclining chair reading an open copy of *Life*. To the right a woman sits outside on a lounge chair. The reader can see the front cover of *Life*. She could be seated either in the front or back yard of her home. Inside to the left of the centerfold is a photo of two teen girls in a bedroom lying on their stomachs. They smile as they flip through pages of *Life*.

Photos along the bottom on the right page represent members of middle-class families sharing and passing along *Life* magazine. At the right centerfold is a photo of two boys. They are seated at a desk reading *Life* together. The next photo to the right shows two women standing by an open car door. One is professionally dressed in a stylish hat entering the passenger side of a car. The reader can see her holding in her left arm a copy of *Life*. The professionally dressed woman is speaking and smiling to the other woman. One of them is passing along *Life* magazine to the other. The implication is that modern professional women read *Life*. The final photo in the bottom right corner shows a professionally dressed man seated in front of a professionally dressed woman. They might be on a train. The man is turned toward the women in which the woman appeared to have passed on her copy of *Life* magazine to the man.

The photos along the bottom represent those who read *Life*. Therefore, directed toward advertisers, *Life* editors state in the text: "[The study] . . . It provides both advertisers and his dealers many valuable new facts about these people . . . shows why they are America's best customers . . . where and how they live . . . just how many of them are men . . . how many are women . . . etc."

Since *Life* editors openly advertised that the magazine targets the white professional middle class, the narrative that Japanese Americans belong to the American educated middle class is consistent with *Life*'s target audience. *Life* editors represent the Japanese American community by showing that the habits and traditions that include modern professional women in the Japanese American community are not different from *Life*'s white middle-class women readers. Thus, Japanese Americans are more American than Japanese.

Chapter 3

LETTER TO THE EDITORS

The following letters to the editor show that we can't be sure of the perceptions of *Life* readers on the photo-essay about "the Nisei." However, given that two of the three published letters were from Japanese Americans, the feature resonated with Japanese Americans. The social circulation of these letters to the editor shows that the "Nisei" were also readers of *Life*.

Mr. Tsurutani states in his letter to the editor on November 4 proudly that he is a Nisei. He shows his pride when he signed name with his educational pedigree—UCLA. 1936. Tsurutani is an educated college graduate and most likely a member of the middle class who *Life* caters to as readers. His letter says:

> Sirs:
> Thank you and my congratulations to LIFE for its kind and unbiased recognition of the basic problems that the Nisei (American-born Japanese) are confronted with here in America.
> A Nisei myself. I could cite many poignant instances that we all experience because of our Oriental mien, which, differing from that of Occidentals, cannot be eradicated in one generation.
> It's entirely up to us to prove to those inclined to denounce us, in nefarious terms as traitors, Japs, spies, etc. that we are good citizens and deserving of our nationality: Americans. We are justly proud being Americans and I feel very confident that we will never disappoint those who have their faith vested in us!
>
> —James S. Tsurutani, UCLA. '36 Santa Monica, Calif.[7]

The following letter from F. Tanaka on November 11 is critical of *Life*'s reporting on a young girl photographed during the Nisei week. The letter said:

> Sirs:
> We enclose a photograph of the Nisei dancer whose picture you published in the Oct. 14 issue. The caption said she was setting "sinuous Oriental evolutions to Western airs." You're wrong. The young lady's performance was strictly American: an original Indian drum dance which she created herself. She is Amy Kojima, 19 graduate of Theodore Roosevelt High School in Los Angeles. Dancing is a hobby with her, and she generously contributed her talent to the Seventh Annual Nisei Festival, which is a growing tourist attraction in Southern California.[8]

Tanaka makes a critical correction: the girl's dance was not an "Oriental evolution of Western airs" but in fact an attempt at a Native American dance

the young girl invented. Tanaka insinuates that *Life* editors assumed the dance was Oriental.

The final letter I'll quote, dated November 4 in a letter to the editor from Charlotte Earnst of Seattle, reads in its entirety (aside from the greeting and signature), "Suki-yaki to you for bringing up the timely question of the Nisei." Seattle had a large Japanese Americans population in 1940. This woman seemed to know something about Japanese food. Sukiyaki is a Japanese dish of sliced thin beef cooked over a grill mixed with vegetables. What is unclear is why Charlotte Earnst used sukiyaki as a means of expressing "good job" to *Life* editors. Was it because it was a Japanese word or is it because sukiyaki represents a foodstuff that came from one culture to be enjoyed by another? We cannot know for sure, but only that she was pleased with the photo-essay.

NOTES

1. Max Everest-Phillips, "The Pre-War Fear of Japanese Espionage: Its Impact and Legacy." *Journal of Contemporary History* 42, no. 2 (2007): 245.

2. Everest-Phillips, "The Pre-War Fear of Japanese Espionage," 257.

3. Everest-Phillips, "The Pre-War Fear of Japanese Espionage," 261.

4. Shirley Jennifer Lim, *A Feeling of Belonging Asian American Women's Public Culture, 1930–1960. American History and Culture* (New York: NYU Press, 2005), 49.

5. Lim, *A Feeling of Belonging Asian American*, 49.

6. Chris Vials, "The Popular Front in the American Century: *Life* magazine, Margaret Bourke-White, and Consumer Realism, 1936–1941," *American Periodicals: A Journal of History & Criticism* 16, no. 1 (2006): 152.

7. LIFE. Letters to the Editor, *Life*, November 4, 1940, 7.

8. LIFE. Letters to the Editor, *Life*, November 11, 1940, 8.

Part II

WORLD WAR II AND JAPANESE AMERICAN INTERNMENT, 1942–1944

Chapter 4

Making Choices

"Coast Japs Are Interned at Mountain Camp"

Rhetoric is about making choices. In terms of creating a photo-essay, *Life* editors had to make choices in what photos to use, what to say, and how to frame the narrative. In 1942, *Life* photographer Hansel Mieth photographed evacuation pictures of Japanese Americans while she was in San Francisco. Upon showing *Life* managing editor Edward K. Thompson the photos, he called them "tearjerkers"; however, he also told Mieth not to "take everything [Japanese Americans] tell you as the gospel truth."[1] *Life* editors never published Mieth's sympathetic photos. Instead, they published a photo-essay using a combination of photos taken by *Life* photographer Eliot Elisofon and *Los Angeles Times* photographer Alfred Humphreys. The photos *Life* editors chose to use for the photo-essay did not include women or families. The choice was an act of rhetoric—privileging one set of photos over another to persuade the audience to view the narrative in a certain way.

The photo-essay titled "Coast Japs Are Interned at Mountain Camp" doesn't hint at the motives behind Executive Order 9066, issued by President Franklin D. Roosevelt on February 19, 1942, requiring "the evacuation of all persons deemed a threat to national security from the West Coast to relocation centers further inland." Nor do the photos include women and families that might engender familial empathy. Without women in the photos, the narrative does not show what Executive Order 9066 did to "relocated" Japanese American families. Without women and families in these pictures, readers might remain distant from the Japanese American plight. *Life*'s photo-essay does not invite or require their readers to think of Japanese American families being displaced in the aftermath of Pearl Harbor because the Japanese Americans in the photos look like the enemy. Without showing women—their wives, mothers, and daughters—*Life* editors separate Japanese

Americans from other Americans, so that it appears in these photos that Japanese Americans don't follow American family values.

Life editors crafted captions and titles that told their readers what to think and how to feel about Japanese Americans. By rejecting Mieth's sympathetic photos and choosing emotionally distant photos by Elisofon and Humphreys, *Life* editors created emotional detachment from Japanese Americans that justified Japanese American internment.

EVACUATION AND MANZANAR CAMP

In contrast, the photo-essay "Coast Japs Are Interned at Mountain Camp" in the April 6, 1942, issue does include women and depicts the evacuation of Japanese Americans to Manzanar camp. The introductory photo covers half of the right page and shows the "LIFE" logo embedded in the photo in white block letters centered in clouds above snow-capped mountains. In the landscape are small figures of men and women carrying bundles and luggage walking alongside military-style barracks. This image introduces the story that follows and provides the setting for this photo-essay.

The LIFE logo inserted into the photo illustrates that *Life* editors also wanted to make a statement about the vast mountainous geographical landscape. It's as if to say, "This is LIFE—in breathtaking geography." Visual design and rhetoric scholars Gunther Kress and Theo van Leeuwen say writing is also visual.[2] Placing the logo "LIFE" in conjunction with a photo image also affects meaning and how a reader experiences the message. The breathtaking geography speaks to "mountain camp" in the title. There are actually two conflicting images at play here. First, the Japanese Americans interned in a relocation camp elicit the image of a prison. And second, a mountain camp in a scenic location elicits an image of recreation and relaxation. These two competing images show how *Life* editors are positioning themselves as they begin the narrative that justifies Japanese American internment. Their emphasis is on the beauty and recreation or relaxation—not on imprisonment.

In the opening photo, the caption reads: "Morning wind sends dust swirling down Owens Valley as First Jap Internees Carry their Luggage to Dormitories Where They Will Live Till End of War."

Kress and Van Leeuwen refer to objects in an image, whether inanimate or human as "participants." When participants are doing an action, such as humans communicating through movement, they are referred to as interactive participants. If the participant is inanimate, such as a rock, it is referred to as "represented." The distinction is relevant when looking for the narrative in this opening photo. The photo is taken from a distance in that the people walking appear small in relationship to the landscape and the buildings.

However, although their faces are indistinguishable, the people walk wearing coats, carrying luggage. Thus, they are interactive participants. Military-style barracks in a tidy row are positioned to represent inanimate objects. The narrative action consists of the movement of people walking toward the military-style barracks. Therefore, the reader can see the narrative—a specific group of people (Japanese Americans) are relocating (moving) to an inland remote mountain camp. The photo implies that they are willing participants in their incarceration—that they understand why this is happening to them and willingly submit.

Life editors' own racism by the racial epithet "Japs" in the title, referencing Japanese Americans as enemies. *Life*'s middle-class readers can barely see the faces of the men and women, which makes them seem distant. As such, *Life* readers across the United States do not have to relate to Japanese Americans and their forced move to Manzanar.

GRANDEUR SCENERY

By highlighting the mountain scene, the theme of the photo-essay represents change from the coast.[3] The change consists of Japanese Americans moving from one geographic location (sea) to the another (mountains), but also a change in how Japanese Americans were viewed by their own government—as alien enemies. The journey from the West Coast was 240 miles through the Mojave Desert to Manzanar camp in the Owens Valley, California.

Life editors are explicit in several places to remind readers of the lovely place called Manzanar, calling it "a scenic spot of lonely loveliness" in the title and "a Wartime Home High in the Spectacular Sierras" and "the snowy Sierras" in captions. *Life* editors also report that "the Japs gasped when they saw Mt. Whitney, highest peak in the U.S." In this way, *Life* editors use the idea of a "mountain camp" as a signal to frame what will follow in the exposé. When Mt. Whitney is revealed to be the "mountain camp," the emphasis shifts from Japanese American internment to the implication that the geographic setting is a place for recreation or leisure. *Life* editors use this rhetorical strategy to persuade readers that Japanese American internment is justified given the lovely place they will live during the war. The statement acts as an "affect" to sway emotion in the reader by informing that these potential enemies will be living in a lovely setting. By "affect" I mean to influence the narrative through emotion so that readers believe that the setting justifies internment—the lovely setting brings relief to moral and mental deterioration of being held as a prisoner.

While *Life* editors reveal that most internees are U.S. citizens of Japanese descent, they help to justify President Roosevelt's order to incarcerate an

entire minority population by depicting the accommodations as comfortable and in a location with spectacular scenery.

JAPS

A primary means for *Life* editors to maintain their rhetorical distance from Japanese Americans is through the constant and continuous use of "Jap" to refer to Japanese Americans. The use of "Jap" is in stark contrast to the 1940 photo-essay about "the Nisei," which did not use the term "Jap" (see chapter 3). But it appears that after Pearl Harbor, the good Japanese Americans suddenly turned into "Japs"—inhuman. To further emphasize that Japanese Americans were inhuman, *Life* editors, deployed terms such as traveler, pilgrim, Nisei, and actual names of Japanese Americans, but followed by the word "Jap." For example, one caption read: "rest stop permits pilgrims to rest. . . . Some Japs strolled into the sagebrush." The photo depicted two well-dressed men standing beside their stopped cars. The reference to "pilgrims" implies travelers with religious connotations. However, in the next sentence the same men are referred to as "Japs." The use of the term "pilgrim" was juxtaposed with the use of "Jap" thereby, framing "Jap" to call attention to the men "strolling in the sagebrush" to relieve themselves—the implication that Japanese Americans are inhuman not only because they are Japanese but also because they would relieve themselves like animals in an outside setting.

The use of the term "Jap" illustrates the refusal of *Life* editors to recognize Japanese Americans as loyal Americans. In this photo-essay, the epithet "Jap" is used in two titles and ten times throughout the photo-essay to refer to Japanese Americans collectively and individually. While *Life* editors did mention that the majority of internees were U.S. citizens, *Life* editors did their best to twist the narrative in that internment of U.S. citizens was justified because they were ethnically Japs.

VOLUNTEERS

This photo-essay is really a story of Japanese American internees who volunteered to arrive at Manzanar early in order to construct and prepare the camp for the later arrival of their families and community. Technically they volunteered, but really there were no options considering Executive Order 9066, loss of livelihoods and property, and a nation calling for their demise.

The key word is "volunteer," implying that Japanese Americans were going to Manzanar on their own free-will. *Life* editors also stress that "four-fifths [of the volunteers] were U.S. citizens." In addition, *Life* editors implied that the

internees understood relocation but also showed loyalty to the United States by accepting relocation. *Life* editors quote a Japanese American internee who "emphasized that he and his comrades come to Manzanar, 'without bitterness or rancour—wanting to show our loyalty in deeds, not words.'"

Life editors say that Manzanar "is no country club" and will detain up to "10,000 potential enemies of the U.S." *Life* editors restate their own stance by referring to Japanese Americans as enemies. Furthermore, *Life* editors insinuate profitability in that Japanese Americans "would wait out the war in willing and not unprofitable internment." Unprofitable internment is purposely an ambiguous phrase suggesting that Japanese Americans will do well economically while being imprisoned. The implication is that taxpayers will pay for housing and infrastructure for the camp; therefore, there is no reason to feel sorry for Japanese Americans. The mental gymnastics to justify Japanese American internment from an economic standpoint is a stretch, particularly since Japanese Americans had lost their property, banks refused to cash their checks, insurance policies were canceled, and business owners were forced to close their businesses—which explains why many Japanese Americans did not resist internment and "volunteered" to arrive early.[4] They had no choice. Their lives and their livelihoods had been destroyed.

WORDS MEAN WHAT THEY SAY

Life editors refer to Japanese Americans in a number of derogatory ways such as Japs, internees, enemy alien, travelers, pilgrims, or Nisei. Words such as "traveler" and "pilgrims" depict people passing through, "internees" and "enemy alien" are people not like us Americans, "Nisei" is a foreign word, and Japanese American is not a true American. All words used imply foreign people—not American. Besides referring to Japanese American in a pejorative manner, this photo-essay reflects poor word choice consistency. One reason could be that *Life* employed writers who were given a task to write the caption or a story for a layout. There may have been a different writer for different parts of the layout all in the same feature.[5] However, editors are ultimately responsible for content and maintaining consistency in referencing and in the narrative. The inconsistencies in referencing Japanese Americans suggest that all the terms used to refer to Japanese Americans were on purpose to place emphasis on the fact that ethnic Japanese were not American thereby justifying internment.

The hate and fear for Japanese Americans was clearly race-based for a group too small to matter because even as U.S. citizens, their voting power had no voice. *Life* editors made an offhand comment in the exposé about Germans and Italians. "German and Italian aliens . . . could be

included in forced relocation." The statement, however, was inconsistent and out of place since the narrative focus was on Japanese American internment. *Life* editors included this comment of Germans and Italians to show that Japanese Americans were not singled out for incarceration. However, German or Italian internees were never mentioned or shown in the rest of the photo-essay nor did *Life* editors develop the claim to report if in fact German or Italian Americans were incarcerated along with Japanese Americans at Manzanar. The internment of Japanese Americans was based on race since to intern German or Italian Americans was met with apathy.[6]

In a statement filled with drama, *Life* editors said, "until every enemy alien and every individual of Japanese descent—whether friend or foe—is banished from the strategic areas of the coastal states." First, the noun "alien" implicates differences between Japanese non-U.S. citizens and Japanese who are U.S. citizens. In the previous chapter, *Life* editors described second-generation Americans by birth as Nisei. First-generation Japanese, who immigrated to the United States, are Issei. Issei were not eligible for U.S. citizenship under the Immigration Act of 1924 (all immigrant Asians were ineligible). The nuanced reference to banish the "alien" distinguishes U.S. citizens by birth from non-U.S. citizen immigrants. In context, "banish . . . those alien people from strategic coastal areas" imply that *Life* editors were in agreement with the government to intern Japanese Americans. The war made it necessary to "banish" all Japanese Americans from the coast. The powerful verb "banish" emphasizes the opinion of *Life* editors. According to *Merriam-Webster*, "banish" means to drive out or to get rid of. Used in this context, the word "banish" implicates persons of Japanese descent. "Banish" was a dramatic way for *Life* editors to say that internment was necessary. The decision to use the word "banish" is a signal that *Life* editors stood behind the government calling for Japanese American internment.

After *Life* editors take the dramatic stance to banish Japanese Americans, they then paint Japanese Americans as compliant during evacuation in stating that the "Japs commented on courteous treatment [by Army]." Editors then immediately quote the commanding general of the Army stating "they [army] would carry out the mission of relocation by force if necessary." By quoting both Japanese internees and the Army commanding general, *Life* editors introduce the importance of the Army. To most Americans, during war the Army represents authority and security. The inclusion of the statement from the Army's commanding officer is evidence that *Life* editors were in support of the government's decision to incarcerate Japanese Americans. Inserting the Army into the narrative shows the Army as working responsibly in doing their job to keep (real) Americans secure.

WITHOUT WOMEN: THE JOURNEY IN CONTRAST

"Okies" were made visible in John Steinbeck's 1939 novel *The Grapes of Wrath* and the iconic photographs of Dorothea Lange, such as *Migrant Mother* (1936). The term "Okie" was a commonplace classist slur for poor people from Oklahoma, especially sharecroppers driven off their land in the 1930s' Great Depression and the Dust Bowl. *Life* editors distinguish between Okies and Japanese American by stating, "Here was no 'Okie' hegira.... The cars in line transcended jalopies." Through the five photos and captions in the double layout, *Life* editors explicitly state that Japanese Americans have middle-class status and are under the care of the U.S. Army.

However, noticeable is the absence of women and family in the journey. In *The Grapes of Wrath*, the Joad family is continually bullied and exploited, but the wisdom of Ma Joad keeps the family together. As Steinbeck characterized her, "[If] she ever deeply wavered the family would fall." Women like the character Ma Joad are the saviors of family. Kozol says that "during World War II *Life* depicted middle-class families to promote patriotic sentiments."[7] In this section of depicting the journey to Manzanar, there are no photos of families traveling through the Mojave Desert.

In the photos, *Life* editors presented Japanese Americans with middle-class status—the norm in American society.[8] In comparison to the Okies, Japanese Americans were judged middle class by their possessions. By using a popular novel, to contrast the social class of Japanese Americans, *Life* editors bring a message—middle-class American citizens of Japanese ancestry are deemed alien enemies. Thus, *Life* editors presumed that readers could see that Japanese Americans were better off than the Okies, therefore, internment won't be that painful.

MIDDLE-CLASS POSSESSIONS

Six photos with captions detail the story comparing the Japanese American journey to Okie migration to California. The short article under the title "Jeeps Lead Japs on Journey from the Sea" fortify the photos that show the journey and middle-class possessions. In comparison to Okies, *Life* editors imply Japanese Americans had better cars as "140 cars piled high with treasured encumbrances," "Okies however, built a trailer out of junk and loaded it with their possessions."[9]

The largest photo in this double-page layout covers half the right page and crosses the centerfold onto the left page. It shows a sweeping view of the Mojave Desert. The photo's subject is a convoy of trucks and cars traveling on top a straight highway alongside unchanging flat sagebrush-covered

terrain. Railroad tracks lined with wooden telephone poles parallel the long straight dusty highway. The initial lines of the caption explain the landscape: "Across the Mojave Desert the four-mile long convoy cuts northward, following the arrow-straight flight of the Sierra Highway to the cool snow-topped mountains."

The caption and the photo support the title of this photo-essay, "Jeeps Lead Japs on Journey from the Sea." The title, like the caption, uses military terminology such as "Jeeps," "convoy," "marshal," and "command" to describe the military escort. Using military terminology signals that Japanese Americans are escorted—like prisoners.

Two photos on the bottom left page continue to contrast the Japanese Americans with Okies. The left bottom photo shows the back of a car with a rocking chair secured over luggage. The other photo shows the backs of two men working under the hood of a car. The caption with the rocker tells readers that the rocking chair is a luxury because "Impedimenta is limited by Army orders to what each internee could carry with him. Required of all were cooking utensils, clothing, tools of trade, bedding." The caption continues, "The rocking chair is pure luxury." The implication is that the symbol of a rocking chair indicates middle-class stability. More important, the underlying message is that the rocking chair implies a woman in the family. In addition, by specifically naming required necessities, *Life* editors suggest domesticity and women. The second photo's caption says "carburetor trouble . . . the diagnostic skill of two young Japs." This photo depicts resourcefulness in fixing a car. However, by showing the backs of the men, the photo creates distance from the reader. More important, the caption contrasts the situation among the Okies who could barely afford gas. For Japanese Americans, "Every car is equipped with spare tire and sufficient gasoline . . . for the 240-mile trip." Japanese Americans unlike the Okies are of middle-class status because they could afford gas prior to their trip. However, referencing Japanese Americans as Japs remind readers of foreignness and the enemy.

In the right page along the bottom are two final photos to complete the story of travel through the Mojave Desert. First, a photo of a line of cars. Two men, one with a large black overcoat and the other in a sweater and collared shirt. Both men wearing stylish fedora hats. They are described as resting pilgrims. Pilgrims according to *Merriam-Webster Dictionary* means "one who journeys in foreign lands." Applying the meaning of "pilgrims" would suggest that *Life* editors considered Japanese Americans as people traveling in a foreign land (California). Thereby emphasizing Japanese as aliens. Notable are men in stylish clothing which might indicate respectable middle-class men. However, in the following sentence, *Life* editors refer to the men as Japs. The sentence states, "Some Japs strolled into sagebrush." The reference to Japs in this caption is consistent with the reference to pilgrims in that

Japanese Americans are aliens "strolling into the sagebrush." Into the sagebrush implies human need but inhuman at the same time to relieve oneself like an animal.

The final photo in the bottom right corner shows a single MP (military police) standing guard near a line of parked cars. Snow-capped mountains in the background hint at the chill. The caption is titled: "Journey's end is Manzanar. . . . Arriving Japs were enchanted by the scenic surroundings." The lone MP shown adds a somber tone to this essay. The MP is not guarding the parked cars; the MP stands guarding the Japanese Americans who might try to escape the camp. This final caption states, "Internees are forbidden to step outside the camp."

In *The Grapes of Wrath*, Okies were poor migrants moving to California seeking employment. The implication in this double-page layout was to contrast the travels of the Okies with that of Japanese American travelers. Unlike Okies, "[Japanese Americans] traveled leisurely and without incident." The word "leisurely" connotes relaxation and "without incident" means that the military did not need to use force during the journey. The comparison emphasizes that Japanese Americans were not in an epic fight for survival like the Okies. However, as *Life* editors imply, this as a leisurely trip is also a stretch in justifying internment.

MODERN AMENITIES AND KEEPING THE READER DISTANT

Manzanar camp is framed with middle-class amenities in housing with modern infrastructure such as running water, sewers, and a hospital. The resolution to this photo-essay is that Japanese Americans may be loyal to the United States by volunteering to go to camp. The Japanese Americans should put readers at ease because Japanese Americans will be confined, but also live in comfort. However, in the double-page layout no photos depict family or create empathy for Japanese Americans. The captions remain distant in referring to Japanese Americans as "Jap" or terms that imply that Japanese are not real Americans.

The final double-page layout to this photo-essay show Japanese Americans registering and doing the work necessary to make the camp comfortable for those that will follow. Across the top of the left page reads the title, "Internees Get Settled in Their Wartime Home High in the Spectacular Sierras." While the title appears dwarfed by the photos, it gives the reader an indication that the subject of the story is about preparing the camp for the long-term stay. The text in the captions insert details of housing, infrastructure, and governing procedures in creating a camp community. Of the eight photos, there

are six in two columns on the left page and two on the right page. Captions provide information as to how internees will govern and organize their communities. In particular, *Life* editors call attention to one woman shown working at the camp. *Life* editors refer to her as American-born Japanese. By using American before Japanese, *Life* editors emphasize that the woman is an American citizen. The implication here is to remind the reader that the people being interned at Manzanar are American citizens. The adjoining photo to the right inside the centerfold is of men filling mattress covers with straw. *Life* editors inform readers that the internees sleep on Army cots. It states, "Japs slept comfortably if not luxuriously." The caption suggests that Japanese Americans are comfortable. Thus, the U.S. government is taking care of basic needs. As such, the statement that Japs are not sleeping in luxury assures the American public that tax dollars are not spent liberally on potential enemies.

A final photo on this page shows young "Nisei girls." The reference to the "Nisei" shows that *Life* editors recognize the status of second-generation Americans. The Nisei are those of Japanese descent who were born in America. Yet using the term "Nisei" depicts them as foreign. The caption also calls attention to a picture of General McArthur on the wall and a graduation picture on the dressing table. The photo of General McArthur reminds the reader that the girls are U.S. educated. The implication is that the young women have an understanding of the current war and their place in it. The context of the camp as prison is not mentioned. Nevertheless, *Life* editors represent a conflicting narrative of what to think of Executive Order 9066 and its treatment of U.S. citizens.

Enforcement of Executive Order 9066 that sent 120,000 Japanese Americans to internment camps was delegated to the U.S. Army. In the environment of war, Luce had a tendency to think of Time Inc. and its magazine, *Life*, as the unofficial arm of the government.[10] Ten days after Pearl Harbor, Luce wrote President Roosevelt: "strict compliance with whatever rules may be laid down for us by the necessities of war—we can think of no greater happiness than to serve . . . our government and to its armed forces."[11]

Luce's statement to President Roosevelt shows the journalistic loyalty *Life* editors held in support for the war. In order to demonstrate patriotism to the American middle-class reader, photos of Japanese American internment had to be framed as justified even though internment meant the incarceration of U.S. citizens without due process of law—a citizen's right under the fifth and fourteenth amendments of the U.S. Constitution.

The next photo-essay about Tule Lake Relocation Camp in California was published in 1944. The photo-essay brings a human perspective from the view of Japanese American women. Unusual was that *Life* photographer Carl Mydans spent a week at Tule Lake and was involved with the layout, captions, and the narrative. *Life* editors also gave him a byline. While the

photos showed a more human view of Japanese Americans through women, *Life* editors often countered Mydans' view with text stating the necessity for internment.

NOTES

1. Dolores Flamiano, *Women, Workers, and Race in LIFE Magazine: Hansel Mieth's Reform Photojournalism, 1934–1955* (London: Routledge, 2016), 215.

2. Gunther R. Kress and Theo van Leeuwen, *Reading Images: The Grammar of Visual Design*, 2nd ed. (London: Routledge, 2006), 17.

3. Kress and Van Leeuwen, *Reading Images*, 59.

4. Flamiano, *Women, Workers, and Race*, 215.

5. Darwin Marable, "Carl Mydans: An Interview," *History of Photography* 26, no. 1 (March 1, 2002), 49.

6. Flamiano, *Women, Workers, and Race*, 215.

7. Wendy Kozol, *Life's America: Family and Nation in Postwar Photojournalism* (Philadelphia: Temple University Press, 1994), 12.

8. Kozol, *Life's America*, 14.

9. John Steinbeck, *The Grapes of Wrath* (New York: Viking, 1939).

10. Loudon Wainwright, *The Great American Magazine: An Inside History of LIFE* (New York: Knopf, 1986), 122.

11. Wainwright, *The Great American Magazine*, 122.

Chapter 5

Complementary Narratives about "Tule Lake Segregation Camp"

Life editors considered the photo-essay titled "Tule Lake: At This Segregation Center Are 18,000 Japanese Considered Disloyal to the U.S." published on March 20, 1944, so important that *Life* photographer Carl Mydans was sent to spend a week at Tule Lake and was also given a byline as the photographer to the news story, even though *Life* photographers rarely received a byline. In addition, Mydans also acted as the second narrator to this photo-essay. *Life* editors explain, "Mydans spent sixteen months as a prisoner in a Jap internment camp" in the Philippines. *Life* editors point out the irony that Mydans, a past prisoner at a Japanese camp, was sent to stay for a week at Tule Lake to photograph for this photo-essay. His photos and his narration countered the hard stance for internment.

The photo-essay depicts Japanese Americans at Tule Lake exercising their constitutional rights as U.S. citizens. The missing constitutional right "liberty" is pointed out in the final double-page spread of the photo-essay. More importantly are the women, children, and families depicted through the photos taken by Mydans. Unlike the 1942 photo-essay at Manzanar, this photo-essay shows heart-warming photos of women as mothers, wives, workers, and community leaders. Japanese American women shown as middle-class wives and mothers contrasted beliefs that Japanese women wore only kimonos and were subservient to men. While captions still used racial epithets such as "Jap," Mydans's photos show humanity. The hidden narrative according to *Life* is that women under the U.S. Constitution are granted the same rights as men. In this way, *Life* editors show Asian American women as equal to and living much like white American middle-class women. Japanese American women are depicted in domestic roles as mothers and wives and in working roles.

Therefore, two complementing narratives are at play in this photo-feature that consists of a series of mini photo-essays. First, Tule Lake camp was

established for Japanese Americans who refused to sign a vow of U.S. loyalty, which no other American was required to do. But since most of the Japanese Americans are American citizens by birth, *Life* editors show that Japanese Americans were allowed to exercise all their rights under the Constitution—that is, except the right of liberty. The second narrative is that Japanese Americans are treated humanely as prisoners. This humane narrative is shown through the photos of women who are depicted similarly to white American women living middle-class lives and as equals to men under the U.S. Constitution. Figure 5.1 illustrates the two complementary narratives.

The two complementary narratives at play unfold in the photo-essay page by page. Led by pictures, the narrative is ambiguous because it is in conflict between the emotion of hatred for enemies and emotion of empathy for treating enemies humanely. By conflict, I mean that narrators, *Life* editors and Mydans, predispose the reader with the emotion hate for an enemy that has attacked the United States. Yet, Mydans's photos show readers how humane the United States can be of its enemies.

In the introduction photo, five Japanese American men in a close-up shot look into the camera. The caption says they are "Japs" and "troublemakers" who are disloyal to the United States. Since hate toward Japanese was

Figure 5.1 Two Complementary Narratives. *Source*: Drawn by Karen L. Ching Carter with Powerpoint smart art.

already a public emotion due to the war against Japan, readers who see the five Japanese American men agree with *Life* editors to hate them.

Well accepted in visual communication studies is the notion that news photos have the power to stir emotions that rally the public and even influence national policy.[1] *Life* editors knew what they were writing, and they knew why. *Life* editors framed Japanese Americans negatively in the introduction as troublemakers because it was in the national interest to do so. As a news magazine, *Life* editors were expected to support America's war effort.[2] However, in later photos within this series, images of Japanese American women in daily life present a more empathetic emotional appeal; thus, *Life* editors show that Americans treat enemies humanely. Therefore, the Tule Lake photo-feature shows humanity toward Japanese Americans while at the same time reminding readers that Japanese Americans are the enemy. In this way, there is room for readers to decide how they feel about Japanese Americans and their incarceration—which apparently they did. An internal report of letters to the editor was conducted by Beulah Holland following this issue. Dated April 24, 1944, the report stated that the Tule Lake story received seventeen letters (to the editor) that said they "hate all Japs."[3] This suggests that the *Life* reader could not get past the hysteria of war with Japan, thereby conflating Japanese Americans with Imperial Japan.

However, with each turn of the page, *Life* editors revealed hidden narratives that could draw some empathy, particularly when readers viewed Mydans's intimate close-up photos of Japanese American women in their daily lives. Photos show Japanese American women exercising constitutional rights such as freedom of religion, freedom of expression, and freedom of civic participation, which showed that Asian women are no different than white American middle-class women in these regards. In the concluding photo-essay, Mydans questions the wisdom of the U.S. government in incarcerating Japanese Americans. He says, "We have a problem of U.S. citizens being interned as aliens." *Life* editors, however, are more ambiguous and conflate Japanese Americans with loyalty to Japan by saying: "The 18,000 Japs at Tule Lake are, in a sense, a form of insurance for the safety of some 10,000 Americans still in the hands of the Japanese."

Thus, in this photo-feature story, the two narrators, *Life* editors and Mydans, each make an emotional appeal.

INTRODUCING TROUBLEMAKERS

The story opened introducing five Japanese American men on the right-hand page in a single photo that covered three-fourths of the page.

The opening photo is a medium-distance shot taken at a low oblique angle. As such, the reader clearly sees the faces of each man from the waist up. The low angle makes the men look powerful.[4] But because the oblique angle does not place the view in a frontal position, the men are not viewed face to face with the reader,[5] which neutralizes the emotive value of the photo. In this case, the reader as an outsider would view the five men as strangers or not of the American world. However, what makes this photo extraordinary is that the men are looking at the reader. By looking directly at the camera, the men demand reciprocity from the reader, thereby causing the reader to have some emotive value toward the men.

The caption then begins the narrative. While the image taken from a medium distance generally connotes more intimacy than a long-distance shot, the caption erases any empathy for the Japanese American men. It reads: "These Five Japs Are among 155 Troublemakers Imprisoned in the Stockade within the Tule Lake Segregation Center. Here They Are Answering Roll Call." *Life* editors point out the men call themselves "pressure boys" and refer to them as "fanatically loyal to Japan." The exposé below, which explains why the photo is newsworthy, gives a brief synopsis of an event known as the November riots in which Japanese Americans, at Tule Lake, protested living conditions, and labels these men as ringleaders of the riot. *Life* editors explain that the U.S. Army was called in to quell the riots. A small headshot, in the left bottom, is of Lieutenant Colonel Verne Austin, who headed the response. From a layout perspective, the large photo of the five Japanese American men overpowers the small stamp-sized headshot of Lieutenant Colonel Austin. However, the headshot is a frontal angle close-up shot in which the lieutenant colonel smiles at the camera. Kress and Van Leeuwen would call this close social distance. Close social distance means that the reader relates to the lieutenant colonel as someone who is part of the reader's world.[6]

Tule Lake has the reputation of being the worst of "all civilian detention camps." The second paragraph of the exposé lightens the news to say that "most of the 18,000 men, women and children of Japanese ancestry now at Tule Lake, are quiet, undemonstrative," and that "70% of them are American citizens by birth." The paragraph continues: "All adults are considered disloyal to the U.S. Either they have asked to be repatriated to Japan, or they have refused to take the oath of allegiance to the U.S. or they are suspected of being dangerous to the national security."

The fact that some have asked to be repatriated to Japan or refused take the oath of allegiance to the United States implies treason, but an example of why one man refused to sign than the other seems understandable if not benign. The exposé discusses Yoshitaka Nakai, age twenty-six. Mr. Yoshitaka bought $8,000 in war bonds, but "when he was picked up for relocation his farm crop went bad. Angry, he refused to sign the oath of allegiance."

THE SETTING AND THE BACKGROUND OF TULE LAKE CAMP

Turning to the next page is the first of five double-page photo layouts. This first shows five long-distance shots of views of the Tule Lake camp and the landscape, the Klamath Basin on the border between California and Oregon. The largest photo crosses the centerfold and covers two-thirds of the right page and more than one-fourth of the left page. It is an expansive view of the camp with the mountain and high plains in the background. The caption states that the camp has "1,032 buildings . . . in the background is Horse Mountain." *Life* editors point out the "24-hour MP (military police) lookout towers" in the foreground. To the right of the camp outside the wire fence are Army barracks and offices of the WRA (War Relocation Authority). The last sentence in the caption reads: "Even if the guards were removed the Japanese probably would not try to escape. They are afraid of the Tule Lake farmers."

Why would the interned Japanese Americans be afraid of the Tule Lake farmers? The exposé on the left page gives some clues. The title in capital block letter state, "CAMP IS ON DRAINED LAKE BOTTOM NEAR SOME OF THE WORLD'S RICHEST FARMLAND." *Life* editors provide the photos and the text to inform their readers of the richness of land where internees are housed. According to geography scholar Robert Wilson, the Klamath Basin, an arid basin, was the largest site for a U.S. Bureau of Reclamation irrigation project. The project was to develop irrigated homesteads that would make farming possible for white settlers.[7] *Life* editors explain at the start of their exposé that "most of it [Klamath Basin] is rockless bottom land, reclaimed by draining the lake. Originally it was homesteaded in 60 acre lots by World War I veterans. It is capable of grossing $1000.00 an acre a year and last month sold for $350 an acre."

According to the U.S. Bureau of Labor Statistics, calculated at an average inflation rate of 3.60 percent, $1,000.00 in 1944 has the purchasing power $14,697.61 in 2020. And $350 per acre in 1944 is equivalent to $5,144.00 in 2020. In providing the value of land in dollar amounts, the exposé begins to give clues as to why Japanese American incarcerates might fear the Tule Lake farmers. The farmland was valuable, and the owners did not want Japanese American prisoners near their land. Information on the worth of the land enticed the reader to continue reading:

> The Tule Lake Segregation Center is located on the edge of this rich, California farmland. It's 1000 acres are not good for cultivation, but last year the War Relocation Authority leased 2,600 adjoining fertile acres for the Japanese to farm. What happened was nearly tragic. The land was put to crops of potatoes,

54 *Chapter 5*

onions, carrots, beets lettuce and peas. The Japanese diked the land, dug irrigation ditches and produced a rich crop of virgin soil.

Then at harvest time trouble broke out. . . . A Japanese workman was killed when his truck was wrecked on the way to the farm area. Demonstrations were held. To get more control of camp government, the Japs proclaimed a policy of *status quo.* They would do no work. They would not farm the fields. As a result, to get the crop in before frost came loyal Japanese from relocation centers had to be brought in to do the harvesting. Thousands of dollars worth of vegetables were almost lost.[8]

Only in the last month has *status quo* at last been eliminated. This year, however, to take no chances, only 400 acres will be planted by the Japanese at Tule Lake.

Life editors do not say whether the demonstrations occurred due to the Japanese workman who was killed or if the policy of *status quo* was related to the November riots mentioned in the opening exposé. Instead the Japanese Americans at Tule Lake are framed as rebels, while at the same time *Life* editors state that (presumably better behaved) Japanese Americans from another camp were brought in to complete the harvest.

There is some lack of clarity between the exposé and captions. Captions to two photos—top left, and the other, bottom left—show scenes. The caption for the top photo begins, "Disloyal Japanese arrive from Manzanar." The caption to the bottom photo says, "Old timers line street . . . waiting or look at new arrivals from Manzanar." A photo on the bottom right on the left page shows the names of Japanese and Japanese characters. The caption reads, "Names of Japanese at camp are painted here. Characters at right read 'Aug. 8, 1943.'" The names are written with English alphabet. The date written to the right is in Japanese characters; however, the foreignness of the pronunciation of names and the date written in characters give a sense that the 18,000 Japanese Americans are not of the American world. In this way, *Life* editors distance the readers from Japanese Americans.

WOMEN AND FAMILY

The second double-page layout consists of three photos. On the right page is a frontal close-up photo of a nurse, in a standard 1940s nursing uniform, cradling a new baby. A woman holding an infant is a common trope in Christian art, a depiction of motherly love and tenderness. The photo of the nurse and baby shows humanity in Japanese American women. Off in the background to the right is a partial image of another nurse cradling another new baby. The caption tells the reader: "A new Japanese baby with silky black hair is

held by a Japanese nurse in the obstetrical ward of the Tule Lake Hospital. There are 25 births a month in the camp—a birth rate above that of the U.S. but below Japan." The caption neutralizes any empathy or humanity a reader might feel in viewing the photo because of the depiction of the common trope of the Madonna and child. The additional comment about the birth rate reminds readers that the children born here are new American citizens. This photo serves as a reminder that 70 percent of the internees at Tule Lake were American citizens by birth.

The remainder of the caption mentions the capacity and supplies at the hospital, which is "a rambling wooden barracks building with 250 beds in eight wards. It has all the drugs, supplies and equipment found in any U.S. Army hospital and can handle virtually any kind of operation." The Japanese Americans are provided with modern resources, implying that while the Japanese Americans might be the enemy, Americans are humane in providing modern medical care (figures 5.2 and 5.3).

WOMEN WHO SUPPORT FAMILY AND EDUCATION

On the left page are two photos. Each covers half the page. The top photo is of a family. The caption tells readers that the photo is of the Manji family in their Tule Lake apartment. The caption continues: "They are classified as disloyal." The caption doesn't say why but does tell about the family history and who they are: The father, sixty-two, came to the United States from Yamaguchi, Japan, in 1904 and became a rice farmer in Nelson, California, where he and his family were living when the war started. His wife arrived here in 1918. The children are all U.S. citizens by birth. The text provides the name and age of each child pictured, from nine years to twenty-two years, and mentions two more sons whose pictures are on the bookshelf and who "are in the U.S. Army." Thus, the caption serves as a reminder that U.S. citizens are being interned. More importantly the caption tells the story of an immigrant family not that different from a European immigrant story in which a father immigrates and the children are U.S. citizens by birth. The photo is a frontal oblique angle medium shot of the family around a dining table, talking and laughing, oblivious to the camera. Two small boys read what looks like comic books while an older woman sits off to the right. *Life* editors do not mention the older woman, thus leaving the reader to presume she might be the grandmother. There is no name for the older woman as there were for the children. The photo's frontal slightly oblique angle appears to place the reader in a voyeur position—looking from the outside. In this way, while the caption implies a middle-class family with two sons serving in the U.S. Army, the family depicted in the photo appears distant to the reader. The

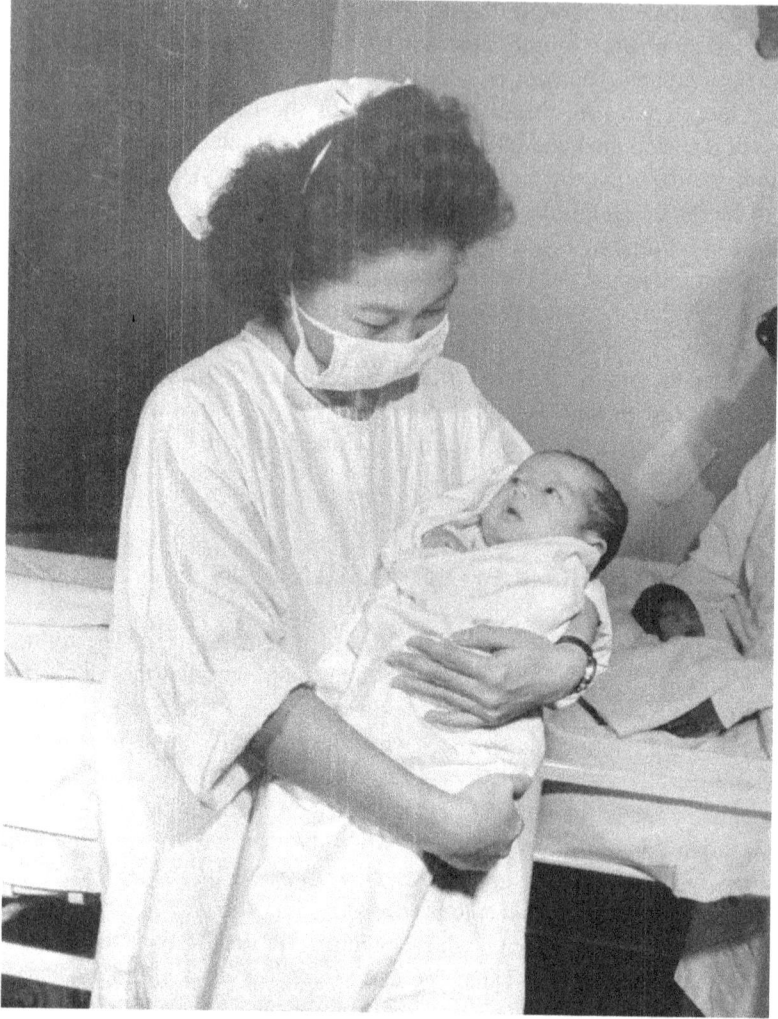

Figure 5.2 New Japanese American Baby Held by Nurse. *Source*: Getty Images, Carl Mydans, *Life* Picture Collection.

reader is viewing the family from the sidelines rather than interacting with the family, thereby preventing the reader to relate to the family circumstances of incarceration at Tule Lake.

The photo below asks for more empathy from a reader. It is of school children seated at tables in a classroom. They sit in chairs turned toward the camera, and many of the children are looking at the camera. Others are looking off to the right presumably at their teacher. The caption says: "School classes, like those in any other U.S. town, are held daily in school barracks

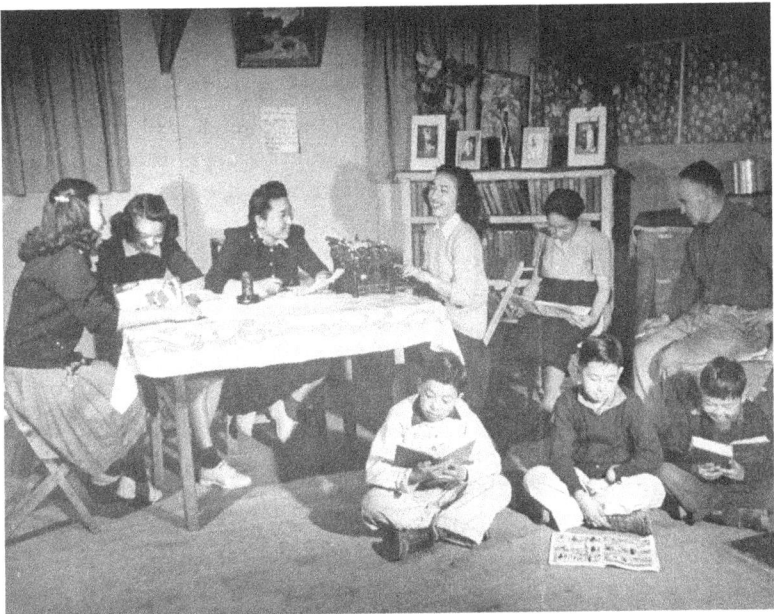

Figure 5.3 Manji Family in Apartment at Tule Lake Japanese Internment Camp.
Source: Getty Images, Carl Mydans, Life Picture Collection.

for the young Japanese. Taught by 46 American teachers and eight Japanese teachers, the lessons are in English. Regular subjects are American history, arithmetic and English grammar."

The caption implies that if the school is like any U.S. school, then the children must also be like children in the United States. Furthermore, the children are also American citizens. The only difference is that there are "Japanese-language schools conducted by Japanese teachers." While the enrollment in the English school is 2,269, the enrollment in Japanese language school is more than double that number, 4,608. The last line says, "The camp has freedom of belief and religion, the Japanese teachers can teach the children what they want."

It was not unusual during the 1940s for second- and third-generation children of Japanese ancestry to have Japanese language classes after school. The same was also true for second- and third-generation Chinese children to have after-school Chinese language lessons. I can say this because in Hawaii, all my father's Japanese American classmates attended Japanese language school, after school, just as my father, a third-generation American, had to attend Chinese language school.[9] In San Francisco, my mother, a second-generation American, attended Chinese language school every day after regular school. The point is that for second- and third-generation Asian Americans,

their first language might be English. Going to Japanese or Chinese language class after school was to help them learn more of the language of their heritage. The last statement in the caption "Japanese teachers teach what they want" may lead the reader to believe that some children learn regular lessons in Japanese. Most likely children took Japanese language lessons after regular school hours because English may be their first language. In misleading readers, *Life* editors thereby distance readers from the children in thinking they only speak in Japanese.

JUSTICE

The third double-page layout shows Japanese Americans at camp in community in leadership positions. By showing that the camp is governed by the internees together with the WRA, *Life* editors show that the camp operates as a democracy. Particularly in light of the November riots. Since the government framed the protest as a riot. *Life* editors crafted the narrative to show that Japanese Americans received justice from their protest for better working and living conditions. The photos and captions show that Japanese Americans are afforded the constitutional right of civic participation. While certain protest participants received due process as prisoners for their part in rioting.

Democratic Principals

The left side of the page has a total of six photos. Three photos inside the centerfold are headshots of three Japanese Americans. The right side of the page are group photos of the committee meeting of Japanese Americans with WRA, roll call for "pressure boys," and a hearing before the WRA committee for young couple asking to leave Tule Lake for another camp. Carl Mydans, who took the photos, refers to each person by name and as Japanese American citizens. Placing headshots of Japanese Americans focus the story from the perspective of Japanese Americans and not WRA government officials. *Life* editors present Japanese Americans as leaders in the democratic process of running a camp (see figure 5.4).

The middle photo is May Iwohara, *Life* editors introduce her as a Compton Jr. College graduate. She managed a flower shop. The implication that she is of middle-class status is through her degree beyond high school and as a manager of a business. *Life* editors want the reader to see in her hands two tea packages sent from Japan. Guiding the reader to view the tea packages neutralizes May's American name. However, another perspective could be that *Life* editors sought to point out a cultural difference.

"Tule Lake Segregation Camp"

Japanese meet with WRA officials on camp problems. Pictured here is Byron Akisuki.

Byron Akitsuki
Executive secretary of coordinating committee. From Los Angeles an engineer.

Right of Civic Participation
Role call "Pressure Boys"
As part of the November riots they were put in a stockade. Return to work program (community service)

May Iwohara
Graduate of Compton Junior College.

Due process (Fifth Amendment)
Hearing of William and Roslyn Mayeda who want to be relocated. Will take the oath to leave Tule Lake.

Yoshitka Nakai, 26

Bought $8000 in War Bonds. When he was pick up for relocation his farm crops went bad. Angry he refused to sign the oath of Allegiance.

Right to fair hearing (Fifth Amendment)

Figure 5.4 Camp Leaders. *Source*: Life magazine, March 28, 1944, p. 30.

The three headshots are also tied to the three photos on the left column of the page. The top left corner photo shows Japanese representatives meeting with WRA officials. Byron Akitsuki introduced as secretary of the coordinating committee is shown in this photo. The caption informs the reader that the Japanese representatives shown are members of the new coordinating committee formed after the November riots. The caption says the group supported a return to work program. In this way, *Life* editors give readers an insight into the governance of the camp with Japanese Americans working with the WRA and participating in democracy. Those that were part of the group that started the riots were put in the stockade. Yet, *Life* editors also point out that the Japanese were not rebellious and want to work with WRA. The implication is that the Japanese at the camp, while considered disloyal to the United States, were working amicably with the U.S. government. The photo below shows the roll call of the "pressure boys" who were put in the stockade following the November riots. The top photo is in contrast to the photo below showing the pressure boys versus the group working with the

establishment. The top and center photo together show justice and order in action.

The lower bottom left photo depicts a young Japanese American couple before a committee. The caption reports that they were repatriated by their parents. Repatriated by their parents means that their parents, "Issei," or first-generation immigrants, are Japanese citizens and therefore their children are considered Japanese citizens. However, the children are American by birth. Repatriation by parents suggests that the couple's parents may have requested Japanese citizenship for their children. Thus, their children were eligible for repatriation to Japan. *Life* editors tell the reader the couple wish to leave the camp. The implication is that the couple is at Tule Lake not because they were disloyal or refused to sign the oath of allegiance, but were at Tule Lake because of their parents' application for them to be Japanese citizens. *Life* editors explain, "When they take the oath of allegiance they will be relocated."

THE WOMEN (AND MEN) AS PRISONERS

The fourth double-page layout consists of nine candid shots of simple actions in everyday life such as haircuts, church services, workplaces, shopping, and playing. However, most revealing in the captions is the attention to basic American values inscribed in the U.S. Constitution. The captions enhance the photos to show freedom of speech, religion, freedom from censorship, equal opportunity, and individualism (figure 5.5).

The Cooperative barbershop 15 cents haircut…	Catholic Mass is said 75% Buddhist, 12% Christians.	A Cooperative beauty salon. Women like to have hair fixed for parties, shows, discussions groups…
Life and dignity of the individual	*Freedom of Religion*	*Freedom of Assembly*
The Cooperative shoe shop… The proprietor has sons in the U.S. Army at Camp Shelby…	Each Mess Hall serves 250-300 persons a meal.	At Cooperative dress and coat shop. "Express individuality"
Loyalty to Country	*Welfare provisions for all*	*Freedom of Expression*
Cooperative periodical store There is no censorship of the reading material	The Kids Play Marbles The language is English, but they also speak Japanese to each other.	Cooperative general store Some collect shells from lake bottom, paint and decorate to resell
Freedom of the Press	*Freedom of Speech*	*Pursuit of Happiness*

Figure 5.5 Everyday Life. *Source: Life* magazine, March 28, 1944, pp. 32–33.

The photos are shot from medium distance in a variety of angles in which *Life* photographer Carl Mydans makes ordinary mundane daily tasks appear interesting. Hidden within the photos and captions is the message that most of the constitutional rights afforded to U.S. citizens are met. Nine photos are organized by the subject's function. When viewing the double-page spread, three vertical photos along the left outside column complement three photos on the right outside columns. The photo on the top left corner shows men at a barber shop. The one on the top right corner shows women under hair dryers at a beauty shop. The middle photo on the left outside shows men working at a shoe shop. The middle photo on the right outside shows women working in a sewing shop. The bottom left corner photo is a bookstore; the bottom right corner a hardware store. Three photos cross the centerfold. They are random photos of a church service (top), mess hall (middle), and boys in a marble game (bottom).

The captions under each photo give the reader an idea of daily life and the economy at Tule Lake. For example, at the barber shop a haircut is 15 cents and a shave is 10 cents. The barber shop grosses $2,750 a month. The shoe repair shop below the barber shop repairs 750 pairs of shoes a week. The hidden narratives in both these photos speak to the right to property. The "takings" clause in the fifth amendment states that property shall not be taken without due compensation. The business is the property. Ironically, Japanese Americans were ordered to camp without compensation for their homes and businesses prior to incarceration. In what seems like an afterthought, *Life* editors state that the shoe proprietor has two sons in the U.S. Army. *Life* editors point out patriotism among Japanese Americans. The caption continues to say the proprietor pays his inmates $12–$19 a month depending on the job. Note the use of the word "inmate." Inmate is synonymous to "prisoner." The term "inmate" is used to emphasize that Tule Lake is for prisoners of Japanese ancestry. However, the reference to "folks" used in the same caption is less harsh than "inmate."

To give readers clues of the camp's educated population and economic self-sufficiency, the bottom left and right corners are of retail stores. The left bottom is a periodical store. The key point made is that there is no censorship and there is freedom of the press. Unlike when at the Japanese prison, Mydans was only allowed one newspaper. *Life* editors want to make the point that Japanese Americans can read and received any written news or communication. The bottom right photo is of a general store. The caption calls it a "Cooperative general store." "It sells groceries, hardware and men's clothes . . . well supplied like any U.S. community of 18,000 people." *Life* editors go on to say that Japanese are enterprising. "They dig up shells from the lake bottom, paint them with nail polish and sell them outside the camp." Snippets of information, such as digging up shells to sell, show not only an

enterprising people but also that Japanese Americans also engage in enterprising activities as other middle-class Americans.

An interesting subject is in the top centerfold. The shot taken is of a church service. From the rear of the congregation, the reader can see the cross at the altar and the back of the priest dressed in liturgical vestments or robe worn for worship. The caption reveals a Catholic mass. The subject of the photo is placed strategically where the reader will not miss it. *Life* editors educate the reader with the caption. While "75% of Japanese at Tule Lake are Buddhist, 12% are Christian, the rest have no church affiliation." Showing a church service versus a Buddhist service was a choice to emphasize that some Japanese Americans are Christian. Thus more relatable to the *Life* middle-class audience. The final sentence says that WRA officials do not interfere with religion. The last statement is meant to emphasize there is freedom of religion at the camp which is right guaranteed by the Constitution.

The right page shows women working at a dress shop and a beauty shop full of women. At the centerfold bottom are six young boys playing a game of marbles. Showing women and children softens the harsh reality of life in an internment camp. The caption under the beauty shop tells the reader that the beauty shop has five hair permanent wave machines and six or seven hair dryers. The photo shows that every drier is being used. The implication is that there is time for leisure since the caption reveals that there are parties, movies, and discussion groups for which women like to look nice. In addition, the women go to shows and discussions. The implication is freedom of speech. The photo below is a dress shop. The caption explains that "women design and make their own clothes." *Life* editors add that "buying new clothes is one of the few ways that these folks have to express their individuality." *Life* editors emphasize the value of individualism in American culture as freedom of speech. The bottom photo in the centerfold shows six boys playing a game of marbles. The caption stresses that the children dress like Americans, not Japanese, and the language they speak is English. This implicitly says these children are Americans by birth. Inserted is a comment by photographer Mydans that the children could make themselves understood in English. The only time they reverted to Japanese was when discussing whether they should allow Mydans to take their picture. The caption most likely mentioned Mydans comment as a subtle message about the photos. Japanese Americans live freely enjoying their constitutional rights at the camp.

LACKING LIBERTY

The Tule Lake feature's concluding statement is visible in the title "They Have Everything Except Liberty." The previous nine pages show Japanese

Americans living freely enjoying their constitutional rights as American citizens. The title however expresses what Japanese Americans don't have—the right to leave the camp or implicitly "due process." This final double-page layout concludes the photo-feature. It includes two photos with more than one half of the left page devoted to a text article. The photo on the bottom left page is of young drum majorettes. The drum majorettes contrast the notion of "liberty." The girls march with batons military-style smiling. On the right page is a full-page photo of two of the girls in kimonos, stage make-up, and doing "an old Japanese folk dance telling a love story." The frontal angle of the camera gives the reader an intimate view of the girls.

In terms of American politics, the meaning takes on an additional layer that came out of the American Revolution—that is, "the independence and freedom of a tyrannical government." However, while "liberty" may be a legacy of the American Revolution, freedom has limits. The U.S. Constitution for many years allowed for racial segregation and injustices such as voting right denied to women, slaves, and Native Americans. Therefore, "liberty," as used in the title, suggests that Japanese American didn't just lack independence and freedom to leave the camp, but they also deserved to be free from oppression from the U.S. government.

The articles states, as it did in other parts of the feature, that 70 percent of Japanese at Tule Lake were American citizens. However, *Life* editors state "they [Japanese Americans] were loyal to Japan, i.e., disloyal to the U.S. They must, of necessity be put in a place where they cannot hurt the U.S." By placing "i.e. [example]" into the sentence, *Life* editors make a subtle point that the U.S. government expects undivided loyalty from its citizens.

Japanese Americans cannot have duel loyalties. However, the point is complicated since "Issei" first-generation Japanese were ineligible for citizenship. Under the Immigration Act of 1924 that banned immigration from Asia, Asians (including Japanese) not born in the United States could not become U.S. citizens. By U.S. law, Japanese not born in the United States would always be aliens. Yet they settle in the United States and have families. Those born in the United States were American citizens, yet they were ordered to camp without due process of law. Japanese Americans by birth were not treated like U.S. citizens. Many Japanese Americans by birth have never known Japan other than "what they read in books." *Life* editors made that point with education: "Japanese American children" have gone to American schools and colleges. Now . . . "they are put in what seems to them a prison." Japanese Americans are shown to value education and take part in activities like middle-class Americans—such as marching as majorettes in a high school or college band.

Most telling of *Life* editors are quotes from Mydans: "Americans interned under the Japanese . . . know that as Americans they are considered enemies

. . . and if they break the rules they will be severely punished." However, "Over here (in America) we have the problem of American citizens being interned as aliens." By quoting Mydans, *Life* editors speak what they think without saying what they think. The enemy is us because we put our own in prison. Mydans makes a final statement: "The internees don't hate us or the WRA the way we hate the Japs."

At the time, stories of internment were full of racial slurs with constant conflation of Japanese Americans with loyalty to Japan.[10] *Life* photographer Hansel Mieth also witnessed bigotry at *Life*. Mieth recalled: "[Picture editor] said his assistant, Peggy Matsui, could not work any longer . . . because she was half Japanese."[11]

NOTES

1. Martin Smith-Rodden and Ivan K Ash, "The Effect of Emotionally Arousing Negative Images on Judgments About News Stories," *Visual Communication Quarterly* 24, no. 1 (January 2, 2017): 15.

2. Claude Cookman, *American Photojournalism: Motivations and Meanings* (Evanston, IL: Northwestern University Press, 2009), 161.

3. LIFE Magazine and the Power of Photography, Princeton University Museum, Princeton, NJ, February 22–September 27, 2020. Photograph of report by Beulah Holland on Exhibit.

4. Kress and Van Leeuwen, *Reading Images*, 140.

5. Kress and Van Leeuwen, *Reading Images*, 134.

6. Kress and Van Leeuwen, *Reading Images*, 136.

7. Robert Wilson, "Landscapes of Promise and Betrayal: Reclamation, Homesteading, and Japanese American Incarceration," *Annals of the Association of American Geographers* 101, no. 2 (March 16, 2011): 429.

8. LIFE. "Tule Lake: At This Segregation Center Are 18,000 Japanese Considered Disloyal to the U.S." *Life*, March 20, 1944, 26.

9. I also had separate Chinese language lessons after school and on Saturdays.

10. Dolores Flamiano, *Women, Workers, and Race in LIFE Magazine: Hansel Mieth's Reform Photojournalism, 1934–1955* (London: Routledge, 2016), 216.

11. Flamiano, *Women, Workers, and Race in LIFE Magazine*, 217.

Part III

IN PREPARATION FOR POSTWAR RACIAL HARMONY, 1945

Chapter 6

Stylish Western Wear in "Marine Pin-Ups and Glamour on Guam"

Shortly after the war, managing editor Dan Longwell commented, in a memo to Luce, referencing reorganization of the magazine, "*Life* will print the shocking and the horrid, but it loves the beautiful." Longwell wanted to revive the energizing spirit of *Life* from its earlier days. Luce agreed and replied in a memo, "We must be more beautiful, have more charm and be more human." Scribbled in the margin was an additional comment, "Also more meaningful."[1] *Life* editors were suffering from uncertainty about the future. News from the war created a flow of continuity and unity of staff in producing a weekly magazine. The war had given *Life* a purpose. The next question: Would readers lose interest in *Life* now that the war has ended?[2]

Photo-essays are scripts that tell readers how to understand social situations, engage in social conventions, and assume social roles. In June 1945, the "Speaking of Pictures" section displayed photos with beauty, charm, and meaning. The title "Marines Find Pin-ups and on Glamour Guam" is a show of photos. *Life* editors informed readers that the photos shown were originally published in *Leatherneck* a U.S. Marine magazine. The double-page layout shows nine full-body portraits of fashionably dressed mixed-race Asian women from Guam. They are engaged in activities that middle-class white American women readers would enjoy. Placing it in the "Speaking of Pictures" section—readers' favorite section—shows that *Life* editors wanted readers to not miss these women. Wainwright said the "Speaking of Pictures" section "often represented lightweight trifling photos."[3] However, mixed-race Asian women displayed as American could hardly have meant to be lightweight reading. First, it's place at the beginning of the magazine, a highly coveted space. *Life* editors placed photos in the "Speaking of Pictures" section that had special interest to the editors. Second, photos of mixed-race

women on Guam, a U.S. territory, suggest *Life* editors had something to say about race in America.

Fashion reflects ideologies of local contexts but also how cultures socialize within dominant cultures.[4] Photos of mixed-race island women wearing modest fashionable Western dresses suggest the women were rooted in American middle-class values. *Life* editors explain that Guam, a U.S. territory, is an important post of the U.S. Navy and has been an important U.S. military post for over forty-five years. As such, the island's inhabitants, such as the women shown, are as American as those on the mainland United States. Through each caption, *Life* editors introduce each woman by name. They explain in the exposé, "though their names are mostly Spanish, these girls have for remote ancestors the handsome, light-skinned, warrior Chamorros who fought the Spaniards until 1695." In addition, *Life* editors use the word "pin-up" in the title to suggest sexualized poses. However, it is obvious to the reader that the women shown are dressed modestly as they pose among tropical greens.

Life editors imply that the women are deemed beautiful because they dress modestly, are self-reliant, resourceful, and proud of their heritage. In the photos, women are dressed in the latest styles of the 1940s. Fashion markers such as Peter pan collars, pearl button blouses, circular skirts, and bobby socks suggest that women on Guam dress respectably like American women on the mainland United States. Fashion helps us signal group conformity.[5] *Life* editors show Guam women in conformity with modern American women's fashion. As such, Guam is inhabited by respectable women.

Life editors directly say in the exposé that "romance could be found in the fabled South Seas." "Fabled South Seas" referred to Hollywood depictions of island life in sexualized terms.[6] *Life* editors however juxtapose the phrase "fabled South Seas" with the phrase "discomfort, disease and death of war." The juxtaposition of the two phrases suggests that *Life* editors wanted to present a counter narrative to sexualized naked women in the fabled South Seas. Through the show of Western fashion, *Life* editors transform the fictional culture of naked South Sea women into mixed-race Asian American women dressed like white middle-class American women. The photos present evidence that *Life* editors wanted readers to see that mixed-race women exist in America and that Guam was part of America.

Life editors assert that mixed-race women on Guam are beautiful, smart, and American. Underlying the meaning behind mixed race is that antimiscegenation was the law in at least forty-one states that criminalized mixed-race marriage. *Life* editors present Guam as part of America and a place in which mixed-race marriages were historically common and prevalent.

The photo-essay opens to a double-page layout showing nine women in individual poses. The following page, however, shows three vertical photos of the U.S. Marines together with mixed-race women, dancing at a party. By

modern twenty-first-century standards, this doesn't appear unusual. However, at the time, the intermingling of races was socially undesirable on the mainland United States. In addition, throughout World War II, all branches of the military were segregated by race. It wasn't until President Harry Truman signed Executive Order 9981 in 1948 that segregation of the military officially ended. While Marine men might hang pin-up posters to remind them of women at home, *Life* editors show that there are equally beautiful women on Guam who are also American.

ANTI-MISCEGENATION

Henry Luce wrote that America "alone among nations of the earth was founded on ideas and ideals which transcend class and caste and racial and occupational differences."[7] Yet, prior to the 1960s, anti-miscegenation statutes that criminalized interracial marriage proliferated in the United States. In 1940, forty-one states prohibited interracial marriage.[8] Asian men like African American men in the United States were viewed as a threat to white racial purity and in some states forbidden to marry white women.[9] In 1948, thirty states still banned intermarriage, and in 1963, twenty-four states retained their bans.[10] It wasn't until the landmark Supreme Court case *Loving v. Virginia*, 1967, when remaining anti-miscegenation laws were declared unconstitutional. Hawaii and Guam however never had anti-miscegenation laws. As islands in the Pacific located along trade routes, these locations saw race mixing from the earliest days of Western sea exploration.

The question is: Why was race mixing verboten on the U.S. mainland? The underlying reason for these laws was to guard against a generation of mixed progeny because a population of mixed-race persons would undermine the power of the white ruling class.[11] Furthermore, the myth of eugenics was a major driver of anti-miscegenation. Eugenics, the science of controlling human breeding, conjured the idea that intermarriage would cause offspring to be physically and intellectually inferior. In truth, anti-miscegenation was widely accepted because of the fear that any mixing of the white race would lower the biological quality of the white race.[12] In addition, defining "inferior quality" was a pseudoscience in which one judge claimed interracial children were "sickly and effeminate and physically inferior to their full-blooded counterparts."[13] While there was less of a fuss over intermarriage between nonwhites, the fear of mixing races enabled and led to the reasons for keeping out Asians in America—ethnic Chinese and Japanese were unassimilable aliens unfit for American citizenship. Asians as nonwhite people were racially and culturally too different from white Americans.[14]

Chapter 6

HIDDEN NARRATIVES AND IMAGINED EXPECTATIONS

The title "Marines Find Pin-Ups and Glamour on Guam" brings to mind American soldiers with pin-up girl posters hanging on the inside walls of military barracks. The pin-up had become mainstream during World War II and had a widespread audience approval.[15] However, the double-page layout of nine island women individually shown is in stark contrast to the image of the typical pin-up girl, who was a white woman with an hour-glass figure, dressed in a negligee or bathing suit. The woman's pose was usually stretched or twisted so the viewer could see attributes such as long legs and large breasts. The top-selling pin-up during the war was that of film star Betty Grable. She was pictured in a modest, white, one-piece bathing suit with heels. Her back facing the camera as she looked into the camera over her shoulder smiling. The image of Betty Grable was iconic in that it portrayed a charming, regular girl next door, but glamorous.

The women shown in this photo-essay are a far cry from the pin-up girl. The women are of mixed-race and of Asian ancestry and wear full Western dress or skirts in which shirt and dress collars cover necks and shoulders. *Life* editors explain the photos and the title: "The U.S. Marines have long felt that somewhere, somehow romance could be found in the fabled South Seas, which in this war have yielded chiefly discomfort, disease and death. At last, in the Marines' magazine, *Leatherneck*, for June, a bouquet of pin-up girls from Guam makes its appearance."

Readers might get the sense the photos of the girls shown have some relationship with the sexualized dream woman. However, *Life* editors continue to explain: "The glamour is of a kind familiar to Americans because in the 45 years since the U.S. took over the island, the Guamanians have taken on many Americanisms of get-up and manner. Before Japs came there were Girl Scout and Boy Scout troops on Guam. Guam runs energetic war bond drives. There are probably 1,000 Guamanians in the U.S. Navy now, mostly as stewards, a job which they fill superlatively well. The island is under the jurisdiction of the U.S. Navy Department and its governor is a naval officer."

Life editors do not trivialize women shown as sex objects. By informing *Life*'s white middle-class audience about Girl and Boy Scout troops purchasing war bonds, *Life* editors imply that the women, and by extension Guam inhabitants, are respectable humans—all-American middle-class patriots. Girl and Boy Scout troops represent activities that many *Life* readers may have experienced. The mission of Girl Scouts, "To build girls of courage, confidence and character who make the world a better place,"[16] shows that Guamanian Americans have the same values as white middle-class Americans. The paragraph reads:

Though their names are mostly Spanish, these girls have for remote ancestors the handsome, light-skinned warrior Chamorros who fought the Spanish until 1695. Their numbers dropped from about 100,000 to a few scattered thousands. Their Micronesian blood was crossed with Filipino Tagalas, with seamen who came on the annual Spanish galleon, with escaping criminals, adventurers and traders of all nations. Under American rule after 1898, the Chamorros multiplied again now number 22,000. The young people all go to school and learn English. The impeccable cleanliness of the young women of Guam has already become celebrated in the Pacific. The first Chamorro lady of the island is Mrs. Aguelde Johnston, whose Marine husband died in a Jap prison camp last year after having risen to the post of island commissioner of public works. Mrs. Johnston is the high school principal.[17]

Words such as "warrior" demand respectability. *Life* editors conflate the term "warrior" with Marines on Guam. U.S. Marines are warriors and demand our respect as they fight for our American freedoms. The women shown are descendants of Chamorro Warriors who also fought for Chamorro freedom from the Spanish. The implication is in the phrase, "derived from the Warrior Chamorro who fought the Spanish three centuries ago." "Warrior Chamorros" suggests hero fighters who don't give up easily just like our Marine soldiers. The next phrase "While the Chamorro people have endured over the centuries, they multiplied prosperously once under U.S. possession" implies that due to American oversight, the women are clean, respectable, and most celebrated in the Pacific. Implicit in the narrative is the normality of mixed races. With the visual description of world traders, *Life* readers can imagine numerous interracial mixes that undoubtably occurred over three centuries. More explicit is the marriage between Mrs. Aguelde Johnston and her Marine husband. This short paragraph explains that the women shown in this photo-essay are counter to pin-up depictions imagined in South Sea Hollywood-style fiction.

THE GIRLS ON GUAM

Photos of women on Guam are not mainstream pin-ups. Instead *Life* editors show them in a modest modern fashion that represents middle-class consumer culture. As one caption stated, "Smart well-kept clothes are worn . . . they make most of their clothing, get U.S. materials." The reference to "get U.S. materials" is on purpose to let the reader know that the fabric, and possibly the pattern, was purchased from the U.S. mainland. The implication suggests that women on Guam enjoy the same fashions as *Life*'s middle-class female readers.

Photos display images of a culture; however, photo-essays frame the narrative of those images. *Life* editors highlighted the mixed-race women on Guam, depicted in trendy Western clothing, and the consumer consumption to indicate middle-class status. Through captions, *Life* editors spoke of mixed-race women who aspired middle-class status in a modern America. As the title "Glamour of Guam" suggests, the focus of this photo-essay is on how the women on Guam have adapted to the glamour standards of white American women. Each woman poses for the camera among a background of luscious green to emphasize their island roots. The close frontal camera angle brings facial details to the forefront. The photos seek to bring about an imaginary relation between the reader and the represented women. Perhaps the reader is intrigued with the women who are identified as mixed race. The double-page spread places close-up photos of three women across the top with the title and exposé located on the left page in the inside column. Along the bottom are vertical rectangular individual full-body photos of six women.

In opening the page, the reader is immediately drawn to "Harriet Chandler." Her American name is immediately relatable to the white American reader as an American name. In the top left corner, left of the exposé, Harriet Chandler is seated in an outside tropical setting. Her Peter pan collared, button-down black-and-white dress has white embroidery that borders a white cloth panel of buttons in the center bodice. She wears a shell-beaded broach necklace and a chain bracelet which speaks fashion, beauty, and elegance. Her smile and head slightly tilted connote playfulness. Her arm rests on her thigh and her eyes look sideways off in the distance from the camera. The caption reads: "Indistinguishable from girl from Toledo is Harriet Chandler of Agana." By simply referencing Toledo, a city in Ohio, the reader is brought into an American environment. The implication is clear that Harriet Chandler is similar to many American women.

Dressed to impress inside the centerfold on the right page is "Miss Elizabeth Perez of Agana Heights, Guam. Gets a lift on Marine Jeep." This seated pose of Elizabeth Perez atop the Jeep's hood displays her for the camera. Slightly inclined back, she looks past the camera. The photo suggests that women on Guam socially interact with American Marines. Miss Perez sitting on the hood of the Jeep implies she is friendly with one or several Marines. Her striped shirt covers the entire upper portion of her body. The neckline is high and not revealing. Her plaid skirt is long and circular and covers her thighs. She wears bobby socks and white oxford shoes, and her pose suggests sexuality, but her clothing does not show sexual prowess nor does it reveal skin.

The photo next to Ms. Perez is of a young girl looking in a hand-held mirror applying lipstick. The caption does not state a name or what she is doing. It simply says, "This girl with a new lipstick has a distinctly Malayan cast of

features." The reference to Malayan brings up a distinct ethnicity. Applying make-up is an act of glamour. Lim says that the ideology of social progress through individualism is intertwined with consumer capitalism. The photo shows that women on Guam particularly have good access to consumer goods.

Along the bottom of the left page are three full-body portraits of Guam beauties. Beginning with the bottom left photo, the caption reads: "Young Girl of Guam poses for a photographer against a tropical background, but scene could be an American city park." The woman is dressed in a solid color shirt in which the collar is snug around her neck. Her skirt is a bright print pattern. She stands against a tree trunk looking sideways past the camera. The phrase "American city park" in the caption implicitly says that the girl is not much different from other young American girls. The girl's name is not known since *Life* editors do not give her name. However, without her name, readers in 1945 cannot make a judgment about her race.

At the bottom center the reader sees a girl posing at a right angle to the camera lens. Her arm is raised with her hand behind her head—as if in a glamour pose. She's wearing a white shirt that also covers her entire upper body including shoulders and neck. Her skirt is knee-length and loose fitting. The caption says, "An Asiatic Appearance, possibly Filipino, is presented by Miss Ignacia Leon Guerrero of Guam's capital and big city Agana." The implication is that in a large capital city, Ignacia Leon Guerrero has access to products and services such as fashionable clothing. Ms. Guerrero's pose also indicates she is aware of how to act as a glamour model possibly through reading American magazines such as *Life* or through Hollywood films.

The photo to the bottom right inside the centerfold is a girl walking while carrying a puppy. She's looking into the camera. The caption introduces her, "A Strain of Polynesian mixed with Filipino appears here in fine wide set eyes of Miss Toni Terlaje of Agana Heights." Interesting, that *Life* editors name Miss Toni Terlaje's race mixture. *Life* editors do not mention a white mixture. The puppy causes a distraction from race. The puppy represents social value and consumer consumption in middle-class status. In terms of social value, the photo of the puppy gives the reader an impression that the girl is nurturing, caring, and responsible. In consumer consumption, pet ownership cost money in acquisition and maintenance because people invest attention and love in caring for a pet.[18] The mixed-race girl holding a puppy gives the reader a favorable impression of the girl as one who holds similar values in the treatment of pets as loving companions.

Class status also reveals social power on Guam. Three additional photos line the bottom right page. Each photo references fashion and consumer consumption as a display of middle-class status. Bottom left is a smiling woman in oxford shoes walking through the gate connected to a picket fence.

Introduced as "'Prettiest on the Island' is the reputation of Miss Barbara Bordallo, daughter of a Guam family prominent in politics." The picket fence may or may not belong to the Bordallo family; however, the symbol of the picket fence is not lost to the reader as it represents an icon of Americana. The picket fence was practical for use to keep children and animals safe since colonial times, but also fencing spread as a symbol of middle-class prosperity in the late nineteenth century through the 1930s.[19] As *Life* magazine's focus was to promote middle-class status, the picket fence is a component of a symbol of the ideal home with a garden enclosed by a picket fence.

The bottom center is a photo of a lovely woman in a collared shirt and a long maxi skirt. Her name is not mentioned in the caption, it reads, "Smart, well-kept clothes are worn by most of Guam's city women." For *Life* editors, this caption and photo is the epitome of asserting authority over how to aspire to middle-class life—resourceful women can dress smartly in well-kept clothing.

In the bottom right corner is Ignacia Guerrero from the previous page. The caption says, "Another glamour pose is assumed by Ignacia Guerrero who studied the technique in American movies shown on Guam." To state that she learned the pose through American movies, *Life* editor's emphasize American influence on Guam. That Guerrero could display a glamour pose shows her ability to adapt to Western modes of pin-up modeling. The implication is that Guerrero's intention was to pose as a pin-up, but she displays modesty. Her flowery dress goes down to her knees. The dress covers her entire upper body including her shoulders and neckline. While her clothes do not add any sensuality to her pose, she smiles innocently. There is not one woman represented in this photo-essay dressed like a sexualized pin-up and only Ignacia Guerrero appears to modestly pose like one.

INTERRACIAL MIXING AT MARINE HEADQUARTERS

Life editors presented the photo-essay about "pin-up" girls on Guam within a complicated story of death, destruction, racial mixing, and American middle-class respectability. Since *Life* republished the photos from *Leatherneck*, a Marine magazine, it reminds us that pin-ups are made by men and for men. However, because the photos did not resemble the traditional "pin-up" girls, I contend that *Life*'s publication of this photo-essay was also a statement about mixed race in America.

The interrelationship between races is pronounced in three concluding photos and captions, where the reader sees Marines mixing with Guam women at a dance. The photo caption in the top photo reveals that the ladies can jitterbug and that there is interconnection between American men and mixed-race

Asian women. The photo shows several servicemen dancing with the Guam women. The bodies appear to move freely through space. The caption says, "Jitterbugging shakes the mess-hall of the Headquarters co . . . the girls are terrific jitterbugging athletes." The caption, implies *Life* editors, focuses on the dance. Jitterbugging is meant to mediate the racial mixing in the photos. "Jitterbug" creates awareness for readers to give the impression that mixed-race women are Americans. Knowing that women can "jitterbug" helps the reader to think of their own experiences imaginatively and possibly identify with the women.

Two more photos complete the essay which show a party atmosphere. The caption for the middle photo stresses that the Guam girls are like white American girls, "alternate wearing their hair up and well down the back." The photo shows servicemen and Guam women seated at tables socializing. The caption starts with the food, "Between dances, coke, oranges and cheese sandwiches are served." *Life* editors portray the dance as a wholesome party. By wholesome I mean American foods. The mention of coke, oranges, and cheese sandwiches sound like typical American fare. *Life* editors suggest that people in Guam eat similar foods as middle-class Americans on the U.S. mainland.

Life editors conclude the photo-essay suggesting that romance can happen in the South Seas. The bottom photo is a close shot of Barbara Bordallo—the woman from the prominent political family—in conversation with an enlisted Marine. The caption says that "Barbara dazzles an enlisted Marine." The implication is one of romance in the South Seas. *Life* editors also note in the caption that fifty Chamorro girls showed up at the dance while there were 250 Marines. The girls were outnumbered, and *Life* editors leave the reader thinking about romance in the South Seas. However, *Life* editors portrayed the women as respectably middle class as understood by its white middle-class reader. Pertinent is that *Life* editors understood their readers. By framing the women holding similar cultural ideals about fashion, accessibility to consumer goods within the context of Guam, a U.S. Territory, *Life* editors prepared their reader to visualize mixed-race women as civilized humans.

Judging by the following "Letter to the Editor," *Life* was successful in representing the women on Guam as respectably middle class. The letter from a writer speaks highly of the women on Guam.

Letter to the Editor
July 9, 1945
I was much interested in your Speaking of Pictures, "Marines Find Pin-ups and Glamour on Guam" (LIFE, June 18) because I was curious to know what the Guamanian girls look like.

Several months ago, my brother, who is in the Navy and was stationed at Guam, asked me to write to Olympia Quintonilla of Sinajana, Guam. Her answer to my letter was a most pleasant surprise because her English and handwriting was excellent. She is 20 years of age and in the second year of high school but wrote that schooling was slowed up while under Japanese rule.

I think it is wonderful that all the young people of Guam go to school and learn English.
Nancy Shaffer
Thomas, W. Va.[20]

By modern twenty-first-century standards, the tone of the letter sounds patronizing. The letter shows that some readers viewed mixed-race women on Guam favorably as humans rather than sex objects.

AND NOW FOR MORNING COFFEE WITH GUAMANIANS

Not to be missed is the vertical half-page advertisement for instant coffee on the left side of the page of dancing Guam girls and U.S. servicemen. The advertisement had a plain folksy form of communication. An illustrated head of a man smiling with a cup of coffee. The text in a speech bubble says: "Now! Even a man can make perfect coffee in just 5 seconds!" In bold block lettering near the bottom of the ad states "No coffee pot . . . no grounds . . . no waste." The ad, read together with the photo-essay, might say something like this: *Take a break with instant coffee. Any man can make coffee. Gather with friends for great conversation or engage in a variety of social interaction such as dancing the jitterbug.*

The advertisement for G. Washington instant coffee was placed in the context of everyday, commonplace experience and plays on the trope of the hapless man who is utterly incompetent about anything domestic, a device that remains common in advertising even into the twenty-first century. The ad might appeal to bachelors or to women who want their husbands to make their own coffee from time to time. The instant coffee ad fit right in with the audience of economically comfortable white middle-class Americans less likely to live on a farm or in a small town.[21] Thus, economically comfortable middle-class Americans are most likely to try the convenience of instant coffee while at the same time leisurely reading about glamour in mixed-race women at a distant South Sea island, Guam, dancing and intermixing with American Marines.

In the next chapter *Life* editors directly confront how outdated beliefs such as interracial marriage halt social progress. By explicitly pointing out Asian

and mixed-race women and family in Hawaii, *Life* editors assert that racial purity is an illusion.

NOTES

1. Loudon Wainwright, *The Great American Magazine: An Inside History of LIFE* (New York: Knopf, 1986), 161.
2. Wainwright, *The Great American Magazine*, 163.
3. Wainwright, *The Great American Magazine*, 25.
4. Leslie Heywood and Justin R. Garcia, "Fashion as Adaptation: The Case of *American Idol*," in *Fashion Talks: Undressing the Power of Style*, ed. Shira Tarrant and Marjorie Jolles (Albany: State University of New York, 2012), 68.
5. Heywood and Garcia, "Fashion as Adaptation," 69.
6. Sean Brawley and Chris Dixon, *Hollywood's South Seas and the Pacific War: Searching for Dorothy Lamour* (London: Palgrave Macmillan, 2012), 145.
7. James L. Baughman, *Henry R. Luce and the Rise of the American News Media* (Boston: Twayne Publishers, 1987), 134.
8. Phyl Newbeck, *Virginia Hasn't Always Been for Lovers: Interracial Marriage Bans and the Case of Richard and Mildred Loving* (Carbondale: Southern Illinois University Press, 2008).
9. Newbeck, *Virginia Hasn't Always Been for Lovers*, 43.
10. Newbeck, *Virginia Hasn't Always Been for Lovers*, 38.
11. Newbeck, *Virginia Hasn't Always Been for Lovers*, 28.
12. Hrishi Karthikeyan and Gabriel J. Chin, "Preserving Racial Identity: Population Patterns and the Application of Anti-Miscegenation Statutes to Asian Americans, 1910–1950," *Asian Law Journal* 9, no 1 (2002): 1–21.
13. Newbeck, *Virginia Hasn't Always Been for Lovers*, 28.
14. Ellen D. Wu, *The Color of Success: Asian Americans and the Origins of the Model Minority* (Princeton, NJ: Princeton University Press, 2013), 2.
15. "For the Marines Fighting Overseas . . . The Era of the Glamorous Pin-Up Girl." *Leatherneck*, November 2017, 40–41. 2017.
16. Girl Scouts, "Who We Are" page, www.girlscouts.org/en/about-girl-scouts/who-we-are.html.
17. LIFE. "Speaking of Pictures . . . Marines find Pin-Ups and Glamour on Guam." *Life*, June 18, 1945, 12.
18. Morris B. Holbrook and Arch G. Woodside, "Animal Companions, Consumption Experiences, and the Marketing of Pets: Transcending Boundaries in the Animal-Human Distinction," *Journal of Business Research* 61, no. 5 (2008): 377.
19. Michael Dolan, "How Did the White Picket Fence Become a Symbol of the Suburbs?" *Smithsonian Magazine*, April 2019.
20. LIFE. Letters to the Editor, *Life*, July 9, 1945, 8.
21. Sheila M. Webb, "A Pictorial Myth in the Pages of *Life*: Small-Town America as the Ideal Place," *Studies in Popular Culture* 28, no. 3 (2006): 44.

Chapter 7

Mixed-Race and Interracial Marriage "Hawaii a Melting Pot"

Language is culture. In "Hawaii: A Melting Pot," *Life* editors tell readers there are 430,000 people in Hawaii and "every race is a minority." While speaking in terms of majority and minority races, *Life* editors also use Hawaiian language words for white (haole), Chinese uncle (pake), and Puerto Rico (poco liko). The use of language signals a certain culture. However, a language user may have adopted the language from the dominant culture. By adopting the language of the dominant culture, the user elevates him or herself to a higher status and becomes part of the dominate culture.[1] Linguistic scholar Bill Ashcroft was referencing how colonial powers, such as the British, colonize "others," and in the process the colonized "other" learns the English language. In doing so the "other" elevates their social status out of primitive jungle status. Thus, the colonized become whiter.[2] In this way, Ashcroft explains how language is tied to race. In this opening paragraph, *Life* editors imply that the Hawaiian speaker adopts English as a sign of status. *Life* editors point out how language is like race and that races like language evolve over time. More specifically, mixed races seen in Hawaii are a fact of life and that racial purity, like language purity, is an illusion.

Life editors frame Hawaii as a place that promotes equality in races. The photo-essay "Hawaii: A Melting Pot: A Score of Races Live Together in Amity" in the November 26, 1945, issue names a number of races, ethnicities, and nationalities; American, British, German, Spanish, Puerto Rican, Chinese, Filipino, Japanese, Micronesian, Polynesian, and an "infinity of combinations of them all." More pertinent is that *Life* editors point out that white people are called Haoles, a Hawaiian word that means outsider. The point they want to make is that Haoles are the white people of "position" or those who hold political power. However, in this photo-essay, *Life* editors only present photos of Haoles in mixed-race unions and as mixed-race

individuals. That is because on Hawaii while many Haoles hold positions of political power, Asian races are the majority who hold economic power. Thus, Asians such as Chinese, Japanese, Filipino, and Pacific Islanders such as Hawaiians absorbed the Haoles into a mixed-race society. The common language that mixes Hawaiian words with English is the language of power in Hawaii. Speaking the language shows island heritage and acceptance of mixed-race people that was, at the time, unmatched on the U.S. mainland.

Typically, a great photo with many discrete parts has a focal point around which everything rotates. An example is in the opening photo of this photo-essay of two small girls, one Asian, one white. The girls position each other looking into the camera smiling, while clasping hands, which is evidence of amity. The reader's eye come to rest on the clasping hands. The caption in this introductory photo introduces the girls "Mary Lou Parker, 4, plays with Letty Mai Pang, 5, A Chinese, in the playground of a Polyracial Honolulu School." The photo is apropos as an opening. Two girls of different races together represent the future of America. *Life* editors are explicit in pointing out the "polyracial" Honolulu school, implying that the girls go to school together. To the *Life* white middle-class reader, segregation of schools between whites and all others had been legal since 1896 thanks to the Supreme Court ruling *Plessy v. Ferguson*,[3] which said that segregation was constitutional. Showing two children (one white, one Asian) as an opening statement represents contrast in mixed-race acceptance between Hawaii and the U.S. mainland.

Central to the photo-essays within this feature is the prevalence of intermarriage across racial, religious, and national lines, along with the mixed-race progeny who are presented proudly by *Life* editors as a new race emerging in a modern America. The importance of this photo-essay is its position in reworking the definition of the American nation as racially white by including mixed-race and Asians in the realm American citizens. This realm of races included native Hawaiians along with the descendants of Chinese, Japanese, and Filipino immigrants who arrived on the islands in the nineteenth century.

Important to note is that while blood line was important to the Hawaiians, unlike on the U.S. mainland, the mixing of blood lines did not denigrate a race but enhanced the race. Thus, single-race persons are equal in status to persons with mixed-race backgrounds. The acceptance of mixed-race persons in Hawaii is in part due to the history of the islands. History scholars Paul Spickard and Rowena Fong point out that in the middle of the nineteenth century the Hawaiian people were dying out.[4] The Hawaiian kings brought in people from the Pacific Rim—Chinese, Japanese, Koreans—as a means to try to restock Hawaiian blood. To explain the pride of mixed-race people on Hawaii to *Life*'s white middle-class reader, the term "mixed-race" was the common reference to people of multiple races in the United States.

Hawaii's location in the Pacific is crucial to military strategy. As such, *Life* editors were asking Americans to embrace people on Hawaii as Americans. Given the historical reality of the denigration of mixed-race people on the mainland United States, the steps that *Life* editors took to build a 1945 photo-essay about mixed-race people in Hawaii was rather bold, particularly as the majority of the Asian population in Hawaii was of Japanese ancestry.[5] Raising awareness of Hawaii as part of the United States with majority Asian inhabitants, *Life* editors point out the obvious, that mixed-race Asians and mixed-race people are prevalent in the United States—which is something the U.S. census should begin to recognize.

MIXED-RACE WAHINES (WOMEN)

A mass illustrated magazine such as *Life* relies on stellar portrait photographs to illustrate some of their most important photo-essays. Profiles of women, especially beautiful women, are often the entrée into a story. *Life* photographer Eliot Elisofon shows, through framed headshots, stories of mixed-race women. The exposé explains his portrait photos as "New Race Emerging and Stabilizing." Elisofon referred to himself as a mild impressionist[6]; he had a way of making women look ladylike and proper. In this double-page layout are headshots and profiles of nine women. The smiles appear genuine. Their faces are thoughtful and confident. *Life* editors are saying, *this is Hawaii, an open mixed-race society*. On the left page are eight framed headshots that circle the exposé. Each caption in capital letters names the mixture of race followed by ethnicities.

Life editors stress on mixed races with the use of bold capital letters to name the races of each woman. The focus on mixed race is intentional. The layout as shown in figure 7.1 is also meaningful in that each woman is given her own space with her own story through individual headshots. *Life* editors showcase the women as star characters in the narrative that mixed race is the new race emerging in America. As such, *Life* editors make a statement that mixed-race women are human. As a headshot, each woman is seen in close-up to bring about an imaginary relationship with the reader. Kress and Van Leeuwen speak of the close-up photo as a form of direct address.[7] Each woman is in personal contact with the reader through camera's close-up frontal view. Perhaps readers might feel admiration for beauty, or women readers might identify with the women shown. The exposé adds to an emotional feel by introducing the women as "healthy and American." In addition to the bold capital letters naming the race mixture, *Life* editors name ethnicities along with name, and sometimes age, occupation, education, or something interesting such as a hobby, which are often markers of middle-class status,[8] and

CAUCASIAN-HAWAIIAN
(English, Belgian, Hawaiian)
Harriet Markem of Outrigger Canoe Club.

MIXED CAUCASIAN
(French, Portuguese)
Alyce Louis, 20, talented young singer and dancer USO.

CAUCASIAN-HAWAIIAN
(English, Hawaiian)
Angeline "Pee Wee" Hopkins, 18, Professional Hula dancer.

CAUCASIAN-HAWAIIAN
(Portuguese, Irish, Hawaiian)
Barbara Sylva, 20, Hawaii Senator's daughter.

A NEW RACE IS EMERGING
The charming faces seen here though of many bloods compose the new mix race...healthy and American.

ASIATIC-CAUCASIAN
(Korean, Spanish, English)
Lava Pak, 23, Army translator...

ASIATIC-HAWAIIAN
(Chinese, Japanese, Hawaiian)
Laola Hironaka, Census might list her Japanese.

JAPANESE
A pureblood
Doris Nitta, 20, University of Hawaii, senior,... take her M.A. at Columbia.

ASIATIC-CAUCASIAN
(Chinese, English)
Barbara Thoene, 16, married to a Caucasian.

Figure 7.1 Headshots. *Source: Life* magazine, November 26, 1945, p. 104.

Life editors place mixed-race Asian women within the realm of American middle-class status.

Starting with the top row in the top left corner, Caucasian Hawaiian (English, Belgium, and Hawaiian) Harriet Markham has a European name. Her headshot, in the top left corner of the page, is a coveted spot because her picture is first seen by a reader's eye when flipping pages. *Life* editors mention that she is a member of the Outrigger Canoe Club. An outrigger is a canoe with side lateral supports. The notion that Ms. Markham is a member of a club implies that she has leisure time and discretionary income to enjoy a sport and afford the cost of a club membership. Thus, *Life* editors present Ms. Markham as a member of the middle class. To the right of Harriet Markham in the center spot is another smiling woman whose caption reads mixed Caucasian (French, Portuguese). It is not by accident that Alyce Louis, twenty, a Caucasian woman, is placed in a coveted center top spot. With an estimated audience of approximately 2.8 million, mostly white middle-class readers, *Life* editors most likely understood that Ms. Louis would appeal to its readers. By placing Ms. Louis in the top center space, readers would see her immediately. The caption states that "she sings and dances with the USO," underscoring her service to military troops. To the right of Ms. Louis is Angeline Hopkins, age eighteen, and a professional hula dancer. *Life* editors give her voice by publishing her nickname, "Pee Wee." While there is no mention as to where the name "Pee Wee" came from, the nickname and the ability to hula makes Ms. Hopkins a special woman with a unique talent.

The center row shows the headshots of two women. The exposé is placed in the center spot. Left of the exposé is Barbara Sylva, twenty, the daughter

of a Hawaii senator and therefore from a political family with power. Noted are her mix of ethnicities—Portuguese, Irish, and Hawaiian. *Life* editors reinforce that Ms. Silva is respectable because she is from a family that holds political power. On the right of the exposé, next to the centerfold, is Lava Pak, twenty-three, an Army translator, which shows that she has a useful skill in serving the military. Her occupation is a marker of middle-class status because translating is a specialized skill. As a possessor of a specialized skill, Ms. Pak is a professional woman.

Along the bottom, three more women are represented. In the center position is the headshot of Doris Nitta. For Ms. Nitta, the caption in part reads "Japanese, a pureblood." The caption later details Ms. Nitta as a "University of Hawaii senior who will take her M.A. at Columbia," which shows educational ambition. The importance of her pure Japanese heritage shows that *Life* editors want the reader to understand the difference between Japanese American and loyalty to Japan. Considering that World War II had ended with the Japanese surrender, placing Ms. Nitta, a Japanese American, alongside white and mixed-race Americans was a bold move. The implication here is that Ms. Nitta may ethnically be Japanese, but she is an American.

The headshots of the two women placed on either side of Ms. Nitta, subtly point out problems with the census categories and anti-miscegenation laws. To the left of Ms. Nitta, along the bottom, is Asiatic Hawaiian (Chinese, Japanese, Hawaiian) Laola Hironaka. The caption says, "The census might list her as Japanese." Referencing the exposé that says "the official U.S. census lists only two races," *Life* editors criticize the U.S. census in only counting some races while leaving out others. To the right of Ms. Nitta is Asiatic Caucasian or "cosmopolitan" Barbara Thoene (Chinese English). Ms. Thoene's caption reads, "16, married to a Caucasian." But in those states with anti-miscegenation laws, Barbara would be prohibited from marrying a Caucasian because she is considered Chinese not Caucasian.

Through these headshots *Life* editors reveal that mixed-race women can freely marry anyone of any race. *Life* editors, thus, belabor the underlying narrative that anti-miscegenation laws do not and never have existed in Hawaii. In addition, *Life* editors explicitly and openly challenge myths that mixed-race progeny are inferior humans.

The right page is a full-page half portrait of the ninth woman, Pearl Stone, sitting in a beach setting. She is "Caucasian-Hawaiian (English and Hawaiian)," nineteen years old, a stenographer in the American Cross, and was voted "Miss Waikiki" last year. Both her father and her mother are of mixed blood, characteristic of the early days when deserters from English and American whaling ships first intermarried with Hawaiian women.

Chapter 7

THE EXPOSÉ

But the nine headshots are only one piece of the photo-essay. The reader's eye is drawn to the title in the exposé, "A New Race Emerging" in large black block letters at the center of the left page. The exposé reads:

> The charming faces seen here, though of many bloods, compose the new mixed-race of Hawaii—tolerant, healthy and American. Nobody in Hawaii conceals his racial mixture and indeed one must give the races of one's four grandparents to get a marriage license. The official U.S. census, however, lists only two mixed-races, the Caucasian-Hawaiian and the Asiatic Hawaiian. All others, no matter how confused their ancestry are listed under their father's race or the racial community that claims them. Though the words "white" and "colored" are never used, it is desirable to have light skin. But part-Hawaiians often list themselves as full-blooded Hawaiians to avoid being laughed at for exaggerating their white strain. The Chinese-Hawaiians and the Caucasian-Hawaiians, are more and more disposed to marry into one another's groups.[9]

Following the end of World War II, this photo-essay is as much a story as it was a statement. A fact—that mixed-race women in Hawaii of Asian and Pacific ancestry are U.S. citizens. The facts destabilize the notion that Americans are white and racially pure. Another fact: Hawaii is part of the United States and the population is predominately Asian. When looking at the faces of the mixed-race women, they are in Western tropical dress and wear no make-up; the question becomes: What is the magazine saying about what Americans look like? Central to this question is the place of Asians in America.

Statements in the exposé imply that the U.S. census categories and the laws governing mixed-race marriage are antiquated and not useful to a modern America. The statement "nobody conceals his racial mixture" is a direct jab to those in the mainland United States who denigrate mixed-race persons with derogatory names such as half-breed, half-caste, or mulatto. The exposé continues with an explanation that one must provide the races of four grandparents to get a marriage license but it doesn't say why. This statement "races of four grandparents" seems to be intentional in that it is the opposite in many U.S. states in which interracial marriage is prohibited. The exposé continues with a taunt to the U.S. census in only listing two mixed races, Caucasian Hawaiian and Asiatic Hawaiian. Then *Life* editors implicitly make a point to say "the U.S. Census pretends other races don't exist." Then a punch line states, "white" and "colored" are never used. *Life* editors imply that such words as "white" and "colored" are inappropriate. In addition, "white and colored" are not capitalized which implies the words don't deserve respect.

Nevertheless, for entertainment purposes, *Life* editors lighten claims of bigotry by stating that "it is desirable to have light skin." The final statement, "Hawaiians like to claim they are pure to avoid being laughed at for exaggerating their white strain," is ambiguous. This statement can be interpreted in more than one way. Is a white strain of blood a bad thing? Or is being pure Hawaiian better than being half white? After confusing the reader, *Life* editors give the reader relief. The last sentence states that those of mixed races (Caucasian Hawaiian or Asiatic Hawaiian) will marry each other. In the end, the white American middle-class reader has nothing to worry about because mixed race is only in Hawaii.

MIXED-RACE KEIKI (CHILD[REN]) AND OHANA (FAMILY)

The next double-page spread features three photos of mixed-race children and teens across the top and four portraits of interracial families along the bottom.

The photo to the right of the boys that crosses the centerfold is a group of girl teens on a park bench under a banyan tree. The caption calls the teens "Waikiki Tomboys"; the caption goes on and provides detail to the setting and the mix of races of the teens, "Marion Woolsey, 14, Chinese-Hawaiian-English, Patricia Cameron, 16, Portuguese Scotch-Irish, Beatrice Clark, 16, Hawaiian-Chinese-German." The caption ends with small detail unseen in the setting—"canoes are stored under roots." The teens are of mixed race. The word "tomboy" implies the girls enjoy active sports like boys. *Life* editors suggest that the canoes hidden under the roots of the banyan tree belong to the girls. The photo implies they have just completed a canoe ride.

The third photo on the top right makes a point that the children in Hawaii are doing the same things as children on the U.S. mainland. They play on a playground. Some children are climbing on a play structure. The caption tells the reader the photo is about children attending American schools and states, "American School, together with Christianity and the English language, are the great Hawaiian unifier of races. Here 5-year-olds play at the Muriel Day Care Center, operated by the Kindergarten Association."

The bottom row of photos features four portraits of interracial families. Bottom left is a white man and Asian women with two children. The caption reads: "Indiana Quaker, Sam Lindley, married a Chinese Quaker and has two fair haired girls. Renee and Rhonda. He raises goats and works as librarian at University of Hawaii. He studies Chinese, wants to visit China." The caption personalizes the family by providing the names of the children. However, while Sam is named, his wife is only known as a Chinese Quaker which may be the novelty to this family's story. It is possible that *Life* editors

presumed that most *Life* readers have never heard of a Chinese woman within the Quaker religion. Therefore, the photo of this family is newsworthy for the religion and race of the woman alone.

The inner center photo to the left of the centerfold is that of another Asian and white mix marriage family with two children. Bold lettering says Japanese Hawaiian; the caption continues in smaller unbolded font "George Watanabe, telephone clerk, married white Alberta Roe. Children look Hawaiian." As a telephone clerk, George Watanabe is respectably middle class. In this case, *Life* editors take a jab at anti-miscegenation laws on the U.S. mainland by openly showing defiance of a social order. For many states in the United States, marriage between an Asian man and a white woman would be illegal. The premise was that of eugenics and in keeping the white race pure.

The lower right inner photo on the next page is a family of three. "Chicago Negro, Pvt. Wade Belton, ex-taxi driver, married Japanese Doris Kameyo. He is taking her to Chicago." The photo of this interracial couple shows America that marriage between a black man and an Asian woman exist despite anti-miscegenation laws. The fourth photo to the right of the Beltons is a family with four children. They are introduced as, "Hawaiian born American Llewellyn N. Jay, a welder, married a Hawaiian born Japanese. Three of the children seem to resemble him. The fourth child the mother. They live at polyracial housing project." The caption alludes to the fact that both the husband and the wife are half Hawaiian. While the reference to "American" is a code word for "white." His half Japanese half Hawaiian wife is presumably also an American but the perception of her Japanese ancestry and Hawaiian background precludes the assumption of being an American.

MAJORITY ASIANS DESPITE ASIAN EXCLUSION

Life editors evaluate the Asian groups in Hawaii from their perspective as white men with media power. In this section, *Life* editors make statements about race, gender, and religion intertwined in American middle-class values. The title "Orientals Dominate Population" reinforce the photo-feature that while every race is a minority, the Asian race, when put together, dominates over Haoles. The double-page spread's exposé begins on the right page under an almost full-page headshot of an Asian Catholic nun. The caption says, "Sister Roberta Noda, pure Japanese and Daughter of Buddhist, is Nun of the Teaching Order of the Sacred Heart." The photo, a close-up, shows her eyes looking toward the sky. The low oblique angle gives her prominence. She holds a Bible. In the background, a small statue of the Virgin Mary appears hanging from a tree. The photo image appears as if the Virgin Mary floats behind Sister Roberta's right shoulder, watching over the nun.

Life editors said the word "pure" to indicate that Sister Roberta is not mixed race. While *Life* editors make no mention of Catholic, I know she is a Catholic nun. Sacred Heart Academy is college prep school in Honolulu and is part of the Archdiocese of Honolulu. My auntie, my father's sister, is an alumnus of Sacred Heart Academy. At the time, during the war, the school was operated and run by the nuns. *Life* editors show readers that Asians, Japanese in particular, can adopt any religion. Sister Roberta, a Catholic nun, has adopted a Western Christian religion. As American men, *Life* editors make a statement about race and religion. Religion is malleable, race and gender are not.

The exposé begins by providing statistical and demographic information, value judgments, and stereotypical assumptions about Asian ethnicities. It begins with, "The population of Hawaii is 60% Asiatic. There are 28,000 Chinese, 155,000 Japanese, 52,000 Filipinos." The next line seems contradictory to the "melting pot" idea of Hawaii. *Life* editors say that "despite considerable intermarrying most Orientals have so far not married outside their own races. The Chinese and Japanese often oppose letting their children marry into other races, holding to the family traditions of the old country." We cannot know how *Life* editors came to say that "Orientals have so far not married outside their race." Nevertheless, we can look to history understand that there may have been some animosity between the groups due to intense conflict between Japan and China that dates from the 1930s.

However, from personal family experience, second- and third-generation Chinese, Japanese, and Filipino islanders socialized often. My father was a student at McKinley High School in Honolulu during the war.[10] He often still remarks about "going out to the pineapple fields to work every week." The statement refers to wartime when high school students on Oahu were bused to the pineapple fields to pick pineapple because of the labor shortage. Every high school had a day when classes were not held, but students still had to show up to go to pick pineapple for that day. Between 2006 and 2012, I accompanied my father to his yearly high school reunions in Honolulu. From his classmates I hear about the old days; intermarriage did not seem to be a problem because some of the talk was about dating and partying. I contend that the war and the responsibilities created for the young people such as picking pineapple in lieu of school, created social opportunities to bond as a community regardless of race. At McKinley High reunions, I was not the only child in attendance with a McKinley High School graduate. A number of mixed-race progeny of McKinley High alumnae were in attendance around my age, which shows that, at the time of the war, there was socializing among different Asian races.

Life editors continue with stereotypes about Asian races, but they do mention the shortage of women that has plagued U.S. Asian immigration.

Through captions on the left page, *Life* editors explain to readers the U.S. immigration laws that caused the shortage of women.

The Chinese, richest of the three, are respectable merchants and professional men. The more recent Japanese are small farmers, storekeepers, and small manufacturers. The Filipinos are still chiefly plantation laborers. All three races have suffered a shortage of women since the men usually came alone to labor in the sugar plantations.

Life editors made value judgments based on their own experience as white middle- and upper-middle-class men. They say, "Chinese and Japanese are two of the best-behaved groups." In parenthesis it continues to comment that "the worst behaved groups the Puerto-Ricans, part-Hawaiians, Filipinos." *Life* editors define "best-behaved" by noting that a "higher percentage of Chinese send their children to school than even the Caucasians." The reference to Caucasians must be intentional. *Life* editors subtly show low aspirations of Caucasians and high aspirations of Chinese. This could be the beginning of a late twentieth-century narrative that certain Asians are model minorities by suggesting that Chinese success as merchants and professionals are due to education, which leaves other Asian ethnicities and Caucasians with less social and economic status.

The final point in the exposé is about the loyalty of Japanese Americans during World War II. A small photo to the right shows Japanese characters inscribed into a headstone along with English words inscribed that says, "Mother Father." The photograph of the headstone is foregrounded for the reader to clearly see the English beneath the Japanese characters. The English inscribed show that the children must be Japanese American by birth. The point is subtle, that Japanese Americans should not be conflated with loyalty to Japan.

Life editors place two photos on the left page as evidence to the narrative that the Chinese are economically more successful than the Filipinos. The left page is divided by two photos that contrast the home of a Chinese immigrant family on the top with the home of a Filipino laborer on the bottom. The top photo of a Chinese family in their home shows architecturally designed furniture. The caption says, "Chinese Family Include Elder Youngs." Shown in the photo are the Youngs, seventy-eight and seventy-one, and son, John, a painter. The caption details why women were not brought to Hawaii. "Chinese brought a few wives from China because their bound feet were useless on plantations. Exclusion Act, which was repealed in 1943 shut out Chinese in 1900."

Life editors cite the legal and cultural references to make a point to readers about the history of Chinese immigration to the United States and discriminatory laws. The reference to Chinese Exclusion shows a pattern of the U.S. discriminatory practice against Asians and other ethnicities in light of antimiscegenation laws that were still in force in many U.S. states.

The bottom photo shows only the room of a Filipino sugar plantation worker. The room has a bed and table and is decorated with photos on the walls, on the table, above the windows, and along the ceiling beams. The caption tells the reader that it is a "Filipino Home shows garish Spanish colonial decoration, photograph of a U.S. Navy son and wedding group. It belongs to a sugar plantation worker who got the relatively high income of $1800 last year. Filipinos are the most thrifty Iloconas" (Iloconas are an ethnic group from the Philippines).

The Filipino worker is not in the photo. According to the consumer price index from the Bureau of Labor Statistics, $1,800 in 1945 is equivalent to $25,639 in 2020. The contrast in economic status between Chinese and Filipino worker is evident in the photo, but the photos serve as evidence that the Chinese are the richest of the Asians as stated in the exposé. We cannot know if the worker was present in the room when the photo was taken, but *Life* editors put the photo on this page for a reason. The room, void of people, show lack of family. The exposé made the comment that the Filipinos were worst behaved when compared to Chinese and Japanese. Perhaps *Life* editors were suggesting that the lack of presence of family may be a reason.

LETTER TO THE EDITOR

It seems that the message that interracial marriage and mixed race in the U.S. territories was a common and natural act. The photo-essay on "Hawaii: A Melting Pot" did make an impact for at least one woman on the U.S. mainland. A letter to the editor dated December 17, 1945, proves the point that the feature highlighting Asian American women had influence on *Life*'s audience. Signed by May Ke-Long of Boston, it stated: "I have a friend who is in love with a Hawaiian boy but feels that it is impossible for them to marry. This article shows that others have taken this step and have succeeded very well for a successful and prosperous life." The women and families on Hawaii live everyday middle-class lives. They married regardless of race, had mixed-race children, maintained jobs, bought homes, and worked hard for their future.

NOTES

1. Bill Ashcroft, "Language and Race." *Social Identities* 7, no. 3 (2001): 17.
2. Ashcroft, "Language and Race," 17.
3. *Plessy v. Ferguson*, 163 U.S. 537 (1896). Landmark Supreme Court case upheld constitutionality of racial segregation. Overturned in 1954 with ruling in *Brown v. Board of Education*.

4. Paul R. Spickard and Rowena Fong, "Pacific Islander Americans and Multiethnicity: A Vision of America's Future?" *Social Forces* 73, no. 4 (1995): 1377.

5. Jonathan Y. Okamura, "Race Relations in Hawai'i during World War II: The Non-Internment of Japanese Americans," *Amerasia Journal* 26, no. 2 (2000): 125.

6. Loudon Wainwright, *The Great American Magazine: An Inside History of LIFE* (New York: Knopf, 1986), 131.

7. Gunther R. Kress and Theo van Leeuwen, *Reading Images: The Grammar of Visual Design*, 2nd ed. (London: Routledge, 2006), 117.

8. Sheila M. Webb, "'America Is a Middle-Class Nation': The Presentation of Class in the Pages of *Life*," in *Class and News*, ed. Don Heider (Lanham, MD: Rowman & Littlefield. 2004), 167–198. See also Karen L. Ching Carter, "High and Low Art in Narrative Construction of a Photo Essay: When Asian American Women became Middle-Class Americans at the Forbidden City Nightclub in San Francisco." *South Atlantic Review* 84, no. 1 (2019): 160. *Life* editors place Asian American women dancers in the realm of the American middle class.

9. LIFE. "Hawaii: A Melting Pot; A Score of Races Live Together in Amity." *Life*, November 26, 104.

10. Clarence Kwai Sung Ching graduated McKinley High school in 1946. I accompanied my father with my brother to six McKinley High School reunions between 2006 and 2012. Other years my father goes "back home." I go with him. We continue to meet with family and his friends who are still alive.

Part IV

THE 1960S AND THE CIVIL RIGHTS ERA, 1960–1965

Chapter 8

Changed Perceptions
"Nancy Kwan, a New Movie Star"

On the October 24, 1960, issue of *Life* magazine, *Life* editors placed Nancy Kwan, a mixed-race woman of Chinese descent, and rising Hollywood star on its cover. Inside that issue, a photo-essay was of Kwan at work on the movie set. Kwan was by no means the only Chinese woman to grace a magazine cover. Anna May Wong was on the cover of *Look Magazine* in 1937. France Nuyen, of Chinese and French heritage, was on *Life*'s cover on October 6, 1958. France Nuyen's first role was of an island girl in the movie musical *South Pacific* (1958); later she played Suzie Wong in *The World of Suzie Wong* on Broadway. Both Nuyen and Kwan's Suzie Wong character sexualized Asian women; however, Hollywood for the first time for an "A" movie cast an Asian woman (Kwan) in a role rather than a white woman to look Asian. The photos of Kwan both on the cover and inside the issue are credited to Paramount Pictures. The photo credits illustrate that Paramount Pictures were making a bet on movie sales. Paramount Pictures would use *Life's* vast circulation to advertise the new movie. Life editors, however, were also making a bet—that magazine sales would increase with an Asian beauty who happens to be a new star on its cover. With Kwan on the cover, sales for the movie and for *Life* magazine would test the acceptance of an Asian woman starring movie role for an "A" movie and on the cover of a national mass illustrated magazine. Box office sales for the movie "The World of Suzy Wong" did not disappoint and Kwan did become a star.

Life's October 24, 1960, magazine was visually a mishmash, 137-page artifact that opened with Nancy Kwan on the cover and closed with a back-cover advertisement of Newport cigarettes. According to *Life* editors a modern American lifestyle included a magazine that brought world news to readers while simultaneously promoting middle-class consumerism. *Life* readers were presumed to have the discretionary income to spend on

luxury items and experiences in entertainment in sports (a photo-essay on the World-Series-winning Pittsburg Pirates), cultural arts (color pictures from the movie *Spartacus*) and advertisements of eighty consumer products such as convenience food (Campbell soups, Great Giant corn), personal care items (Listerine), and electronics (Zenith televisions). The majority of consumer products were full-page color advertisements that made the issue visually dynamic in that it was sometimes hard to distinguish the advertisement from the photo-essays.

CHANGED PERCEPTIONS OF ASIAN WOMEN IN AMERICA

The most significant events influencing changed perceptions of Asian women after World War II was, first, the enactment of the War Brides Act—the entry of Asian wives and children of American servicemen who served in wars overseas—and a series of Chinese refugee admissions throughout the 1950s. The Asian migration stream from both the War Brides Act and accepting of refugees escaping Communist China through Hong Kong produced significant transformation of Asian communities.[1] More Asians began to enter and live among the white professional classes and demonstrate stable families. Many of the Chinese refugees were student scholars, political anticommunists, and Hong Kong–Taiwan professionals. As such, white middle-class Americans began to experience educated middle-class Chinese as neighbors and colleagues, so that white Americans began to believe that the Chinese were not as fundamentally alien as previously thought.[2] In the context of the Cold War migration, the American public was becoming more aware of the Chinese in America, and by extension more familiar with the diversity of Asian groups that existed.

COVERING NANCY KWAN

The name Nancy Kwan is likely to elicit a blank stare from someone unfamiliar with Asian American history. If, however, one alludes to fictional creations such as Suzie Wong from the 1960 movie *The World of Suzie Wong*, more people would catch the reference. The fictional character Suzie Wong, a Chinese prostitute, eclipsed the real lives of Asian females of the time. The character Suzie Wong popularized the stereotype that Asian women were exotic, demure, and sexually available. However, while the movie was about a Chinese prostitute, *Life* editors repositioned Kwan, the real person, in a photo-essay as a professional actress rather than a sexualized image of Asia

for a white middle-class audience. *Life*'s approach to telling Kwan's story in this photo-essay challenged racial beliefs that all Asian women were sexually promiscuous. Using strategies in composing an essay with photos and captions, *Life* editors promoted an alternative idea about Asian women. In one sense *Life* editors were comparing something imaginary with something real—but which is real and which is constructed?

Feminist scholar Sheridan Prasso writes a history that connects Chinese women with prostitution.[3] Chinese men began to arrive in the 1850s during the gold rush, but due to the dearth of women in general, Chinese men began importing Chinese women as wives and as prostitutes.[4] California, not a slave state, tolerated the sale of Chinese women on the docks of San Francisco before large audiences including police officers.[5] In the early twentieth century, Hollywood popularized the Asian female prostitute in movies. Notable was Chinese American actress Anna May Wong who not only played slave girls and prostitutes in black-and-white film but also played the character of the "Dragon Lady," a cold manipulative killer who was a prostitute. The Dragon Lady character was taken from a series of books (begun in 1911) based on an eccentric evil Chinese man named Dr. Fu Manchu. The British author, Arthur Ward, said he knew "nothing of the Chinese, but something of Chinatown." Thus, Ward admits the image of the Dragon Lady was fictional. However, the image of the Asian female as a prostitute was reinforced time and again. In 1960, *The World of Suzie Wong* was a continuation of the storyline that Asian women were prostitutes.

More important, *The World of Suzie Wong* was a box office success. The movie is about an American architect who moves to Hong Kong to paint as an artist and falls in love with the Chinese prostitute Suzie Wong, whom he hires as a model. In 1960, the movie spawned interest in what America termed as "the Orient" in that Americans became aware of Hong Kong as a British colony that introduced a liberal idea about interracial marriage. At the time of the film's release, some Asian Americans had a sense of pride that an Asian actress had a leading role in a major Hollywood film.[6] For others the storyline was a terrible example of imaging Asian women as prostitutes while also stereotypically portraying them as childlike and in need of being rescued from poverty.

To perform a Western stereotype of an Asian woman demonstrates that race itself is a performance. *Life* editors shed light on the complexity in the construction of race by presenting Kwan and Suzie together through a photo-essay. By showing Kwan working as an actress playing the character of Suzie, *Life* editors open the possibility that Asian women can more easily claim an American identity separate from Suzie. Nancy Kwan's being cast in a lead role of a major film demonstrated that Hollywood producers changed their view regarding casting Asians in Hollywood movies. For *Life* editors,

Kwan was a significant story because if the movie had been made earlier, Kwan might not have had the role of Suzie. Between 1930 and 1955, the Hollywood Motion Picture Production Code forbade portrayals of interracial romance, stating that "miscegenation" is forbidden.[7] Citing the "Code," Hollywood had previously placed Caucasian actors and actresses in all starring Asian roles. However, in 1960, the only issue producers had in casting Kwan as Suzie Wong was whether she looked Asian enough because of her Eurasian heritage. At the same time, even though Kwan's race is consistent with the role she played, *Life* editors portrayed Kwan in the photo-essay as a professional actress. The character, Suzie, was not Kwan. Instead, the captions talked about Kwan, the actress, at work.

The fact that *Life* editors decided to place a visually commanding portrait with sexual overtones of Kwan in her character as Suzie on the cover was a calculated act of marketing. *Life* magazine, a visual medium, built its reputation on the pleasures of viewing pictures along with its narrative structures and conventions. A sexualized movie star on the cover of a magazine resonated and probably continues to resonate with people because, as stated earlier in the introduction, *Life*'s pass-along factor in 1938 calculated 17 million readers. Pass-along factor presumes people socialize with other readers who might share an interest in the magazine cover and start talking. The talking among readers about a picture in the magazine is a brilliant marketing ploy. Historian Rickie Solinger counted no less than two sexualized images of women every month on the cover of *Life*, which was a biweekly magazine, throughout the 1950s. He states, "They appeared two each month on the cover in the fifties, like clockwork."[8] I counted the sexualized images of female stars on covers in 1960 and found eleven. Commonly known are Marilyn Monroe (August 15), a sex symbol; Lee Remick (June 6), a new star; Dina Merrill (January 11), a model and actress; and Nancy Kwan (October 24). Therefore, for *Life*'s sustained circulation of 6,700,000, placing Nancy Kwan on the cover in October of 1960 was a marketing strategy as much as the novelty of an Asian woman on the cover of an American mass-produced magazine.

Another aspect of the marketing ploy is in the promotion of a movie through a photo-essay about the lead actress rather than for the movie production company to purchase advertising space. The photo of Kwan on the cover is credited to Bert Stern and Paramount Pictures, the studio that produced *The World of Suzie Wong*. By 1960 *Life* was the best-selling weekly magazine, with sales of 6–7 million copies each week; market researchers estimated that each of those copies was read by an additional five people.[9] By allowing *Life* to utilize the photo of Kwan, Paramount Pictures bet that the leading sexy Asian woman would be a box office draw. The photos inside the magazine that show Kwan on the movie set are also credited to Bert Stern

and Paramount Pictures. The role of *Life* editors in this case was to arrange the photos into a coherent story aided by an exposé and captions. *Life* editors and Paramount Pictures were a marketing team—*Life* to sell magazines and Paramount Pictures to sell a movie.

Life's visual representations of Kwan on the cover and later in the photo-essay mediated competing cultural discourses by promoting an Asian-faced leading actress in a non-threatening manner to middle-class white Americans. While the cover portrayed a stereotyped Asian prostitute, the photo-essay portrayed an Asian woman as the talented actress. The photo-essay was also indistinguishable from the advertisements targeting middle-class consumers. *Life* editors deployed a strategy that made viewing an Asian woman in American society seems common. The photo-essay, an advertisement for a movie, is integrated alongside other advertisements that targeted middle-class consumers. Through the photo-essay, *Life* editors shifted a reader's expectations away from preconceived viewpoints of the Asian women as a prostitute. The photo-essay of Kwan, the actress, provided an opportunity to assess *Life*'s attention to Asian women and by extension to re-imagine the Asian woman.

ON THE COVER

Getting on the cover of *Life* magazine was considered the pinnacle of postwar success, in particular, for Hollywood stars.[10] The cover of any magazine represents a unified identity of the magazine and its readers, and from a pure marketing perspective the cover also shows the newness of the issue. Newness is demonstrated in that the reader has not yet seen the issue, and the cover feature cannot be read elsewhere. For *Life*, its identity was for its iconic photo-essays and its wholesome appeal to families. Ed Thompson, managing editor at *Life* (1949–1961), said, "*Life* to me, is a friendly neighbor, almost one of the family."[11] Clearly *Life* had developed the reputation as America's favorite magazine[12] with most of its readers from the middle and upper middle classes. Thus, getting on the cover of *Life* meant visibility among the important elite[13] because that audience could propel a career through public opinion.

The full-body image of Kwan is a left-side view with her face turned toward the camera. She is dressed in yellow satin Chinese fitted dress called cheongsam, and her left thigh shows through the slit of her dress toward the camera. A sense of texture is provided by a beaded curtain in the background. The colors of the beads are bright silver and gold with hues of blue, red, and green that form the image of flower petals, and give the appearance of a light source that hit the beads of the curtain to increase a sense of dimension. Kwan's eyes gaze

into the camera and demand that the viewer gaze back. The shine of the gold satin cheongsam amps up the glamour factor that is fitting for Kwan's star position in a major film. Her sleek black hair falls loose and adds a dark pop against the glittery background. Yes, in this photo Kwan is meant to be looked at.

Feminist theory argues that Nancy's body position was textually constructed for the male gaze.[14] Her pose is an example of a twentieth-century spectacle that had been commodified for mass entertainment.[15] Film scholars speak of the "gaze" of male privilege (when viewing women) through processes of objectification; however, Kozol reminds us that not all "gaze" is controlling.[16] Sometimes the gaze emits empathy, sometimes pleasure. However, as discussed earlier, Kwan's image on the cover was meant to be gazed for pleasure as any other sexualized female movie star. Movie stars resonate with readers and sex sells magazines. While the image of Kwan plays into the sexual stereotype that Asian women were prostitutes, the caption informed readers in block lettering at the lower right corner, "NANCY KWAN: A NEW STAR AS SUZIE WONG." The reader is provided basic information to entice them to read more inside the magazine while gazing at Kwan's body portrait against the glittery silver and gold beaded curtain—the glamour of a Hollywood actress.

An additional caption to the cover is on page two inside the table of contents. It reads: "Wearing the sultry look and slit-skirted *cheongsam* of her title role as a naughty Hong Kong nightclub girl, new Eurasian star Nancy Ka Shen Kwan stands before a beaded bistro curtain during filming of *The World of Suzie Wong*."

By mentioning Kwan's full name, *Life* editors transcend racial stereotypes and give Kwan respectability not only as a movie star but as a human being. The two foreign sounding words "Ka Shen" is part of Nancy Kwan the person. *Life* editors introduce Kwan with dignity. The caption inside the table of contents provides more information about Nancy Kwan's race and the name of the movie, but it is buried on page two, within the table of contents. Thus, the placement of factual information such as Kwan's race demonstrates that from the point of view of *Life* editors, such information was not important because it was obvious Kwan is Asian. More important was the fact that *Life* editors wanted to be the first magazine to introduce a new movie star as it would drive sales.

The date of release of this issue with Kwan on the cover was released on October 24, before the movie release on November 10, 1960. Therefore, readers could see the newness of this issue and get to know the lead star Nancy Kwan. As stated earlier, getting on the cover of *Life* was considered the pinnacle of postwar success, and for a number of Hollywood stars, *Life* brought career-enhancing success.[17] Kwan on the cover of *Life* by any measure is a success.

However, at least one reader found Kwan's presence on the cover as a disruptive presence for a family magazine. In a letter to the editor dated November 14, 1960, a reader from Ohio wrote: "After seeing the cover of Nancy Kwan as Suzie Wong (Oct 24) I am moved to write: There are countless things you could use as a cover design instead of this sex stuff; pictures of our parks, scenes from our cities and country, fine churches and historical places, an ocean liner loading for Europe."

Ironically on the cover of the November 14 issue containing this letter is a front headshot of Sophia Loren. Her eyes stare straight at the reader, her mouth slightly open. Prominently displayed is a ring, a large blue gem surrounded by three rows of small diamonds. Her ring finger and pinkie outline her chin. The caption on the cover reads: "Tiger-Eyed Temptress, Sophia Loren." As stated earlier, it was not unusual that *Life* would feature a movie star on its cover with some sexual undertones.[18] With regard to the "sex stuff," the writer might have associated an Asian woman with the sex trade particularly in her character role as Suzie Wong. Yet, he did not mention a problem with sex with past covers, in his letter. His last suggestion "an ocean liner loading for Europe," might reveal the crux of his problem. Instead of an Asian woman with a focus toward Asia, he would have rather seen a picture that focused on Europe. Thereby, laying bare his preference for a white star instead of an Asian-looking star on the cover of a white American mass-produced picture magazine.

NANCY KWAN THE ACTRESS

Block lettering in the far upper left corner informs the reader that this is an article about the "movies." The lower right corner directs the reader, "For a new star, see next page." Centrally focused on this page is the silhouette of a woman with long dark hair, walking down an open spiral staircase. Her face is visually imperceptible as her long black mane blends over her face into the blackened background. The camera angles upward from below. From this camera angle the woman has an appearance of courage as she walks down the staircase. Gradient light in the upper left corner gives the full-page photo dimensional texture. The staircase circles down to the lower right corner of the page. At the bottom of the staircase there are two couples dancing. The men are white, dancing with Asian women. The darkness of the monochrome black, white, and gradient gray photo creates a sense of mystery for the reader while at the same time portrays a confident woman walking down the staircase. The page title "Enter Suzie Wong" in white oriental stick lettering, framed in black runs vertically against the open staircase.

This opening photo is analogous to the opening statement of a news article. It is an attention-getting statement. In conjunction with the title "Enter Suzie Wong," the anonymous outline of the body of a woman implies that Suzie Wong is a fictional character in the movie *The World of Suzie Wong*.

The next page begins the lead paragraph as in a typical news article. The exposé acts in the guise of presenting the news rather than as a sale pitch for the movie. The lead phrase here is, "Hong Kong Lassie Plays Suzie Role." This is located in black block print in the upper right column of the page layout. The exposé reads:

> The girl on the stairway on the previous page is walking into the glamorous life of a movie star. Her name is Nancy Ka Shen Kwan and she is 21 years old, daughter of a Scottish fashion model and a Chinese architect. She grew up in a Hong Kong convent, an English finishing school and the Royal Ballet School in London and U.S. filmmakers found her in Hong Kong at her father's dinner table. She was a freckled face Oriental with long Occidental legs. They put her to work in a road company of the "World of Suzy Wong" the 1958 Broadway hit. Then they assigned her the movie role after France Nuyen, the Broadway star who was to play the film abruptly departed. As Suzy, Kwan is a naughty girl of the night clubs who falls in love with an American, played by William Holden, and accepts the odd idea that not being naughty can be nice too.[19]

The exposé introduces Kwan like the typical news article. The opening paragraph answers the who, what, when, where, and why questions of any news article. Three photos that surround the exposé bring clues to the central theme of the story which is that Nancy Kwan is from a respectable middle-class family since her father is an architect and her mother a fashion model. The photos give detail that add glamour and fun to Kwan's story. The photo to the right of the exposé shows Kwan, in a bikini at the beach, her back to the camera, as she smiles at the reader over her shoulder. The caption reads, "A sun bather, Nancy tosses a mischievous smile. She has mocking ways, 'He is good,' she says of veteran star William Holden. 'I think he will go far.' Nancy's hair is dark red brown, her eyes are cinnamon color."

Two photos are stacked below the exposé. Each photo shows Nancy at work in a scene with William Holden. The caption reads: "An eager student, Nancy responds to William Holden's coaching on kissing (*top*) then giggles. Richard Quine awarded her with high marks. 'She reacts like a Yo-Yo,' said Quine. Said Holden, 'She is a real bug.'"

Both photos are in vertical succession. The top photo showcases seriousness in acting a scene. The bottom photo shows playfulness while working to perfect a scene. Like in a news article, the photo-essay makes a point that

perfecting a scene is hard work. The photos emphasize that acting is work, thereby showing Kwan as working.

As the reader turns the page, however, photos are on the inside to the left of the centerfold. Advertisements flank the photos of Kwan on the left. A full-page advertisement is on the page opposite. Focusing only on the photo of Kwan, the top right photo has Kwan sitting slightly inclined with her feet raised on a large mattress. The caption tells us a make-up man is wiping the bottom of her feet. The caption reads: "Looking Tickled, Nancy permits make-up man to clean stage dust off her feet. In making the film, she was always eager to work. 'One word of guidance,' said her director, 'and she would rise to the bait like a trout.'"

Below is a photo of her sitting in a rattan armchair taking a nap. The caption: "Looking Dreamy, Nancy naps between scenes. She would wake up from such rests with either new ideas about why the film would be a big success or new reasons why she should be allowed to redo all of her scenes."

Taken together, the photos reveal Kwan's day-to-day work life. *Life* editors portray Kwan as a hard worker.

The photo-essay concludes on the following page in which Kwan is pictured smiling while engaging with a baby. The caption reads: "WINNING OVER BABY, Nancy tickles nose of Calvin Hsia who plays her son in the movie. With six brothers and sisters, Nancy is an old hand with babies." While Kwan is shown as a strong professional woman, she is also gentle and caring. Showing Kwan play with a baby, who is also her movie child, may please white middle-class readers as they witness a maternal act. Since it is the final photo, it is considered the least important information. However, the photo does provide a glimpse of what *Life* editors believe in—that Kwan, a professional working woman can also be a warm and caring mother.

THE CHEONGSAM AND FASHION INSIDE THE OCTOBER 24, 1960, ISSUE

Although Nancy Kwan was not American born, she became an iconic American movie star. *Life* editors portrayed her as such—the glamorous pose in a cheongsam on the cover—a woman who forged ahead to have a career on the big screen. For *Life* editors, the image of an Asian woman dressed in a cheongsam exhibited class through fashion. The portrayal of Kwan as a woman with class is evident in the photo-essay, but also in the context of *Life* editors' desire to promote a modern American life. Since any particular photo-essay can only be understood in its current moment, this section examines the representation of the photo-essay about Nancy Kwan on the cover

wearing a cheongsam and how fashion is situated in the October 24, 1960, issue that represents class status and the modern American woman.

In the realm of fashion, the cheongsam represents Kwan's heritage through dress. The cheongsam which represents old-world China becomes an expression of glamour and professional success for the modern American woman of Chinese descent. Shirley Lim suggests Kwan along with France Nuyen, the Broadway Suzie Wong, gave the cheongsam particular meaning in that it became the symbol of Asian women's sexuality.[20] Lim's argument is of social and cultural importance in that Asian Americans identified with Kwan and Nuyen who found success wearing the cheongsam, so that the dress no longer was an identifier of old or "backward" Chinese culture, but instead became a symbol of pride and beauty for one's history and heritage.

Kwan, dressed in a cheongsam, suggests foreignness. That sense of foreignness in class status and fashion permeated the photo-essays in this issue. *Life* editors depicted Kwan to the forefront as an Asian beauty, with energy and talent while at the same time promoting fashion as a marker for modern Americans. Certainly, *Life* editors were also bringing entertainment news to its readers and placing Kwan on the cover was both natural and risky at the same time. However, the number of foreign relation articles that filled this issue, using Kwan, wearing a cheongsam, fit with *Life*'s message for educating white middle-class Americans on world current events and indirectly fashion trends.

MIDDLE-CLASS CONSUMPTION ELEVATES CLASS STATUS

Life editors presented the photo-essay about Nancy Kwan, a new movie star, as an advertisement for the movie *The World of Suzie Wong*. As an advertisement it fits alongside other advertisements that emphasized middle-class consumer culture. Journalism scholar Sheila Webb examined cultural intermediaries, or the class of people in occupations such as sales, marketing, advertising, public relations, fashion, and decoration,[21] who elevate the taste of middle-class readers. Webb notes that photos help define norms and behaviors of the middle and upper middle class so that those hoping to join the ranks of the middle class can learn how.[22]

NOTES

1. Hsu, Madeline Yuan-yin. *The Good Immigrants: How the Yellow Peril Became the Model Minority* (Princeton, NJ: Princeton University Press, 2015), 17. See also: Takaki, Ronald T. *Strangers from a Different Shore : A History of Asian Americans*, 1st ed. (Boston: Little, Brown, 1989).

2. Ibid., *Strangers from a Different Shore*, 167.

3. Sheridan Prasso, *The Asian Mystique: Dragon Ladies, Geisha Girls, and Our Fantasies of the Exotic Orient* (New York: Public Affairs, 2005).

4. Prasso, *The Asian Mystique*, 58.

5. Prasso, *The Asian Mystique*, 59.

6. I remember debates with my family in the 1960s after the movie's release. My mother was pleased about Kwan's starring role. My grand aunts were not. In retrospect, it may have been generational. My mother, a younger woman, saw Kwan's role as a character whereas her aunts saw it as a replay of stereotypes.

7. Hanying Wang, "Portrayals of Chinese Women's Images in Hollywood Mainstream Films—An Analysis of Four Representative Films of Different Periods." *Intercultural Communication Studies* 21, no. 3 (2012): 78.

8. Rickie Solinger, "The Smutty Side of *Life*: Picturing Babes and Icons of Gender Difference in the Early 1950s," in *Looking at LIFE Magazine*, ed. Erika Doss (Washington, DC: Smithsonian Institution Press, 2001), 202.

9. Michelle Elizabeth Cicero, "Rocketing Into Your Daily Life: *Life* Magazine, the Postwar Advertising Revolution, and the Selling of the United States Space Program, 1957–1966" (PhD diss., University of North Carolina Wilmington, 2007), 56.

10. Erika Doss, *Looking at LIFE Magazine* (Washington, DC: Smithsonian Institution Press, 2001), 3.

11. Wendy Kozol, *Life's America: Family and Nation in Postwar Photojournalism* (Philadelphia: Temple University Press, 1994).

12. Doss. *Looking at LIFE Magazine*, 1.

13. Doss, *Looking at LIFE Magazine*, 4.

14. Laura Mulvey, "Unmasking the Gaze: Some Thoughts on New Feminist Film Theory and History," *Lectora: Revista de Dones i Textualitat*, no. 7 (2001): 7.

15. Mulvey, "Unmasking the Gaze," 7.

16. Wendy Kozol, "Gazing at Race in the Pages of *Life*: Picturing Segregation through Theory and History." In Doss, *Looking at LIFE Magazine*, 161.

17. Doss, *Looking at LIFE Magazine*, 3.

18. Solinger, "The Smutty Side of *Life*."

19. LIFE. "Enter Suzie Wong: A Hong Kong Lassie Plays Suzie's Role." *Life*, October 24, 1960, 55–60.

20. Shirley Jennifer Lim, *A Feeling of Belonging: Asian American Women's Public Culture, 1930-1960* (New York: New York University Press, 2005), 170.

21. Sheila M. Webb, "The Consumer-Citizen: *Life* magazine's Construction of a Middle-Class Lifestyle through Consumption Scenarios," *Studies in Popular Culture* 34, no. 2 (2012): 23.

22. Webb, "The Consumer-Citizen," 23.

Chapter 9

Patsy Takemoto Mink, More than the "First Congresswoman from Overseas"

Patsy Takemoto Mink was the first woman of color elected to Congress in 1965. The "close-up" photo-essay of Mrs. Mink was in the January 22, 1965, issue released before the second inauguration of President Lyndon Johnson. The context could not be more aligned with the newsworthiness of Ms. Takemoto Mink, a Japanese American from Hawaii. She represented an American story of triumph of civil rights and women's rights. The photo-essay titled "First Congresswoman from Overseas" is a testament to *Life* editors' use of language to avoid racial identification. The title sidestepped marking race as a factor to define an American national identity. In addition, using the word "overseas" made sense in this photo-essay title. Hawaii is in fact "overseas"—Honolulu is more than 2,500 miles from Los Angeles—a far and away state within the United States, but the term also implies intrigue as someplace foreign. The subtitle, located above the title, reads, "Hawaii's Patsy Mink goes to Washington." Thus, *Life* editors artfully made a Japanese American U.S. Congresswoman from Hawaii seem foreign but still part of America.

The bonus for *Life* editors was the sensational feel to the story. Hawaii's majority Asian and racially mixed population added the sense of foreignness. Even before Hawaii became the fiftieth U.S. state in 1959, it had been marketed primarily by tour agencies as a beach destination very far away, in the middle of the Pacific. For example, in October 1965, *Life* had fourteen pages of photos on visiting Hawaii. The photos in that issue show spectacular views of craters, waterfalls, and mountains with people frolicking among the wave at the beach. Within the feature, a page titled "travel" had a map of the islands and instructions on how to island hop by airplane. Other than native Hawaiians dressed to perform native dances for tourists, the Asian population that inhabited the islands were largely invisible. The Hawaiian Islands

marketed as a tourist spot, catered to middle- and upper-middle-class white Americans on the U.S. mainland. The photo-essay of Patsy Takemoto Mink was newsworthy—a Japanese American woman going to Washington to take part in the governing of the United States. At the same time, *Life* editors could utilize her story as a symbol of nonviolent racial and gender integration in America.

SIMPLY CALL ME AMERICAN

Life editors presented Patsy Takemoto Mink as a "Close-up," a special feature dedicated to one special topic. We know this is a special "close-up" feature because the term is clearly written in print, in the top left corner of the page. In dedicating three pages to Patsy Mink, *Life* editors positioned her as a professional working woman in addition to providing markers of middle-class status such as motherhood and artistic interests.

The close-up of Patsy Takemoto Mink opens with a large family photo of Mrs. Mink, her husband, and their daughter. All three smile looking into the camera with the backdrop of an outdoor tropical setting. What's clear is that Mink's husband is white and thus their daughter is mixed race. The caption tells the reader that Mink's husband's name is John and that he is a geologist. The caption continues to explain the family photo below. Wearing campaign shirts reading "Think Mink," the family stands proudly. Daughter Gwen is twelve. *Life* editors quote Mink in a caption to the left of the photo: "Getting elected took a lot of island hopping, and sometimes five coffee hours in one evening, but—it was festive too."

Mink's election is news that demands the reader accept the information. *Life* editors as journalists put forth objective facts—through photos. However, *Life* editors center the understanding of those facts (photos) in the subjective experience of their white middle-class reader.

The Mink family photo occupies more than half of the page. As a family photo, it situates the photo-essay in a female perspective which is centrifugal in the photo-essay. Kress and Van Leeuwen would call the photo a representation of participants.[1] The theme is of family action in that the reader is positioned close to the family. Patsy Mink, her husband John, and their daughter, Gwen, smile as they face the reader frontally. The Mink family looking directly at the camera greets the reader. A smaller photo at the top left corner of the page is of Mrs. Mink holding a briefcase. She walks in a dark overcoat toward the camera. She is smiling as she looks at the camera. Her husband John is by her side in the act of speaking as he looks at Mink. The focus of the photo is squarely on Mrs. Mink. The two photos together show that Mink is both a professional working woman with attention to family. The

implication is that Mink holds family values dear to middle-class Americans while also speaking for racial and gender progress in equal representation in middle-class professions.

The photos on this page work against the power of authority in the structure of expectations. Mink is in an interracial marriage. The photo-essay is constructed rhetorically that shows her as an American. The family photo is a modern feminine experience of a professional woman and an interracial family. At the same time *Life* editors give Mrs. Mink control by reversing the expected role of the female in domestic roles. For example, the small photo showing Mink in a dark overcoat with a briefcase is in contrast to more common images of men in dark suits walking with a briefcase. This observational place of reverse expectation is highlighted in several more photos as *Life* editors show Mink in preparation for her journey to Washington. The interactive elements of texts that relate to the photo indirectly weave connections to mark race and gender into the story. The title is a good example of interactive texts in relation to race and gender. Mink is the "First Congresswoman from Overseas." The title and subtitle are visual images. The title is in large bold font, the subtitle, in small font, is not bolded. The bold font title indicates *Life* editors want the reader to be first cognizant of that the woman is from overseas without regard to race as a marker of the standard white American identity. The focus on Hawaii in the subtitle also does not hint at race. The visual image of text tells of gender but says nothing of race. However, as the reader views the photos on the page, the entirety of the photo-essay is a reverse expectation of seeing the white American in Congress.

Since *Life* editors are the authors of this page, they speak in the guise of Patsy Mink. Through captions, the exposé, and the title, *Life* editors speak through Mink as a character in the story. The exposé begins: "'I just live for the day when people will look at me and simply call me an American.' This fervent hope does not come from a recent immigrant but from a brand-new member of the United States House of Representatives. Patsy Takamoto Mink, 37, is of Japanese descent and a congresswoman at large from her native Hawaii."

The above statement is made as if in face-to-face communication with the reader. The "I" is the real speaker, that is to say, Mink, but the images of Mink are only representations of her. *Life* editors are the author of the composition on the page. The relationship between *Life* editors and the reader is portrayed through Mink. Thus, the photo encourages the reader to respond to Mink. At the same time, whether or not the reader identifies with Mink, the reader does understand how they are being addressed.

The implication of Mink's statement is that white middle-class Americans might believe that Asians cannot be fully American but must instead have some sort of divided loyalty. *Life* editors demand that readers form a

relationship with Mink's status as a Congresswoman. This means that *Life* editors who produced the text and the *Life* photographer who produced the photo address the reader in the voice of a friend in that the friend introduces the reader to a new thought—that Americans can come in any color.

Life editors continue to quote Mink: "'I feel, act and live like any other American the country over. What I bring to Congress,' she says, 'is a Hawaiian background of tolerance and equality that can contribute a great deal to better understanding between races.'"

With this quote there are two functions. There is the visual image of Mink and her family in directly addressing the reader and the text of the exposé educating the reader. *Life* editors used the image of Mink's family to make the point of an interracial marriage. The photo and the text together explicitly speak of race tolerance and equality. To have a representative in Congress of Japanese ancestry married to a white American asks the reader to have a social affinity with an interracial married couple. Through the image of family, *Life* editors want the reader to form a bond with Mink.

Kress and Van Leeuwen discuss the concept of salience, which is an element made in the visual to attract the reader's attention.[2] In this case it is the largeness of Mink's family photo with the people forming the largest component in the photo. The reader gazes at the interracial couple, but the face of the child is the central focus. Wendy Kozol discussed the racial gaze as different from the male gaze, which was coined by Mulvey on how males

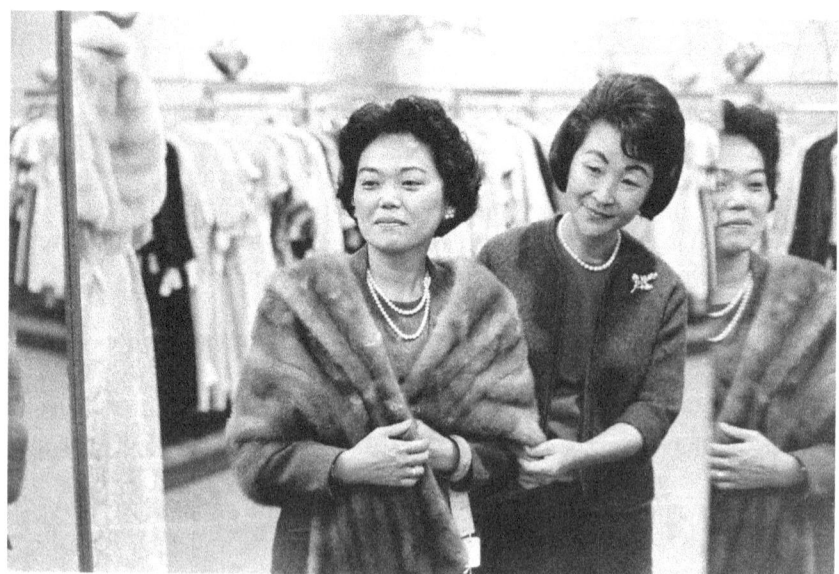

Figure 9.1 **Japanese American Patsy Mink Congresswoman from Hawaii.** *Source*: Getty Images, Ralph Crane, *Life* Picture Collection.

gaze women as objects of desire.³ The racial gaze looks with curiosity to see a child as a mixed race, a blend of both parents. The reason for the focus on the child's face is to create interest for the white middle-class *Life* reader in a nation that still had anti-miscegenation laws in effect. In creating this layout, *Life* editors had a mental image of their readers.⁴ If the viewer is of white American middle-class background, then in this case, the gaze is racial at the Asianness of the child who is mixed race.

The exposé closes with a final quote: "I hate to hear people refer the mainland as 'back in the States,' says Mrs. Mink. 'We feel very much part of the United States and we want other people to see us that way too.'" This final quote opens a space for what defines an American. The follow-up phrase "we want other people to see us" comes from Patsy Mink but also from *Life* editors in that Patsy Mink and the State of Hawaii is majority Asian, but a place where one can be American of Asian ancestry (figure 9.1).

PROFESSIONAL

As the reader turns the page, the close-up feature changes tone and repositions the reader from a friend of Mink to an observation of Mink in daily life. The photos situate the reader as an observer because Mink is not looking into the camera. Following each of the three photos on this page is first a caption followed by a quote by Mrs. Mink. The three photos of Mrs. Mink cover a full page. The most salient photo is the large photo that takes most of the lower half of the page. In this photo Mink is in a women's clothing store. The caption states, "Patsy tries on mink stole in Honolulu." The photo shows Mink looking at herself in a mirror as she sizes the mink jacket snug against her torso. The sales woman looking in the mirror is presumably also judging the fit of the mink on Mrs. Mink. The word play on mink is an attempt to insert humor into the story line occurring at a time of upheaval when people of color were statutorily given equal rights to that of white Americans in jobs, education, and housing through the Civil Rights Act of 1964 and signed into law by President Lyndon Johnson. The play on humor may have been a way to lighten any intensity related to political or social upheaval.

In the photo of Mrs. Mink wearing the mink stole, she is both the subject and the object. As the subject of the photo, Mrs. Mink is looking out at herself in the mirror. She is inside the photo not as an object but as herself in her own image. The reader, however, is in a dual position to gaze at her as an outsider and as an insider. The top photo on the left of the page show Mrs. Mink greeting her husband near the front door of their home. The reader is the viewer, not part of the photo. In addition, the photo shows Mrs. Mink's full body. She is smiling as her husband is taking off his shoes before entering their home.

The show of taking off shoes before entering the home is a show of domesticity in which a house wife cares for the cleanliness of her home. Taking off one's shoes before entering the home is attributed to Japaneseness because the caption says, "following a Japanese practice—before entering their house in Hawaii." A few shoes and house slippers lie on doormat. However, while it is a Japanese practice to remove shoes before entering a home, it is also a practice in Hawaii among Asian races because in the days that Asians immigrated as plantation workers, removing shoes before entering anyone's home was a practical matter of not tracking in dirt after walking in the fields. In addition, my grandfather who grew up on Kauai in the early twentieth century often told me stories of not wearing shoes, even to school. Thus, when my grandfather did wear shoes, for special occasions, they removed shoes before entering the home to protect the shoes as well as the home.

Kress and Van Leeuwen talk about invisible boundaries that imply social distance. They state that the more we see of a face or of a head, the photo implies an intimate distance. However, with whole figures or a full body, the photo implies a public distance in which people remain strangers.[5] *Life* editors chose a photo that shows the full bodies of Mrs. Mink and her husband. The implication is to keep the reader at a distance as an observer of the scene. Nevertheless, because the photo takes place in front of the Mink home, the setting implies a middle-class home. When the caption states that taking off shoes is common Japanese practice before entering the home, the caption with photo implicates Mrs. Mink in a feminine position—in that the setting of the "home" connects women to the task of sustaining a home environment. Mrs. Mink's stance at the door entrance suggests she is the authority of the home and its cleanliness. Therefore, the photo shows Mrs. Mink in a domestic activity from a middle-class feminine standpoint. The reader at a social distance is an observer of the cultural practice of taking off shoes before entering the home.

The photo directly below to the right center of the page shows a different facet of Mrs. Mink—her hobby in creating Japanese masks. The photo shows a side view of Mrs. Mink as she looks at a Japanese traditional mask. The caption tells the reader that the mask has special meaning in Japanese culture. It reads in part: "Patsy treasured this Japanese paper maché doll, whose eyes, by tradition, aren't painted in until the owner's secret wishes come true."

The Japanese mask belongs to Mrs. Mink's private world as her hobby. The mask tradition also belongs to a feminine connection with home hobbies. Through the photo, *Life* editor's give the reader a perception of home life that marks a world which middle-class Americans might find familiar. A hobby such as collecting and creating masks is included in this photo-essay to show daily duty in the home of a woman.

As a news magazine, *Life* editors reported through photos and text a slice of Patsy Mink's life as a middle-class American. The overall composition of the three photos on this particular page created distance between the reader and *Life* editors so that readers received a sense of an objective news story. Since the two top photo frames are smaller relative to the bottom photo, the page layout is similar to that of a family photo album.

MIDDLE-CLASS AMERICA IN 1965, INTERRACIAL MARRIAGE, AND CONSUMER CONSUMPTION

As discussed in chapter 7, anti-miscegenation was still the law in many states in 1965.[6] However, with this photo-essay of the Mink family, *Life* editors show that interracial marriage is a nonissue in Hawaii. The message behind the photo-essay is of progress with racial and gender equality in America. When looking at the family photo of the Minks together, the reader sees a Japanese American woman married to a white American man living a modern American middle-class lifestyle.

To foster the middle-class image, and to tie into Mrs. Mink a professional woman, opposite the page of Mrs. Mink is a full-page color ad for Royal typewriters. The title of the ad "Royal Touch" is speaking to women in the workplace. The opening line says: "For offices, schools or homes." Below are pictured three women on the left side of the page. One woman is dressed for school, one dressed for the office, and one dressed for travel. On the right side of the page, the text speak to the reader. It starts, "Ask the girls: students, top executives' secretaries, professional women." The theme is women in professional roles. The women look out at the reader smiling. As an advertisement there is an offer to purchase Royal Touch typewriters. Kress and Van Leeuwen make a distinction between communicative functions between the left side of a page and right side of the page layout.[7] When looking at the double-page layout, the left page is of Patsy Mink and on the right page are professional women. The photos of Patsy Mink opposite the ad for Royal Touch typewriters seek to make the imaginary relation between the professional women and Patsy Mink. In addition the word "touch" is used in the photo-essay of Patsy Mink with her hobby of mask painting. The title "Japanese Customs and a Touch of Elegance" is used to perhaps bring admiration for Patsy Mink's hobby of painting masks, her role as a professional woman, along with the modern use of an electric typewriter. Interracial marriage is immaterial to the message. Interracial marriage is not the issue. Progress of racial and gender equality was exactly the point *Life* editors wanted to make with the placement of the advertisement.

The photo-essay concludes on the inside column of the centerfold with a photo of Mrs. Mink in full figure, dancing the hula on the beach. The focus is

on Patsy Mink, not on her interracial marriage but on a middle-class lifestyle. With Diamond Head, a Hawaiian landmark, in the background, the photo is juxtaposed with an advertisement to the left in the outside column for visiting Phoenix, Arizona. As on the previous page the photos and advertisements are side by side. The advertisement mentions that Phoenix is also known as the "Valley of the Sun." The photo of Patsy Mink on the beach in Hawaii makes a relationship between the two locations, which encourages tourism and accentuates Hawaii, a place where one might find beautiful and smart Asian American women like Patsy Mink.

A FINAL POINT

We know that males did gaze at this photo-essay of Patsy Mink. In a letter to the editor dated February 12, 1965, Robert G. Bridgeman of Waynesville, North Carolina, wrote, "In your close up. Patsy Mink is pictured doing the hula in her yard at Waipahu 15 miles west of Honolulu. With an old landmark like Diamond Head in the background, that would put her on Waikiki beach, 20 miles from Waipahu." Waikiki it was___ED

The letter to the editor signed by managing editor Edward Thompson (ED) tells us that *Life* editors viewed the photo-essay of Patsy Mink as a positive story and a representation of America. Robert G. Bridgeman clearly had been to Honolulu and was familiar with Oahu. More importantly he gazed at Patsy Mink. By posting this letter, *Life* editors show readers that Hawaii is known by many readers. The islands are familiar to Americans as part of America. By extension so should be the people of Hawaii, like Patsy Mink and her family.

NOTES

1. Gunther R. Kress and Theo van Leeuwen, *Reading Images: The Grammar of Visual Design*, 2nd ed. (London: Routledge, 2006), 47.
2. Kress and Van Leeuwen, *Reading Images*, 177.
3. Wendy Kozol, "Gazing at Race in the Pages of *Life*: Picturing Segregation through Theory and History," in *Looking at LIFE Magazine*, ed. Erika Doss, 159–175 (Washington, DC: Smithsonian Institution Press, 2001), 160.
4. Kress and Van Leeuwen, *Reading Images*, 114.
5. Kress and Van Leeuwen, *Reading Images*, 125.
6. Phyl Newbeck, *Virginia Hasn't Always Been for Lovers: Interracial Marriage Bans and the Case of Richard and Mildred Loving* (Carbondale: Southern Illinois University Press, 2008), 38.
7. Kress and Van Leeuwen, *Reading Images*, 116.

Afterword

Stories about Asian women as sex objects, temptresses, or prostitutes have been around for almost two centuries within the United States. Like the rest of the world, on March 16, 2021, I watched the news report of six Asian women shot and killed at spas in the Atlanta, Georgia, area. I was aghast and angry when the suspect claimed that he had a sex addiction and wanted to eliminate temptation from the massage spas. As a fourth-generation American who happens to have an Asian face, I am reminded that many people will never see me for who I am, a human being but, instead, as a blank face for others to project their own stories—all too often sexualized fantasies. The question becomes: How do we change narratives such as those that package Asian women as sexual objects?

Life editors used their cultural authority to show Asian American women as distinct from women in Asia. *Life*'s America suggested that American women of Asian descent were acting and living much like white American middle-class women counterparts. The vehicle for change is not ideas but action. Through photo-essays or stories, *Life* magazine editors took rhetorical action by composing narratives that affirmed Asian American women as middle-class Americans and as humans. *Life* Editors showed that stereotypes, superficial layers from a white American perspective, were not the reality in the lives of Asian American women. As in my first chapter, titled "Chinese School," *Life* editors showed little girls in Chinese costume. Yet, the photo-essay revealed young Chinese American girls attending a Catholic school during the Great Depression. The hidden narrative is that Chinese American families could afford the tuition and believed in providing their daughters a Christian education.

With photos, fear can be overcome through revelation. Photo-essays in *Life* revealed Asian American women as part of American culture. This is

most evident in the dancers at the Forbidden City nightclub in San Francisco. The Chinese-themed nightclub, the superficial entertainment of Chinese American women dancing, revealed Asian American women who were attending college.

Prejudices do not disappear in one year or even in one generation. Instead, changing prejudicial views is an infinite pursuit of changing societal narratives. The action to change narratives never ends because it takes effort to redefine one's personal identity. As luck would have it, *Life*'s founder and publisher Henry Luce was born and raised in China and had exposure to Asians. His own identity was tied to Asian people and thus he saw them as people. Luce is long gone, but his identity as a white man of privilege allowed him authority to create narratives through photos, exposing millions of white middle-class Americans to Asian American women—whom most white Americans had never seen before.

Today's media is fragmented, but with new technological platforms that support social media, we as women in the Asian American community can and must tell stories about who we are. Even when or if the current anti-Asian hate dies down, we as American women with an Asian face will still be left in a society that has objectified us for generations. We don't need a new Henry Luce to tell our American story. We have the power to create narratives while dismantling some of those stereotypes about us. This moment, March 16, 2021, has forced me to recognize my Asian face, my race, as inextricable from my gender. But as violence against Asians in America is currently receiving national news coverage, we Americans with Asian faces speak out, demanding respect and dignity as we live our lives.

<div style="text-align: right;">Karen Lynn Ching Carter, March 2021</div>

Bibliography

Ashcroft, Bill. "Language and Race." *Social Identities* 7, no. 3 (2001): 311–328. https://doi.org/10.1080/13504630120087190.
Baughman, James L. "Who Read *Life*? The Circulation of America's Favorite Magazine." In *Looking at LIFE Magazine*, edited by Erika Doss, 41–51. Washington, DC: Smithsonian Institution Press, 2001.
———. *Henry R. Luce and the Rise of the American News Media*. Boston: Twayne Publishers, 1987.
Brawley, Sean, and Chris Dixon. *Hollywood's South Seas and the Pacific War: Searching for Dorothy Lamour*. London: Palgrave Macmillan, 2012.
Buck, Pearl S. *The Good Earth*. New York: John Day, 1931.
Carter, Karen L. Ching. "High and Low Art in Narrative Construction of a Photo Essay: When Asian American Women became Middle-Class Americans at the Forbidden City Nightclub in San Francisco." *South Atlantic Review* 84, no. 1 (2019): 160–177.
Carter, Karen Lynn Ching. "Performing Ethos in Administrative Hearings Constructing a Credible Persona under the Chinese Exclusion Act Over Time." PhD diss., Arizona State University, 2016. ProQuest (AAT 10105910).
Chang, Stewart. "Feminism in Yellowface." *Harvard Journal of Law & Gender* 38 no. 2 (2015): 235–268.
Cicero, Michelle Elizabeth. "Rocketing Into Your Daily Life: *Life* Magazine, the Postwar Advertising Revolution, and the Selling of the United States Space Program, 1957–1966." PhD diss., University of North Carolina Wilmington, 2007.
Cohen, Miriam. "Population, Politics, and Unemployment Policy in the Great Depression." *Social Science History* 38 nos. 1–2 (2015): 79–87. https://doi.org/10.1017/ssh.2015.7.
Cookman, Claude. *American Photojournalism: Motivations and Meanings*. Evanston, IL: Northwestern University Press, 2009.
Creef, Elena Tajima. *Imaging Japanese America: The Visual Construction of Citizenship, Nation, and the Body*. New York: New York University Press, 2004.

DiBari Jr., Michael. *Advancing the Civil Rights Movement: Race and Geography of Life Magazine's Visual Representation, 1954–1965*. Lanham, MD: Rowman & Littlefield, 2017.

Dolan, Michael. "How Did the White Picket Fence Become a Symbol of the Suburbs?" *Smithsonian Magazine*, April 2019. https://www.smithsonianmag.com/history/history-white-picket-fence-180971635/.

Dong, Lorraine. "The Forbidden City Legacy and Its Chinese American Women." *Chinese America: History and Perspectives* 2 (1992): 125–148.

Doss, Erika, ed. *Looking at LIFE Magazine*. Washington, DC: Smithsonian Institution Press, 2001.

Eisenstaedt, Alfred. *Eisenstaedt's Guide to Photography*. New York: Viking Press, 1978.

———. *Eisenstaedt: Remembrances*. edited by Doris C. O'Neil. New York: Little, Brown, 1990.

Everest-Phillips, Max. 2007. "The Pre-War Fear of Japanese Espionage: Its Impact and Legacy." *Journal of Contemporary History* 42 (2): 243–265. https://doi.org/10.1177/0022009407075546.

Flamiano, Dolores. *Women, Workers, and Race in LIFE Magazine: Hansel Mieth's Reform Photojournalism, 1934–1955*. London: Routledge, 2016.

"For the Marines Fighting Overseas . . . The Era of the Glamorous Pin-Up Girl." *Leatherneck*, November 2017, 40–41. 2017. https://mca-marines.org/wp-content/uploads/2018/12/Leatherneck_November2017.pdf.

Girl Scouts. "Who We Are" page. www.girlscouts.org/en/about-girl-scouts/who-we-are.html.

Gross, Terry. "A 'Forgotten History' of How the U.S. Government Segregated America." *Fresh Air*. NPR, May 3, 2017. https://www.npr.org/2017/05/03/526655831/a-forgotten-history-of-how-the-u-s-government-segregated-america.

Heywood, Leslie, and Justin R. Garcia. "Fashion as Adaptation: The Case of American Idol." In *Fashion Talks: Undressing the Power of Style*, edited by Shira Tarrant and Marjorie Jolles, 67–81. Albany: State University of New York, 2012.

Hill, Ronald Paul, Jeannie Gaines, and R. Mark Wilson. "Consumer Behavior, Extended Self, and Sacred Consumption: An Alternative Perspective from Our Animal Companions." *Journal of Business Research* 61, no. 5 (2008): 553–562. https://doi.org/10.1016/j.jbusres.2006.11.009.

Holbrook, Morris B., and Arch G. Woodside. "Animal Companions, Consumption Experiences, and the Marketing of Pets: Transcending Boundaries in the Animal-Human Distinction." *Journal of Business Research* 61, no. 5 (2008): 377–381. https://doi.org/10.1016/j.jbusres.2007.06.024.

Hsu, Madeline Y. *The Good Immigrants: How the Yellow Peril Became the Model Minority*. Politics and Society in Modern America 114. Princeton, NJ: Princeton University Press, 2015.

Kang, Laura Hyun Yi. *Compositional Subjects: Enfiguring Asian/American Women*. Durham, NC: Duke University Press, 2002.

Karthikeyan, Hrishi, and Gabriel J. Chin. "Preserving Racial Identity: Population Patterns and the Application of Anti-Miscegenation Statutes to Asian Americans, 1910–1950." *Asian Law Journal* 9, no 1 (2002): 1–21.

Kohr, Kaitlyn Elizabeth. "Our Lady of Perpetual Desire: Religious Discourses of the American Pin-Up Girl in World War II." Master's thesis, Sarah Lawrence College, 2015. https://digitalcommons.slc.edu/womenshistory_etd/3.

Kozol, Wendy. *Life's America: Family and Nation in Postwar Photojournalism.* Philadelphia: Temple University Press, 1994.

———. "Gazing at Race in the Pages of *Life*: Picturing Segregation Through Theory and History." In *Looking at LIFE Magazine*, edited by Erika Doss, 159–175. Washington, DC: Smithsonian Institution Press, 2001.

Kress, Gunther R. and Theo van Leeuwen. *Reading Images: The Grammar of Visual Design.* 2nd ed. London: Routledge, 2006.

Kuo, Karen. *East is West and West is East: Gender, Culture, and Interwar Encounters between Asia and America.* Asian American History & Culture. Philadelphia: Temple University Press, 2013.

Lee, Anthony W. "Crooning Kings and Dancing Queens: San Francisco's Chinatown and the Forbidden City Theater." In *Reading California: Art, Image, and Identity, 1900-2000*, edited by Stephanie Barron, Ilene Susan Fort, and Sheri Bernstein, 199–220. Berkeley: University of California Press, 2000.

———. *Picturing Chinatown: Art and Orientalism in San Francisco.* Berkeley: University of California Press, 2001.

Lee, Erika. *At America's Gates: Chinese Immigration During the Exclusion Era, 1882–1943.* Chapel Hill: University of North Carolina Press, 2003.

———. "The 'Yellow Peril' and Asian Exclusion in the Americas." *Pacific Historical Review* 76, no. 4 (2007): 537–562. https://doi.org/10.1525/phr.2007.76.4.537.

Lee, Sharon M., and Marilyn Fernandez. "Trends in Asian American Racial/Ethnic Intermarriage: Comparison of 1980 and 1990 Census Data." *Sociological Perspectives* 41, no. 2 (1998): 323–342. https://doi.org/10.2307/1389480.

LIFE. "Chinatown School." *Life*, November 23, 1936, 24–25.

———. "Coast Japs are Interned in Mountain Camp." *Life*, April 6, 1942, 15–19.

———. "First Congresswoman from Overseas: Hawaii's Patsy Mink Goes to Washington." *Life*, January 29, 1965, 49–52.

———. "Hawaii: A Melting Pot; A Score of Races Live Together in Amity." *Life*, November 26, 1945, 103–111.

———. "Life Goes To the 'Forbidden City': San Franciscans Pack Chinatown's No. 1 Night Club." *Life*, December 9, 1940, 124–127.

———. "Enter Suzie Wong: A Hong Kong Lassie Plays Suzie's Role." *Life*, October 24, 1960, 55–60.

———. "Introduction to the First Issue of LIFE." *Life*, November 23, 1936.

———. "The Nisei: California Casts an Anxious Eye upon Japanese-Americans in Its Midst." *Life*, October 14, 1940, 75–82.

———. "Speaking of Pictures . . . Marines find Pin-Ups and Glamour on Guam." *Life*, June 18, 1945, 12–14.

———. "Tule Lake: At this Segregation Center are 18,000 Japanese Considered Disloyal to the U.S." *Life*, March 20, 1944, 25–35.

LIFE Magazine and the Power of Photography. Exhibit. Princeton University Museum, Princeton, NJ. February 22–September 27, 2020.

Lim, Shirley Jennifer. *A Feeling of Belonging: Asian American Women's Public Culture, 1930-1960*. American History and Culture 3. New York: New York University Press, 2005.

Long, Kelly Ann. "Friend or Foe: *Life*'s Wartime Images of the Chinese." In *Looking at LIFE Magazine*, edited by Erika Doss, 55–75. Washington, DC: Smithsonian Institution Press, 2001.

Luce, Henry Robinson. *The ideas of Henry Luce*. New York: Atheneum, 1959.

Marable, Darwin. "Carl Mydans: An interview." *History of Photography* 26, no. 1 (2002): 47–52. https://doi.org/10.1080/03087298.2002.10443253.

Mulvey, Laura. "Unmasking the Gaze: Some Thoughts on New Feminist Film Theory and History." *Lectora: Revista de Dones i Textualitat* 7 (2001): 5–14.

Murakami, Yumiko. "Hollywood's Slanted View." *Japan Quarterly* 46, no. 3 (1999): 54–62.

Newbeck, Phyl. *Virginia Hasn't Always Been for Lovers: Interracial Marriage Bans and the Case of Richard and Mildred Loving*. Carbondale: Southern Illinois University Press, 2008.

Okamura, Jonathan Y. "Race Relations in Hawai'i During World War II: The Non-Internment of Japanese Americans." *Amerasia Journal* 26, no. 2 (2000): 117–141. https://doi.org/10.17953/amer.26.2.m22163g2t347k608.

Okihiro, Gary Y. *Margins and Mainstreams: Asians in American History and Culture*. Seattle: University of Washington Press, 2014.

Peffer, George Anthony. *If They Don't Bring Their Women Here: Chinese Female Immigration Before Exclusion*. Urbana: University of Illinois Press, 1999.

Phu, Thy. *Picturing Model Citizens: Civility in Asian American Visual Culture*. Philadelphia: Temple University Press, 2012.

Prasso, Sheridan. *The Asian Mystique: Dragon Ladies, Geisha Girls, and Our Fantasies of the Exotic Orient*. New York: Public Affairs, 2005.

Riessman, Catherine Kohler. *Narrative Methods for the Human Sciences*. Thousand Oaks, CA: Sage, 2007.

Royster, Jacqueline Jones, and Gesa E. Kirsch. *Feminist Rhetorical Practices: New Horizons for Rhetoric, Composition, and Literacy Studies*. Studies in Rhetorics and Feminisms. Carbondale: Southern Illinois University Press, 2012.

Said, Edward W. *Orientalism*. New York: Pantheon Press, 1978.

Smith, Terry. "*Life*-Style Modernity: Making Modern America." In *Looking at LIFE Magazine*, edited by Erika Doss, 25–39. Washington, DC: Smithsonian Institution Press, 2001.

Smith-Rodden, Martin, and Ivan K Ash. "The Effect of Emotionally Arousing Negative Images on Judgments About News Stories." *Visual Communication Quarterly* 24, no. 1 (January 2, 2017): 15–31. http://www.tandfonline.com/doi/abs/10.1080/15551393.2016.1272418.

Solinger, Rickie. "The Smutty Side of *Life*: Picturing Babes and Icons of Gender Difference in the Early 1950s." In *Looking at LIFE Magazine*, edited by Erika Doss, 201–219. Washington, DC: Smithsonian Institution Press, 2001.

Spickard, Paul R., and Rowena Fong. "Pacific Islander Americans and Multiethnicity: A Vision of America's Future?" *Social Forces* 73, no. 4 (1995): 1365–1383. https://doi.org/10.2307/2580451.

Steinbeck, John. *The Grapes of Wrath*. New York: Viking, 1939.
Sutherland, Patrick. "The Photo Essay." *Visual Anthropology Review* 32, no. 2 (2016): 115–121. https://doi.org/10.1111/var.12103.
Vials, Chris. "The Popular Front in the American Century: *Life* Magazine, Margaret Bourke-White, and Consumer Realism, 1936–1941." *American Periodicals: A Journal of History & Criticism* 16, no. 1 (2006): 74–102. https://doi.org/10.1353/amp.2006.0009.
———. *Realism for the Masses: Aesthetics, Popular Front Pluralism, and U.S. Culture, 1935–1947*. Jackson, MS: University Press of Mississippi, 2009.
Wainwright, Loudon. *The Great American Magazine: An Inside History of LIFE*. New York: Knopf, 1986.
Wang, Hanying. "Portrayals of Chinese Women's Images in Hollywood Mainstream Films—An Analysis of Four Representative Films of Different Periods." *Intercultural Communication Studies* 21, no. 3 (2012): 82–92. https://web.uri.edu/iaics/files/07Wang.pdf.
Webb, Sheila M. "'America Is a Middle-Class Nation': The Presentation of Class in the Pages of *Life*." In *Class and News*, edited by Don Heider, 167–198. Lanham, MD: Rowman & Littlefield. 2004.
———. "Art Commentary for the Middlebrow: Promoting Modernism & Modern Art through Popular Culture—How *Life* Magazine Brought 'The New' into Middle-Class Homes." *American Journalism* 27, no. 3 (2010): 115–150. https://doi.org/10.1080/08821127.2010.10678155.
———. "Creating *Life*: 'America's Most Potent Editorial Force.'" *Journalism & Mass Communication Monographs* 18, no. 2 (2016): 55–108. https://doi.org/10.1177/1522637916639393.
———. "The Consumer-Citizen: *Life* Magazine's Construction of a Middle-Class Lifestyle Through Consumption Scenarios." *Studies in Popular Culture* 34, no. 2 (2012): 23–47.
———. "A Pictorial Myth in the Pages of *Life*: Small-Town America as the Ideal Place." *Studies in Popular Culture* 28, no. 3 (2006): 35–58.
Wilson, Robert. "Landscapes of Promise and Betrayal: Reclamation, Homesteading, and Japanese American Incarceration." *Annals of the Association of American Geographers* 101, no. 2 (2011): 424–444. https://doi.org/10.1080/00045608.2010.545291.
Wu, Ellen D. *The Color of Success: Asian Americans and the Origins of the Model Minority*. Politics and Society in Modern America 100. Princeton, NJ: Princeton University Press, 2013.

Index

Note: Page locators in italics refer to figures.

advertisements: in "First Congresswoman from Overseas," 111–12; in "Forbidden City," 18; in "Glamour on Guam," 76–77; G. Washington instant coffee, 76; John Hancock Insurance, 29–30; in "Nancy Kwan," 93–94, 97, 101; in "The Nisei," 29–30; photo-essay and, xiv–xv, xx; Royal Touch typewriters, 111
Akitsuki, Byron, 59, *59*
America: citizenship in, 6–7; four eras of, xix; white, xiii, xv, xvi, xvii
Ancient Japanese and American traditions, 23–26, *24*
anti-miscegenation, 88; "First Congresswoman from Overseas" and, 111; "Glamour on Guam" and, 68–69; "Hawaii" and, 83, 86. *See also* interracial marriage; racism
Army, U.S.: in "Mountain Camp," 42–44, 46; in "Tule Lake," 52–53
Ashcroft, Bill, 79
Asian American Women: definition of, xv; as middle class, xiii, xvi–xvii, xix, 113; perception of, 94; prostitute stereotyping of, xiii, xv, 14, 95, 98, 113; racist laws and, xv, xxivn19, xxivn20, 4. *See also* Chinese Americans; Japanese Americans; women
Austin, Verne, 52

Belton, Wade, 86
Billings, John Shaw, 13
Bordallo, Barbara, 74, 75
Bourke-White, Margaret, xvi
Bowron, Fletcher, 27
Breckner, Robert, 16
Bridgeman, Robert G., 112
Buck, Pearl S., 9

Cameron, Patricia, 85
Carter, Karen, 18
Catholicism, 7–9, 11–12
censorship, xxi, xxvn53
Chamorro, 68, 71, 75
Chandler, Harriet, 72
cheongsam, 97–98, 101–2
Chinese: immigration of, 4–6, 12n13, 94
Chinese Americans: gender imbalance in, 6; girls, 5, 6, *7*; in "Hawaii," 87–89; women on magazine covers, 93
Chinese Exclusion Act, 5–6, 88

"Chinese School," xx; analysis of, 6–10, 7; candid photo in, 10; Catholicism in, 7–9; education in, 9; exposé in, 4, 8; in first issue of *Life*, 3–5, 11–12; Great Depression, costumes, middle class and, 10–12; language lessons in, 8; photos in, 9; uniforms in, 10–11; Young American Chinese girls, 6, 7; "Young Americans" in, 6, 11

citizenship: in America, 6–7; anti-miscegenation and, 69; mixed-race, Asians and, 80, 84; "Tule Lake" and, 63–64

Civil Rights Act (1964), 109

Clark, Beatrice, 85

Clark, George Rogers, 29–30

close social distance, 52

close-up photos, 81

"Coast Japs Are Interned at Mountain Camp," xxi; Army in, 42–44, 46; Executive Order 9066 and, 37, 40, 46; exposé in, 39, 41–42; Germans, Italians and, 41–42; grandeur scenery in, 39–40; internment justification in, 38–41, 45; Issei in, 42; Japanese American evacuation in, 38–40; Japanese American families in, 37; "Jap" in, 40, 44, 45; "Jeeps Lead Japs on Journey from the Sea" and, 43–45; middle class possessions in, 43–45; modern amenities in, 45–47; narrative of, 37–38, 46; Nisei girls in, 46; Okies and, 43–45; Pearl Harbor and, 37, 40; pejorative words in, 41; profitability in, 41; racism in, 39; Roosevelt and, 37, 39; volunteers in, 40–41; without women, 43. *See also* Japanese Americans

constitutional rights, 49–51, 58, *60*, 60–62

costumes, 10–12

critical imagination, xviii

Diekemper, Ray, 16

Earnst, Charlotte, 33

Eisenstadt, Alfred, 4, 9, 10

Elisofon, Eliot, 37, 81

espionage, 21–22, 26

eugenics, 69, 86

Executive Order 9066, 37, 40, 46

Executive Order 9981, 69

exposé: in "Chinese School," 4, 8; definition of, 4; in "First Congresswoman from Overseas," 107–9; in "Forbidden City," 13, 15–16; in "Glamour on Guam," 68; in "Hawaii," 81–85, 87–89; in "Mountain Camp," 39, 41–42; in "Nancy Kwan," 100; in "The Nisei," 22–24; in "Tule Lake," 52, 53

farmers, 53–54

fashion: cheongsam, 97–98, 101–2; in "Glamour on Guam," 68, 70–72, 74, 75

feminist rhetorical historiography: critical imagination in, xviii; social circulation in, xviii; strategic contemplation in, xviii

feminist theory, on male gaze, 98, 108–9

Filipinos, 87–89

"First Congresswoman from Overseas," xxiii; advertisements in, 111–12; anti-miscegenation and, 111; close-up in, 105–6; exposé in, 107–9; Hawaiian Islands in, 105–6, 109, 112; hobbies in, 110, 111; interracial marriage in, 107–8, 111–12; language in, 105; letter to editor on, 112; middle class consumer consumption in, 111–12; Mink as American, 106–9, *108*; Mink daily life in, 109–11; mixed-race family in, 106–7; racial gaze in, 108–9; women professionals in, 111

Fong, Rowena, 80

"Forbidden City." *See* "Life Goes to The Forbidden City"

Fourteenth Amendment of the U.S. Constitution, 6

Germans, 41–42
girls: Chinese American, 5, 6, 7; Japanese American, 28–29; in "Mountain Camp," 46; pin-up, 70; Two Nuns Questioning Bashful Girl, 2; Young American Chinese girls, 6, 7. *See also* women
"Glamour on Guam." *See* "Marines Find Pin-Ups and Glamour on Guam"
The Good Earth (Buck), 9
Grable, Betty, 70
The Grapes of Wrath (Steinbeck), 43, 45
Great Depression: "Chinese School," costumes, middle class and, 10–12; "Forbidden City" and, xx; "The Nisei" and, xx–xxi; unemployment during, 4
Guam. *See* "Marines Find Pin-ups and Glamour on Guam"
Guamanian Americans, 70–71
Guerrero, Ignacia Leon, 73, 74
G. Washington instant coffee advertisement, 76

Haoles, 79–80
"Hawaii," xxii; anti-miscegenation and, 83, 86; Asian majority in, 86–89; exposé in, 81–85, 87–89; Haoles in, 79–80; Hawaiian history in, 80; headshots in, *82*, 82–83; interracial marriage in, 80–81, 83, 85–86, 89; language in, 79–80; letter to editor on, 89; mixed-race children and families in, 85–86; mixed-races in, 79, 84–85, 89; mixed-race women in, 81–83, *82*; polyracial school in, 80; racial demographics in, 87–88; religion in, 86–87; "Waikiki Tomboys" in, 85; women shortage, immigration laws and, 87–88
Hawaiian Islands, 105–6, 109, 112

Hironaka, Laola, *82*, 83
Holden, William, 100
Holland, Beulah, 51
Hollywood: Asian American Women prostitute stereotype in, 95; depiction of Asian American Women, xv; Oriental themes in, 14, 15; *Shadow of the West* by, 21, 22; "South Seas" in, 68, 71; spy scare by, 21; Suzie Wong character in, 93–95, 99
Hollywood Motion Picture Production Code, 96
Hopkins, Angeline, 82, *82*
Hsia, Calvin, 101
Humphreys, Alfred, 37

immigration: of Chinese, 4–6, 12n13, 94; Chinese Exclusion Act on, 5–6, 88; Immigration Act on, xxivn20, 42, 63; women shortage and, 87–88. *See also* Page Act
Immigration Act (1924), xxivn20, 42, 63
internment. *See* "Coast Japs Are Interned at Mountain Camp"; "Tule Lake"
interracial marriage: in "First Congresswoman from Overseas," 107–8, 111–12; in "Hawaii," 80–81, 83, 85–86, 89. *See also* anti-miscegenation
interracial mixing, 74–76. *See also* race
invisible boundaries, 110
Issei, 42, 60
Italians, 41–42
Iwohara, May, 58, *59*

Japanese American internment. *See* "Coast Japs Are Interned at Mountain Camp"; "Tule Lake"
Japanese Americans: as aliens, 42, 44–45; ancient traditions of, 23–26, *24*; banishment of, 42; espionage rumored in, 21–22, 26; fear of, 22–23, 41; girls, 28–29; in "Hawaii,"

87–88; as inhuman, 40; as "Jap," 40, 44, 45, 49, 50, 64; as middle class consumers, 29–30; patriotism of, 25–26; racial discrimination of, 24–26; as troublemakers in "Tule Lake," 51–52; women, 23, 27–28, 49–51. *See also* "Coast Japs Are Interned at Mountain Camp"; Issei; Nisei; "The Nisei"; Sansei; "Tule Lake"
Jay, Llewellyn N., 86
"Jeeps Lead Japs on Journey from the Sea," 43–45
Jessup, John, xvi
John Hancock Insurance advertisement, 29–30
Johnson, Lyndon, xxiii, 105, 109
Johnston, Aguelde, 71

Kameyo, Doris, 86
Ke-Long, May, 89
Kirsch, Gesa, xviii
Kobayashi, Shizue, 28
Kozol, Wendy, 43; on male gaze, 98; on racial gaze, 108–9
Kress, Gunther: on close social distance, 52; on close-up photos, 81; on invisible boundaries, 110; objects in images, 38; on page layout, 111; on photo angles, 9; on representation of participants, 106; on salience, 108
Kuo, Karen, xv
Kwan, Nancy. *See* "Nancy Kwan"

language: Asian accents in, 4; in "Chinese School," 8; colonialism and, 79; in "First Congresswoman from Overseas," 105; in "Hawaii," 79–80; in "The Nisei," 24–25; power of, 79–80; schools for, 57–58
Leatherneck, 67, 70, 74
"Life Goes to The Forbidden City": advertisements in, 18; dancers in, 13, 16; entertainment in, 14; exposé in, 13, 15–16; Great Depression and, xx; hidden narratives of middle class status in, 17–18; Li Tei Ming in, 16; middle class and, 14, 16–17; middle class consumer consumption in, 18; as novelty news, 14–17; Oriental themes in, 14, 15; race in, 16; sexual stereotypes in, 13–15; Stanford students in, 15, 16
Life magazine: first issue of, xx, 3–5, 11–12; middle class white Americans and, xiii, xv, xvi, xvii; readers of, xvii, 31. *See also* Luce, Henry; specific topics
Lim, Shirley, xvi, 23, 73, 102
Lindley, Renee, 85
Lindley, Rhonda, 85
Lindley, Sam, 85
Li Tei Ming, 16
Longwell, Dan, 67
Loren, Sophia, 99
Louis, Alyce, 82, *82*
Loving v. Virginia, 69
Luce, Henry, 46, 69, 114; childhood of, xiv, 3; on *Life* content, 13–14, 67; on photo-essays, xiii–xiv, 4; speeches by, xvi; Wainwright on, xiv, xxiiin7; on women readers, 18–19

Mai Pang, Letty, 80
male gaze, 98, 108–9
Manzanar camp. *See* "Coast Japs Are Interned at Mountain Camp"
Marines, U.S. *See* "Marines Find Pin-Ups and Glamour on Guam"
"Marines Find Pin-Ups and Glamour on Guam," xxii; advertisement in, 76–77; anti-miscegenation and, 68–69; Chamorro in, 68, 71, 75; Executive Order 9981 and, 69; exposé in, 68; fashion in, 68, 70–72, 74, 75; food in, 75; Guamanian Americans in, 70–71; hidden narratives in, 70–71; interracial mixing and, 74–76; *Leatherneck* and, 67, 70, 74; letter to editors on, 75–76; Marines in, 68–69, 71, 72; middle class

consumer consumption in, 72–75; mixed-race women in, 67–68, 70–73; pin-up girls and, 70; segregation and, 69; "South Seas" in, 68, 71; in "Speaking of Pictures," 67; women in, 71–74

Markham, Harriet, 82, *82*

McCarran-Walter Act, 7

McKinley High School, 87, 90n10

Meith, Hansel, xvi, 37, 64

middle class: Asian American Women as, xiii, xvi–xvii, xix, 113; consumer consumption in, 18, 29–30, 72–75, 102, 111–12; education in, 4–5; "Forbidden City" and, 14, 16–17; Great Depression, costumes, "Chinese School" and, 10–12; hidden narratives, "Forbidden City" and, 17–18; *Life* readers as, 30–31; in "The Nisei," 22, 26, 30–31; possessions and, 43–45; white Americans as, xiii, xv, xvi, xvii

Mink, Patsy Takemoto. *See* "First Congresswoman from Overseas"

mixed race. *See* race

"Mountain Camp." *See* "Coast Japs Are Interned at Mountain Camp"

Mt. Whitney, 39

Mulvey, Laura, 108–9

Mydans, Carl, xxi; "Tule Lake" and, 46–47, 49–51, 58, 61–64

Nakai, Yoshitaka, 52

"Nancy Kwan, A New Star," xxii–xxiii; as actress, 99–101; advertisements in, 93–94, 97, 101; Chinese immigration and, 94; exposé in, 100; fashion in, 101–2; Kwan cover in, 93, 96–99; letter to editor on, 99; male gaze in, 98; marketing in, 96–97, 102; middle class consumer consumption in, 102; mixed reviews of, 95, 103n6; Paramount Pictures and, 93, 96–97; sexualized covers and, 96; sexual stereotypes in, 94–95, 98; Suzie Wong character in, 94–95, 99; War Brides Act and, 94; *The World of Suzy Wong* in, 93–95

narrative: hidden in "Forbidden City," 17–18; hidden in "Glamour on Guam," 70–71; of "Mountain Camp," 37–38, 46; in photo-essay, xiv, xv, xix, 113–14; social circulation in, xviii; two in "Tule Lake," 49–50, *50*, 51

Naturalization Act, 6, 7

Nisei, 22, 46

"The Nisei," xviii, xx–xxi; advertisements in, 29–30; Ancient Japanese and American traditions in, 23–26, *24*; espionage rumored in, 21–22, 26; exposé in, 22–24; girls, talent and, 28–29; Japanese Americans, middle class consumers and, 29–30; Japanese American women, high class society and, 27–28; language in, 24–25; letters to editors on, 32–33; middle class in, 22, 26, 30–31; Nisei Festival in, 27–28; patriotism in, 25–26; racial discrimination in, 24–26; Sansei in, 24, 28; *Shadow of the West* and, 21, 22; students in, 26–27; war and, 30; women in, 23, 27. *See also* Japanese American

Nisei Festival, 27–28

Nitta, Doris, *82*, 83

Noda, Roberta, 86–87

November riots, 52, 54, 58–59

Nuyen, France, 93, 100, 102

objects in images, 38

Okie, 43–45

Page Act, xv, xvi, 5–6

Page Law. *See* Page Act

page layout, 111

Pak, Lava, *82*, 83

Paramount Pictures, 93, 96–97

Parker, Mary Lou, 80

patriotism: of Japanese Americans, 25–26; of Luce, 46
Pearl Harbor, 37, 40
Perez, Elizabeth, 72
photo angles, 9
photo-essay, 3–4; advertisements and, xiv–xv, xx; critical imagination in, xviii; definition of, xiii–xiv, 67; narrative in, xiv, xv, xix, 113–14; strategic contemplation in, xviii–xix; visual rhetoric in, xvi
pin-up girls, 70
Plessy v. Ferguson, xxivn19, 80, 89n3
Prasso, Sheridan, 95
"pressure boys," 52, 58–59, *59*
prostitutes: Asian American Women stereotyped as, xiii, xv, 14, 95, 98, 113; Chinese women assumed as, 5

Quine, Richard, 100

race: citizenship and, 80, 84; demographics, "Hawaii" and, 87–88; interracial mixing in "Glamour on Guam," 74–76; mixed children and families in "Hawaii," 85–86; mixed family in "First Congresswoman from Overseas," 106–7; mixed in "Hawaii," 79, 84–85, 89; mixed women in "Glamour on Guam," 67–68, 70–74; mixed women in "Hawaii," 81–83, *82*; mixing in "Forbidden City," 16. *See also* interracial marriage
racial gaze, 108–9
racism: anti-miscegenation and, 68–69, 83, 86, 88, 111; Asian American Women and, xv, xxivn19, xxivn20, 4; discrimination of Japanese Americans, 24–26, 39; eugenics and, 69, 86; "Jap," 40, 44, 45, 49, 50, 64; *Plessy v. Ferguson*, xxivn19, 80, 89n3. *See also* anti-miscegenation; segregation; stereotype
religion, 62, 86–87

repatriation, definition of, 60
representation of participants, 106
Roe, Alberta, 86
Roosevelt, Franklin Delano, 4, 37, 39
Royal Touch typewriters advertisement, 111
Royster, Jacqueline, xviii

salience, 108
Sansei, 24, 28
school: for language, 57–58; polyracial in "Hawaii," 80; St. Mary's Catholic, 11–12; in "Tule Lake," 56–57. *See also* "Chinese School"
segregation: in education, xv, xxivn19, 80, 89n3; in military, 69
sexual stereotypes: Asian American Women as prostitute, xiii, xv, 14, 95, 98, 113; in "Forbidden City," 13–15; in Hollywood, 95; in "Nancy Kwan," 94–96, 98; "South Seas," 68, 71; Suzie Wong character, 93–95, 99; violence and, 113–14. *See also* stereotype
Shadow of the West, 21, 22
social circulation, xviii
Solinger, Rickie, 96
"Speaking of Pictures," 67
Spickard, Paul, 80
Steinbeck, John, 43, 45
stereotypes: Asian accents in, 4; Hollywood and, 14–15; Okie, 43–45; Oriental, 13–15. *See also* sexual stereotypes
Stern, Bert, 96
St. Mary's Catholic school, 11–12
Stone, Pearl, *82*, 83
strategic contemplation, xviii–xix
students: in "The Nisei," 26–27; Stanford, 15, 16
Sun, Dorothy, 16
Suzie Wong (character): Kwan as, 94–95, 99; Nuyen as, 93. *See also* "Nancy Kwan, A New Star"
Sylva, Barbara, *82*, 82–83

Tanaka, F., 32–33
Terlaje, Toni, 73
Thoene, Barbara, *82*, 83
Thompson, Edward K., 37, 97, 112
Toy, Noel, 17
Truman, Harry, 69
Tsurutani, James S., 32
"Tule Lake," xxi; Army in, 52–53; citizenship and, 63–64; constitutional rights at, 49–51, 58, *60*, 60–62; economy in, 61; everyday life in, *60*, 60–62; exposé in, 52, 53; farmers in, 53–54; humane treatment in, 50, 51, 55, *56*, *57*; Immigration Act (1924) and, 63; "Jap" in, 49, 50, 64; justice in, 58–60, *59*; leisure in, 62; letters to editors on, 51; liberty lacking in, 62–64; Mydans and, 46–47, 49–51, 58, 61–64; November riots in, 52, 54, 58–59; "pressure boys" in, 52, 58–59, *59*; religion in, 62; repatriation in, 60; schools in, 56–57; setting of, 53–54; *status quo* in, 54; troublemakers in, 51–52; two narratives in, 49–50, *50*, 51; women and family in, 54–56, *56*, *57*, *60*, 60–62; women in, 49–51; WRA in, 53, 58–59, 62. *See also* Japanese Americans
Two Nuns Questioning Bashful Girl, 2

Van Leeuwen, Theo: on close social distance, 52; on close-up photos, 81; on invisible boundaries, 110; on objects in images, 38; on page layout, 111; on photo angles, 9; on representation of participants, 106; on salience, 108
Virgin Mary Mass, 11
visual rhetoric, xvi
volunteers, 40–41

Wainwright, Loudon, 67; on *Life* first issue, xx, 3–4; on Luce, xiv, xxiii7
War Brides Act, 94
Ward, Arthur, 95
War Relocation Authority (WRA): censorship by, xxi, xxvn53; in "Tule Lake," 53, 58–59, 62
Watanabe, George, 86
Webb, Sheila, 14, 102
Wilson, Robert, 53
women: as educated professionals, 30–31, 111; family, "Tule Lake" and, 54–56, *56*, *57*, *60*, 60–62; immigration laws and, 87–88; Japanese American, 23, 27–28, 49–51; on magazine covers, 93; mixed-race, 67–68, 70–74, 81–83, *82*; as readers, 18–19. *See also* Asian American Women; Chinese Americans; girls; Japanese Americans
Wong, Anna May, 93, 95
Wong, Jadin, 14–15, 17–18
Wong, Suzie. *See* Suzie Wong (character)
Woolsey, Marion, 85
The World of Suzy Wong, 93–95
World War II, xxi, 43, 69, 70
WRA. *See* War Relocation Authority

Yamaguchi, Frank, 26
Young American Chinese girls, 6, 7

About the Author

Karen L. Ching Carter is a university senior lecturer in English at the University of Vaasa, Finland. Her research focuses on Western stereotypes about Asians and their legal, political, and social implications on Asian American identity. Other research publications include writing English as second language for doctoral students and English writing for publication in the social sciences and humanities. A fourth-generation American of Chinese heritage, she has a PhD in English, writing, rhetoric, and literacies from Arizona State University.

www.ingramcontent.com/pod-product-compliance
Lightning Source LLC
Chambersburg PA
CBHW061717300426
44115CB00014B/2733